Victorian &
Edwardian
Lancashire

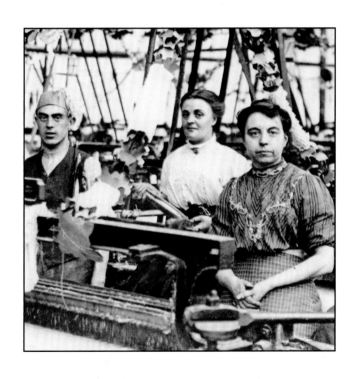

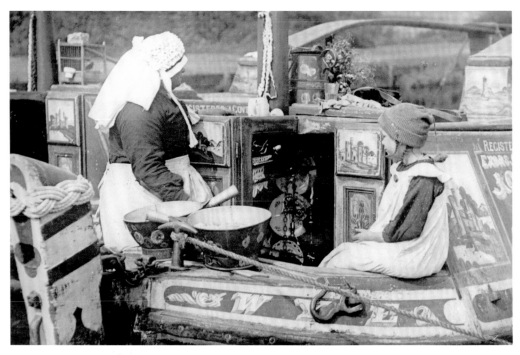

LEEDS AND LIVERPOOL CANAL, WIGAN

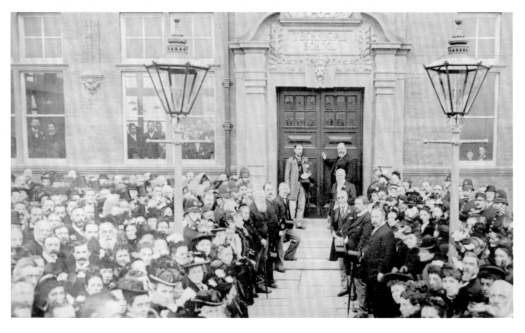

LEIGH TECHNICAL SCHOOL OPENING, 1894

Victorian &
Edwardian
Lancashire

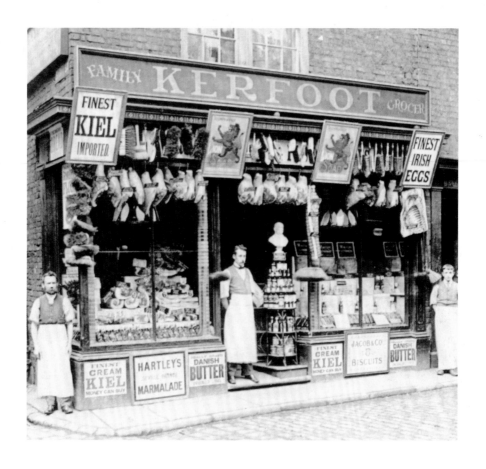

John Hudson

AMBERLEY

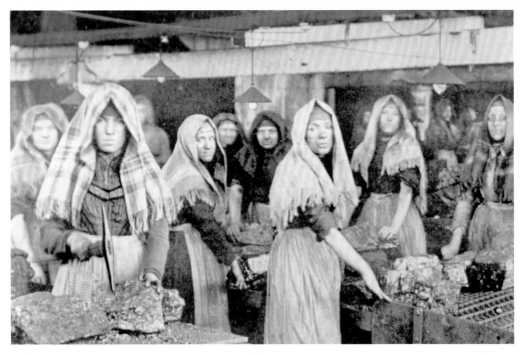

PIT BROW GIRLS, ATHERTON

First published 1993 under the title *Lancashire of 100 Years Ago*
This revised edition first published 2008

Amberley Publishing
Cirencester Road, Chalford,
Stroud, Gloucestershire, GL6 8PE

British Library Cataloguing in Publication Data.
A catalogue record for this book is available from the British Library.

ISBN 978-1-84868-025-8

Typesetting and origination by Amberley Publishing
Printed in Great Britain by Amberley Publishing

INTRODUCTION

In industrial Lancashire, as in few other English communities, the turn of the last century can be seen as modern times dressed in bowler hats and moustaches. When we look at 100-year-old photographs of farm workers in the rural shires, we see men whose surroundings had changed little for generations, and whose lives were still ruled by the rising and setting of the sun and the changing of the seasons. Street scenes in Manchester and Burnley, Oldham and Accrington in the 1890s tell a far different story. They take us to a world that had been disciplined and regimented by factory work for a century or more, where the progress of commerce was eased by the telephone, telegraph, and highly organized public transport by road, rail and sea, and where the workers escaped from their labours at the pub, the music hall and League soccer grounds in which the deeds of Preston North End, Blackburn Rovers, Bolton Wanderers and their foes were the talk of the terraces. Civilization had even progressed to the extent that there were times when you could scarcely open a newspaper without reading about football hooliganism.

Life was hard and there was poverty, but mill-working families with a couple of their children on the looms and another youngster on half-time could feel comfortably enough off, with money left at the end of the week for small luxuries or to put towards holidays and outings. Growing numbers of workers by this time were even being granted a week's leave in the summer, a trend that was switching the focus of wakes holidays from local fairs and festivities to trips to the seaside towns of Blackpool, Southport and Morecambe. Regionally, the trade union movement and the Nonconformist churches had played their part in this process of self-discipline and household management, as had the more universal moral tenor of late Victorian times. The world of the 1890s was far removed from that of half a century earlier, when the workers of the Lancashire towns were still only half-tamed by the Industrial Revolution, absenteeism from work was an accepted fact of Monday mornings and the sporting champions of the day were not demon footballers recruited from the Scottish pit towns but battle-hardened fighting dogs and cockerels. The years between the 1840s and '90s also saw the wholesale clearance of seventeenth- and eighteenth-century slums, programmes comparable with the urban renewal of the 1960s, and it is well for us to remember that many of the worn-out Victorian terraces bulldozed away in our memory were the decent modern homes that provided our forefathers of Victorian and Edwardian times with 'fair if plain' accommodation, to quote one of the texts in this book.

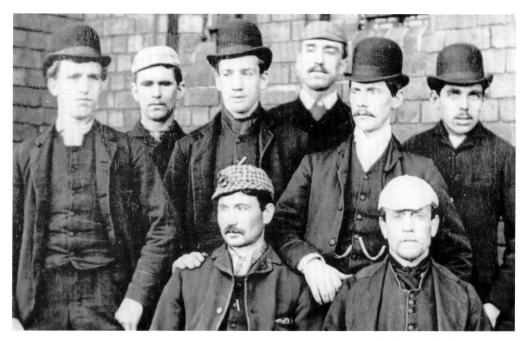

MENS BIBLE CLASS, WIGAN

There were other signs that society was 'growing up'. Local government was moving away from the 'old money' and the mill owners to smaller businessmen still excited about the progress of democracy, and their enthusiasm and confidence was reflected in municipal buildings—town halls and swimming baths, museums and art galleries—that added lustre and stature to many a community. These public halls, too, gave our towns a focal point for leisure, activities, not least the musical soirées and concerts beloved of self-improving Lancastrians, and there began to emerge through these meeting places a middle class of Liberals and Tories, Church people and Chapel, who could come together on common ground and learn to respect each other's point of view. There were still political upheavals afoot, women's suffrage and the rise of socialism not least among them, but never again was the political divide as bitter and intolerant as it had

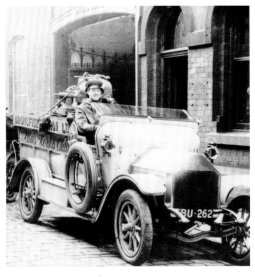

DELIVERIES LEAVE ATLAS WORKS, OLDHAM

been in the middle of the century, when the great battles of Chartism and Free Trade were fought.

Many of the public building projects involved ratepayers' money and private enterprise, a combination still favoured by the movers and shakers of today. The 1890s was the decade in which Blackpool hit the jackpot with the South Pier in '93, the Tower in '94, the Gigantic Wheel in '96, the illuminations in '97, the trams in '98 and the Tower Ballroom in '99. Farther south, 1894 also saw the fruition of another great civil engineering project, the opening of the Manchester Ship Canal. That was a typical Manchester venture, a source of huge civic pride in the city and a certain amount of carping and sniggering beyond. 'Why should we envy London when we've got the Ship Canal coming?' is a sentiment expressed only semi-frivolously in one of the texts quoted in this book, and it is clear from reading Manchester's chatty *Spy* magazine of the day that the prospect of the landlocked old city becoming a seaport had captured the imagination of hundreds of thousands.

In the early 1990s the visitor to Manchester is bombarded with slogans in praise of the city's latest pet projects, the Metro railway and the bid for the Olympic Games, the latter most graphically manifested by a vast swimming complex soon to tower above its neighbouring Victoria Station. There are those who deride Manchester's Olympic ambitions and those who question the need for a rapid transit link between Bury and Altrincham, just as in the 1890s the critics declared the Ship Canal a good idea, but a century behind the times. The fact remains, however, that by the First World War, Manchester's inland port accounted for 5 per cent of Britain's export trade; and today, cussed as ever, the city can point to Metro cars well used and liked by satisfied travellers, and the prospect of a swimming pool to make most cities' look like a duck pond, Olympic Games or no. A hundred years on, the locals' belief in the Victorian 'What Manchester does today. . .' maximum remains as steadfast as ever.

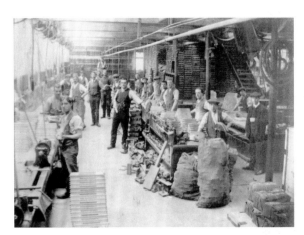

KIRK'S SHUTTLE WORKS, BLACKBURN

There comes a time, however, when we must draw the line on our admiration for the comparative sophistication of turn-of-the-century Lancashire life. For while it is a fact

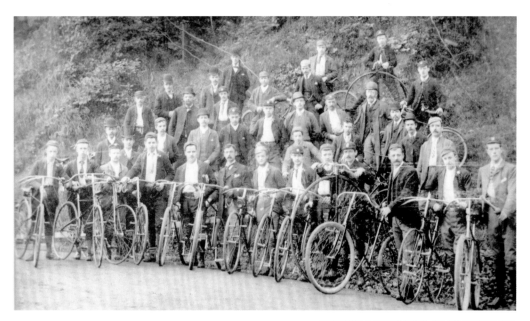

OLDHAM CYCLISTS AT GREENFIELD

that a present-day time traveller would feel far more at home in 1893 than in 1843, there was still much of the Third World about living conditions of a century ago.

Though the Cotton Famine of the early 1860s, a by-product of the American Civil War, was a fading memory, there was still hardship in the cotton industry through what the masters called strikes and the workers lock-outs, a terminological dispute that has survived into modern times. In the coal industry where labour unrest was also rife, few years would pass without the wives and mothers of some poor pit town of Lancashire. South Wales or the North-east mourning the loss of their men through explosions that left dozens and sometimes hundreds dead—Abram and Wood End, and into the 20th century, Maypole and Pretoria, to name just a handful of those still etched in the folk memory of thousands in this part of the world.

Then there were the endless tragedies at sea as shipbuilders pressed new technology to its limits and beyond, the naked flames that swept away whole tenement blocks and communities in the night, the rail disasters and the gas blasts. For all the mill-workers' and miners' comparatively sound earning power, the demon drink and the spectre of the workhouse were no trifling matter for thousands of hard-pressed women, and the time-travelling feminists among us would have had a field-day in the Lancashire of one hundred years ago.

Most of all, from our modern standpoint, we would find it distressing to cope with the filth generated by horses by the thousand in our towns, with enlightened sewerage systems that seemed always to work better in the sanitary inspectors' earnest reports in the council chamber than on a hot August afternoon in the backstreets of Burnley, and with the grime belched out by a forest of house chimneys and factory smokestacks in our damp valley towns.

We would also miss homogenized food, homogenized safety standards—and homogenized people, for folks then were a mass of rough edges and ways unfamiliar to us.

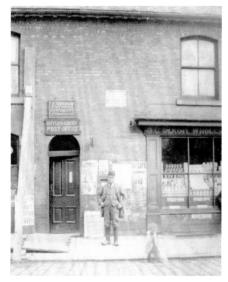

BUTLER GREEN POST OFFICE, WASHBROOK, CHADDERTON

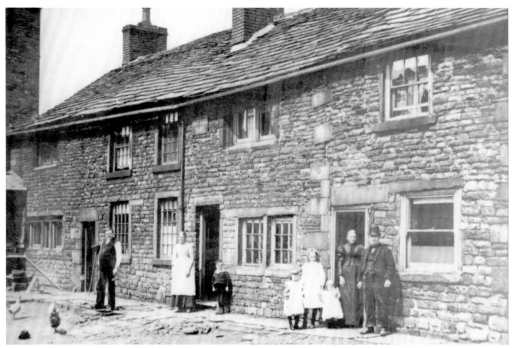

POTTERS YARD, OLDHAM

Again, moral teaching and an increasingly uniform lifestyle had taken then some distance from the kind of over-the-top but accurately portrayed characters that had peopled Dickens's novels of a generation or so earlier, all tears and kisses and hugs and loud proclamations, whether in joy or sorrow. But they were still men and women moulded by their own locality, with little or no outside influence, and if you were not of their small world then there were gulfs of suspicion and prejudice to be crossed before you could be at ease with them. Some would say that the First World War was rather a high price to pay for the breaking down of this particular British barrier.

This, then, is the half-familiar, half-alien world recorded in these pages, in which contemporary writings and photographs combine to flesh out our knowledge of times now at the very verges of living memory. Most of the pictures and texts date from the 1880s to the end of Edwardian times, and those that stray slightly outside these limits can still be seen as typical of the period. Professional photographers were to be found in even the humblest of mill towns from the 1870s onwards, but it is inevitable that many of the pictures in this collection are from the early years of Edward VII's reign, when the sending and collecting of postcards became the twentieth century's first great craze. It is thanks to that eminently people-oriented hobby that we know as much as we do about our towns and villages at the turn of the century—and what made our forefathers tick in that intriguing, elusive Lancashire of one hundred years ago.

John Hudson, 1993

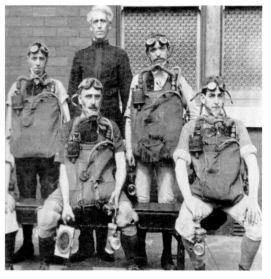

FIRE FIGHTERS,
PEARSON AND KNOWSLEY PIT, INCE

Victorian
& Edwardian
Lancashire

BEACH HOTEL,
Hollingworth Lake.

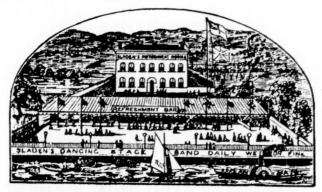

JAMES SLADEN

Respectfully informs his Friends and Visitors to Hollingworth Lake that he has made

EXTENSIVE ALTERATIONS AND IMPROVEMENTS IN HIS PREMISES,

With a view to meet the requirements of his Guests during the Season. He has considerably enlarged the Hotel, so that it offers the comforts and attractions of a First-class Establishment. There are Private as well as Public Refreshment Rooms for either small or large parties. Arrangements can also be made on a liberal scale for the entertainment at either Dinner, Tea, or Supper of Members of different Societies. If due notice is given, any number of Persons up to One Thousand can be accommodated with a PLACE OF MEETING ENTIRELY TO THEMSELVES.

WEDDING BREAKFASTS PROVIDED.

The Hotel is Licensed to Sell RUM, GIN, BRANDY, WHISKEY, and other SPIRITS, which will be found of the Best Quality.

The WINES are of the Choicest Vintage ; and the Mild and Bitter ALES and the STOUT are excellent.

A BAND IN ATTENDANCE

Every day during the Summer Season, on the large and commodious Dancing Stage, which is brilliantly illuminated with gas at dusk.

An additional Covered Dancing Stage has been erected, nearly 2,000 yards in extent, making a Dancing Accommodation at the Beach Hotel of nearly 4,000 yards.

CIGARS AND TOBACCO.

STABLING and Good Accommodation for Horses and Vehicles.

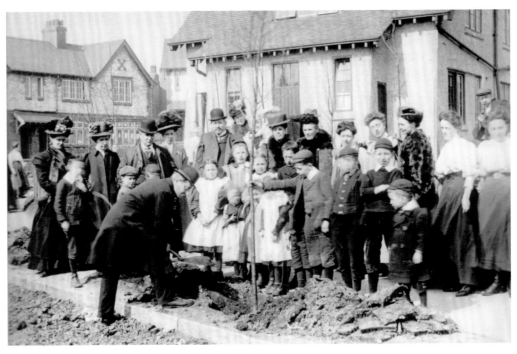

TREE PLANTING, HOLLINS GARDEN SUBURB, OLDHAM 1909

FAIRLY IF PLAINLY HOUSED

Much is made of the nuisance of smoke, but even in this respect Lancashire is hardly so black as she is painted. One is positive he has swallowed as much soot and smoke in some parts of London as ever he has in the busy towns of the North, and the writer has certainly seen more misery and wretchedness in homes in the Midlands and the South than he has in Lancashire. It is a notable fact that it is not factory people who dwell in slumland, or bring slums into existence; one must go to a stratum of workers much below the cotton operative for the dire evidences of poverty. The mill-hand is generally very fairly if very plainly housed. As a proof of this, it is only necessary to mention one fact. Single-roomed tenements are only one per cent of the total number of houses occupied by factory workers, whereas in London the proportion at the last census was fourteen per cent.

As the reviewer of a book on the housing problem said in *The Times* recently:

> The largest aggregations of people, the greatest amount of casual labour and poverty, and the worst housing conditions are found in the trading centres, not in the factory towns proper. The worst conditions of all occur in the old seaport towns; or, perhaps, it would be more correct to say did occur twenty years ago, for much improvement has since been effected. Even in factory towns the worst cases are in the more central areas of the older towns, built before the rise of the factory system; and these are matched by the poorer parts of many small and old towns of a totally different character, in which there has never been a factory or a large increase of population. Such towns may make a fair outward show while concealing far greater evils than are to be found in places, such as Oldham, which have truly been created by the factory.

Those who have a penchant for talking of the hopeless condition and environment of Lancashire workers can have little idea either of the situation of these towns—and it should be remembered that even in this workaday region only one-fourth of the county is given over to industrialism—or of the improvement that is constantly taking place both inside and outside the factory. There is no doubt, too, that money is larger in amount and better distributed than ever it was, and that there are actually more working people 'living retired', as the phrase goes, than ever before. There is not an old weaver or spinner living who does not

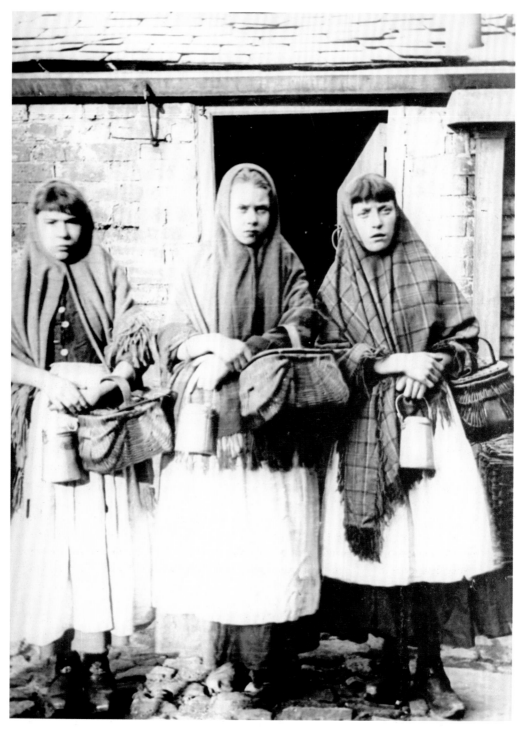

MILL GIRLS WITH SNAP BASKETS AND CANS

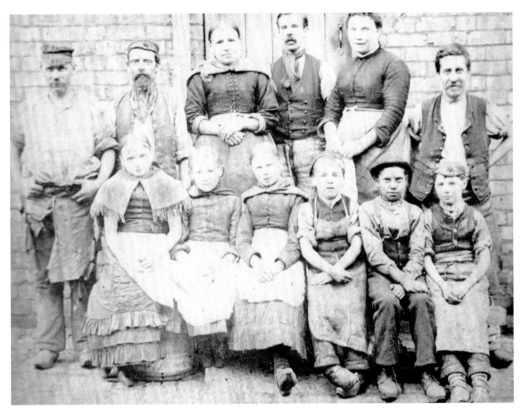

MILL CHILDREN AND MENTORS, WIGAN

vividly contrast the lean times of his youth with the comfort and luxury brought about by the factories of the present day.

No one will deny that on the whole the general conditions in the mills themselves are better. Despite the past indifference of the Legislature and the selfishness of parents, the workers in the textile industries have to-day not a great deal to grumble at, beyond the occasional tyranny of a tackler or the quality of the stuff they are sometimes asked to work up. Their hours are not excessive—a ten hours' day and a 55½ hours' week—ventilation, smoke abatement, and sanitation laws are being enforced on the masters; and the trades unions see to it that the wages are kept up to a satisfactory level. The working age for children, maybe, still leaves room for improvement in the interest of both individuals and the State, but the good people who try to make your flesh creep with stories of little children torn from their warm beds in the morning and sent through the cruel wind and rain to slave for unfeeling masters, hardly put the case fairly in the county's interest. They seem to forget that Lancashire is not the only place where young people have to start work early in the morning. The agricultural labourer's child has also to get up with the lark, and, what is more, has no warm mill to shelter him. The lot of a Lancashire 'doffer' or 'tenter' walking a few hundred yards between home and factory is surely not more dreadful than that of the peasant lad going out into the fields while yet the cold mists lie on the ground and every implement he touches chills to the bone.

The fact of the matter is, there is a good deal of sentimental nonsense talked on the subject of the 'cruelty' and 'slavery' of the factory system of Lancashire. Ask these same factory people if they would change their present occupations for what is called the free, open-air life of the peasant. Would they be satisfied, does one think, with a chaw-bacon existence and twelve shillings a week? Would the men forgo their high pay and town pleasures for the long daily round of the agricultural labourer, and would the women, having once enjoyed the fruits of four looms, take kindly to the scant raiment and scantier fare which are associated with the weeding of fields and the digging of potatoes?

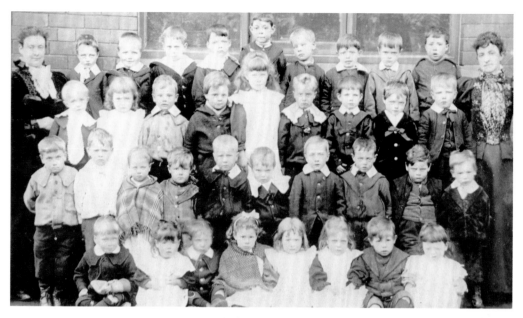

RICHARD EVANS SCHOOL, ASHTON-IN-MAKERFIELD

One need go no further than to the servant girl question to point the moral. What is the real cause of the famine in serving-maids? It is not so much that girls receive worse treatment than they used to do, on that as a race we have become more independent. The servant girl wants more wages and more freedom, and to get both she, strange as it may seem, flies to those steam-driven workplaces that have been so much abused. To use their own phrase, servants will not be 'cooped up', and they go for release to the spindles and the looms. They prefer, rather than be household drudges from one Thursday night to another, to finish their work at half-past five each day, to be free from twelve o'clock on Saturday noon until six on Monday morning, to live on better food, and to dress like ladies.

Frank Ormerod

'WELL-OFF' IN THE BACKSTREETS

When does one begin to feel 'well-off'? Often I pass the tiny cottage where I was born, and if the door is open it seems as though one could poke the fire from the door-step. Yet at one time it housed five of us, and it did not seem too small. The back-door opened on to a cul-de-sac, where quite a number of people lived regularly on the edge of extreme poverty. They ought, by any decent standard, to have been unhappy, but I do not remember that they were. They drank, sang, and fought, and did all sorts of unconventional things, but they did not mope. If one or other of them had to go into the workhouse they did it with an air. They went round the streets to bid good-byes and as they passed round the corner they waved their hands not too forlornly.

In none of the cottages were the floors carpeted, or even covered with oil-cloth or linoleum. They sprinkled the floors with sand, and they ate off well-scrubbed tables their plainest of food. Most of them worked in the cotton mills, and when times were bad they just 'clemmed'. There was no unemployment pay then, and so bad times just pressed them in the ribs. If the rent or rate collector called, they told him to do his damnedest, and if he did they 'went down' cheerfully, and considered it as almost going in training. I have heard them tell how much weight could be put on whilst 'doing time'.

The fact is, you can descend to a level when you cease to care what happens, and can meet the drabbest of life with a grim jest. I played with other children in the gutter, scraped dirt with a spoon, joined in the fifth of November bonfire, when old bedding and other discarded junk was mercifully cremated, and tried to induce a geranium to grow in a window-box despite the lack of sun, the smoky fog, and daily accumulation of pungent dust.

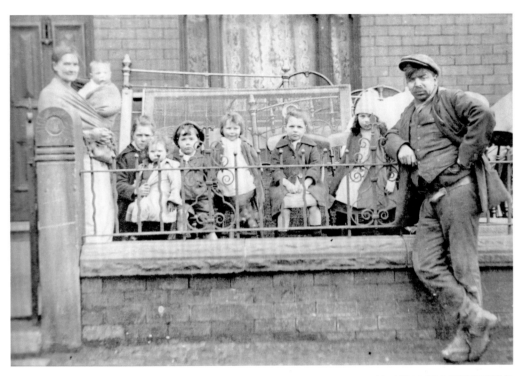

AN EVICTED FAMILY, ASHTON-IN-MAKERFIELD

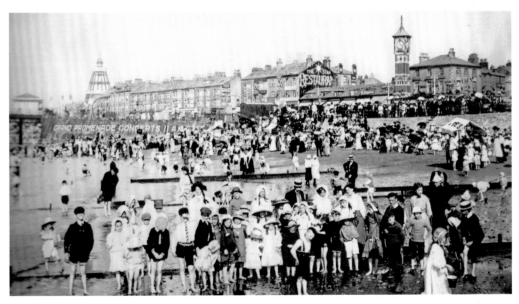

ON THE SANDS AT MORECAMBE

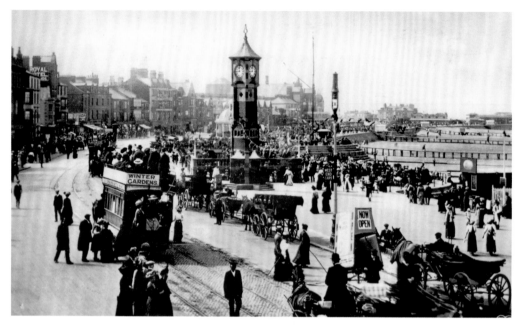

PROMENADE AND CLOCK TOWER, MORECAMBE

My playmates seemed as happy as any other children. We played singing games, and other rollicking affairs centring round a 'den' which happened to be a handy midden door. Most of the children have become decent citizens, despite their early handicaps, or maybe because of them. We learned to look after ourselves, to devise our own amusements, and not to be a nuisance to others. A cuff on the ear taught us not to overstep neighbourly indulgence.

After I had learned to read an early friend of my mother, who had 'married well', gave me a *Strahan's Annual* which her children had discarded, and opened up to me a new vision. It was, I suppose, an ordinary children's annual, but it was to me an approach to fairy-land. There was in it, I remember, an abridged version of Spenser's *Faerie Queen*, a shortened *Pilgrim's Progress*, a story about the Black Hole of Calcutta, a fairy story called *Yellow-cap*, and a yarn about Robin Hood, in which that hero also was held to be of fairy origin. They were all so real to me, that when my teacher asked me who was Robin Hood I immediately said that he was a fairy, to the ribald amusement of my more sophisticated classmates. I also began to read the Bible, and became so steeped in it that I was always placed at the front of the class when we were examined on religious knowledge, so that my tiny hand could more readily catch the inspector's eye. I came a cropper when that clerical gentleman once asked me why I read the Bible, and I answered that I liked the battle stories! Perhaps I did myself all injustice. I may even then have been sensitive to the majesty and rhythm of the Authorized Version.

We were all too poor to know anything about holidays, and I caught my first glimpse of the sea when as a choir-boy I went on the annual choir trip to Morecambe. I saw it from near the station entrance at the end of a long street, and I thought it was a dark coloured wall! It was not until I was turned twenty-one that I knew the pleasure of a more prolonged stay. Not many mill-workers had more than four days' holiday at the seaside then, and only an aristocrat could hope for a full week. We set out about five in the morning, taking clothes and food in a tin box, and we never thought of arriving home at the end of the four days until about midnight. Never since have I attained the intensive joy of holiday-making that could be packed in so short a time. We did not mind sleeping four in a bed, and four beds in a room. Those were indeed the days.

I am aware that many people in this country are still living in intense poverty. Far too many. There is still the dreadful curse of unemployment and social injustice. But I have heard people claim to be poor who do not know what real poverty can mean. In my younger days some of our parents were afraid of holidays coming, as it meant loss of wages, and a real setback. They had to buy food and clothing 'on tick'. Then came pawning, and after that the small money-lender. I saw so much in my early days of the evils of 'tick' that I have never

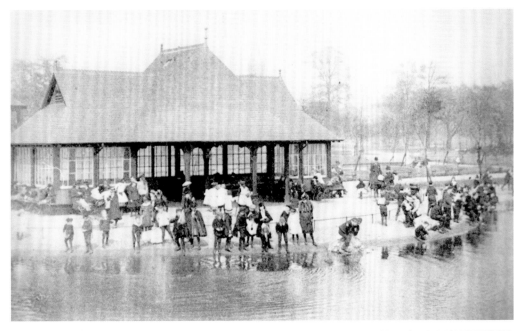

CHILDREN'S CORNER, WHITWORTH PARK, MANCHESTER

since been able to reconcile myself to the flaunted virtues of 'hire purchase' or any other of the highfalutin names under which modern systems of 'tick' fly their flag. 'Tick' remains 'tick' to me, and I see no virtue in it.

It seems impossible to me to doubt that working-class standards of living have risen on the whole. Nobody would have dreamed of a week's holiday in my younger days, to be spent at the seaside or even on the Continent. There were no cinemas or dance halls. Football grounds were very modest affairs. No greyhound tracks or immense sports stadiums. There were no baths, and no electric light. We went to bed with candles and slept in white-washed rooms. We read the evening paper, when we could afford to buy one, by a naked gas flame. A parloured house, 'lobbied off', was only for the better off. It was absurd that we never thought of anything better.

What I am trying to get at is that only those who knew the earlier standards realize the improvement. Outside absolute destitution, being 'hard up' on the modem scale might have meant something like luxury in my younger days. My weekly spending money, raised gradually from one penny to sixpence per week, would be very small beer to the youth of to-day. Are they then so much the happier? I doubt it. We never heard of youthful suicides, and 'nerves' seemed non-existent. The very fact of having to make our own amusements had its share in forming character. Being 'well off' is largely a state of mind.

T. Thompson

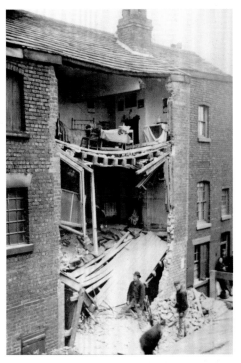

GAS EXPLOSION, WIGAN

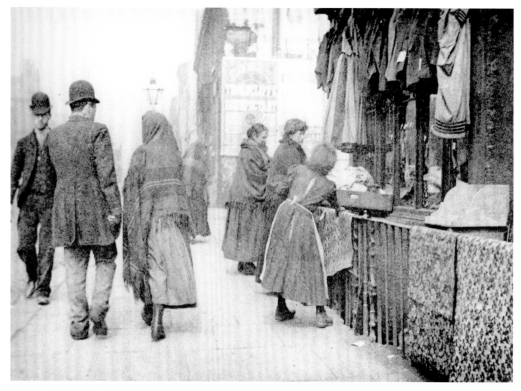

STREET LIFE, ROCHDALE ROAD, MANCHESTER

CLOAK AND HAT TRICK

This morning a young woman named Ruth Braithwaite, a domestic servant, was charged at Lancaster with obtaining a quantity of goods by false pretences from James Dickinson Ellershaw, hosier. It appeared that the prisoner went to the shop with a man named Robinson, who has a wife and family living at Barrow.

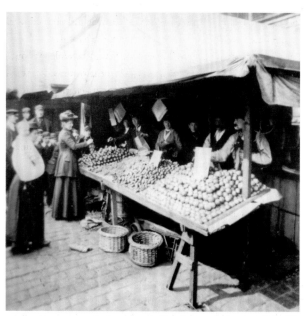

Robinson, who is also in custody, told Mr Ellershaw that he had saved the life of a gentleman on the railway, and to enable him to go to America he had made him a present of £500. He also said that he was going to marry the young woman, but that as she was poor he wanted to rig her out with clothes. A dress, cloak, hat and other articles were obtained to the amount of £6 9s. 3d. It was subsequently ascertained that the couple had been living together at Morecambe and Bolton. Before leaving Ellershaw's, Robinson gave an order for another lot of goods, value £10 9s. 6d., but these have not been delivered. Braithwaite was remanded in order that Robinson might be brought to court with her.

Northern Daily Telegraph, June 1892

FRUIT STALLS, BLACKBURN MARKET

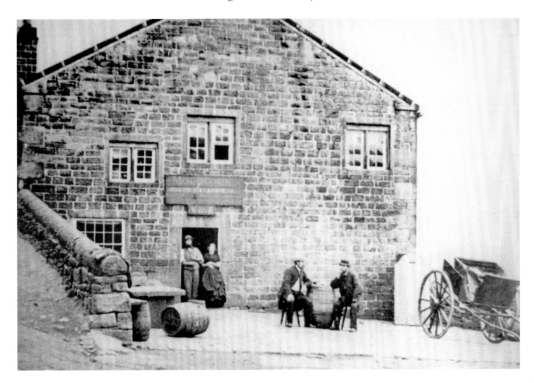

MOORCOCK INN, 'BILL O' JACK'S', GREENFIELD

PERPETUAL PLAGUES OF DARKNESS

Cotton predominates in Rochdale, the spindles in the district being about one million seven hundred and fifty thousand, and the looms numbering about twenty-three thousand, the output including such fabrics as domestics, checks, stripes, oxfords, zephyrs, flannelettes, fine sheetings, and heavy domestics. Round about the town they have numerous collieries to feed their boiler fires, and they have also foundries and workshops for the construction of textile machinery. Some centuries have elapsed since they discovered their coal, and used it for smelting, on a small scale, and iron ore which was found to exist in the shale above it.

Here, as elsewhere, the manufacturing spirit has been destructive as well as constructive. Rochdale was once much more picturesque in its surroundings than it is now, as remnants of its old halls bear witness. These, in various stages of decay, and with legendary lore attached to them, are to be met with, built generally of stone, and attractive to the antiquarian eye with their gables and mullioned windows. When John Ruskin visited Rochdale the sight of one of these decayed houses saddened him. He says,

> Just outside the town I came upon an old cottage or mansion, I hardly know which to call it, set close under the hill and beside the river, perhaps built somewhere in the Stuart time, with mullioned windows and low-arched porch, round which in the little triangular garden, one can imagine the family as they used to sit in old summer times; the ripple of the river heard faintly through the sweetbriar hedge, and the sheep on the far-off wolds shining in the evening sunlight. There, uninhabited for many and many a year, it had been left an unguarded haven of ruin; the garden gate still swung close to its latch, the garden blighted utterly into a field of ashes, not even a weed taking root there; the roof torn into shapeless rents; the shutters hanging about the windows in rags of rotten wood; before the gate the stream that had gladdened it now soaking slowly by, black as ebony, and thick with curdling scum; the banks above it trodden into unctuous, sooty slime; far in front of it, between it and the old hills, the furnaces of the town foaming forth perpetual plagues of sulphurous darkness; the volumes of the steam clouds coiling low over a waste of grassless fields, fenced from each other not by hedges but by slabs of square stone, like gravestones, riveted together with iron.

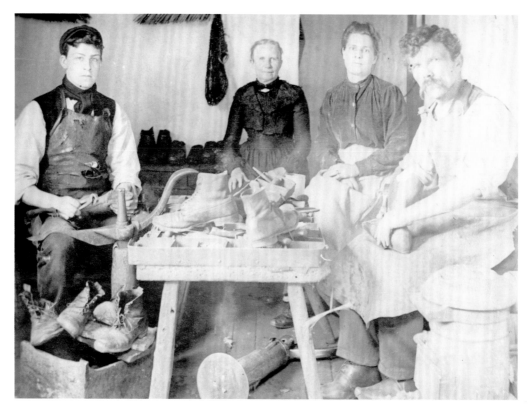

MR FEARNLEY'S CLOG SHOP, ASTLEY

The house thus described stood upon the banks of the Roach here, and it is significant that upon the site of it they have erected the handsome structure described architecturally as being in the domestic Gothic style, and which answers the purpose of a Town Hall.

We cannot stay longer in Rochdale, but must avail ourselves of another steam tram car. There are several to choose from, one of which would take us between unbroken lines of buildings through Smallbridge to Littleborough at the foot of Blackstone Edge. By another car we could go to Heywood and Bury, but the one which suits our purpose is that which traverses the Bacup road towards Whitworth. It is a tolerably steep climb out of the town in that direction, but though in our progress we come in sight of the bordering-hills with deep cloughs between, the habitations of men, like the poor, are always with us, and with more or less compactness line the road, with its flagstone footways, and when we arrive at our terminus we are still in touch with manufacturing surroundings. Here, having left our car, we will, for a change, pursue our journey to Bacup on foot. So, passing by deep-delled Healey we come to Whitworth, lying between the quarried heights, and here, too, in the village once famous for its bone-setting doctors, we find that they spin and weave cotton in considerable quantities.

The road now lies for some four miles or more between the hills in gradually ascending gradients, the footways still being flagged; they get the flag and building stones from the hill sides in great quantities, and you may see how deeply scarred they are with the quarrying. Before us on either hand stretch the two long lines of stone-built houses and slopes, not spreading far backwards, with mills among them, relieved here and there architecturally by the village churches, placed on commanding eminences, the dissenting chapels, the schoolhouses, or the more favoured residences standing within their own enclosures on the rising ground. The prospect to a pedestrian is not altogether an inviting one. Pleasanter, no doubt, it would be to traverse the breezy highlands such as those of Rowley Moor to the left, from which one might be in sight of Knoll Hill, with its flattened summit, on one side, and Brown Wardle, that famous beacon height and hill of watching, on the other; but our purpose being to trace the course of industrial life we must keep to the path of duty,

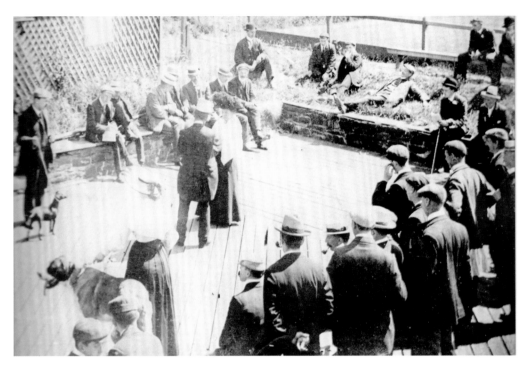

DOG SHOW, UPHOLLAND

which lies along the flagstones of the hard-featured highway. The good folk who dwell hereabouts are mainly of the operative class, the women, like many of their sisters in Lancashire, are often seen wearing shawls over their heads, and the footways frequently echo to the chatter of iron-plated clogs. The use of this wooden-soled footgear obtains more or less in all manufacturing towns of the county; the imprints of it are to be met with in the yielding soil of forest and moorland paths, and in your passage along the town streets you will see how important is the clogger among tradesmen, and what fanciful art he can bring to bear upon his craft. The Lancashire clog is an outcome of the sabot, which the Flemish weaver brought with him; the sabot, however, was wholly of wood with a lining of lambskin, but the Lancashire clog has a leathern top. We read in Baines that they still preserve at Rivington, near Bolton, 'a pair of wooden shoes of a Flemish weaver, on the model of which the modern clogs of the district, extending from the Roach to the Ribble, seem to have been constructed.' Here, too, in this neighbourhood, as elsewhere in Lancashire, you may find that in distinguishing persons there is a disposition to dispense with surnames, the Christian name alone being used, often with a linked pedigree and place of location attached. For instance, it is on record that in the village of Whitworth, there was once living a woman 'for whom it would have been useless to enquire there by her proper name, but anybody in the village could have instantly directed you to Susy o' Yem's o' Fairoff's at "th' Top-o'th'-Rake".'

John Mortimer

SHOWDOWN AT THE SHOW

It would be difficult to enumerate half the things the Lancashire man has a liking for, but special mention ought to be made of two, gardening and music. In the towns, of course, the first-named hobby can be little indulged, but wherever a patch of ground, likely or unlikely, can be obtained in the country, there the native will plant his greenstuff and old-fashioned flowers, and tend them with untiring devotion. In quite unexpected places, on ground where one would scarce hope to raise a blade of grass, one comes upon gardens ablaze with daffodils and tulips, roses and sweet williams, asters and dahlias. The soil for the purpose, maybe, has been carried for miles, and all kinds of artificial means adopted to enable the gardener to bring his flowers and vegetables to the highest pitch of cultivation, and sometimes to beat all England in open competition.

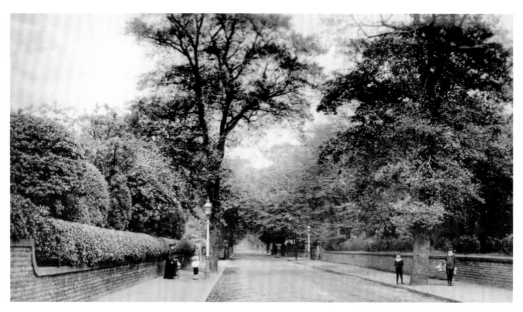

WHALLEY RANGE, MANCHESTER

Along with his inborn love of a garden, the Lancashire man has ingrained in his nature a desire to triumph over his neighbour in the duality and size of his products. A generation ago, before a Puritanical regime had robbed village life of much of its colour, the cottage gardener found encouragement for his skill and industry in the various shows held at the inns all over the countryside. Well does the writer remember the festive days when shining copper kettles, brass preserving pans, silver teapots, and other prizes, all decked with coloured ribbons, were hung out of public-house windows on long poles to announce the annual shows and stimulate the growers of big gooseberries, monster dahlias, and giant sticks of celery. They were days long looked forward to, and the competitions had the effect of promoting a very healthy rivalry. Sometimes a prize was offered for the best bunch of wild flowers, the longest willow shoot, or the best plaited stick of rushes; but many of the authorities, looking only upon the little extra conviviality which attended the exhibitions, and seeing no virtue in friendly contests which kept the villagers in touch with soil all the year round or sent them into the fields and woods in search of the beautiful products of Nature, swept the competitions away, as they have done so many other simple and innocent pleasures. Shows are, of course, still held, but they are larger affairs altogether, and often held under conditions which give the villager little chance of success. He finds himself, maybe, in competition with a wealthy landowner or factory master, who can afford to spend any amount of money and employ trained gardeners, and a game played under these disadvantages soon begins to pall, let the cottager be ever so enthusiastic.

Frank Ormerod

FAIR STINKEN O' BRASS

When people are reputed to be wealthy and especially if they make a parade of their wealth, it is sometimes said in the vernacular that 'they fair stinken o' brass!'. Vulgar as is this phrase, it has the true Chaucerean ring about it. You might almost take it to be a quotation from the Canterbury Tales. For expressiveness and force it cannot be surpassed.

The stories that are told of some of the wealthier inhabitants of Rossendale are curious and amusing. 'Same as yo', maister George' has become a classic saying. It originated thus: The occasion was the election of a poor-law guardian—an exciting event when political parties, Whig and Tory, brought out their candidates, and put forth their strength in the contest. Political feeling ran high then as now, and guardians were elected on the colour of their politics, quite independently of their special fitness for the position. George Hargreaves, Esquire, JP, was

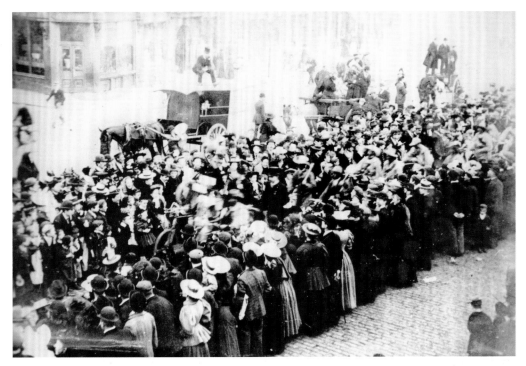

CYCLE PROCESSION, TRAFFORD ROAD, MANCHESTER

the ruling Tory spirit in the very heart of the Rossendale Valley in bygone years—a man of the staunchest integrity and blameless life, but Tory to the backbone. The voters, many of whom were dependent on him in various ways, because he was a man of property and an employer of labour, were crowding, into the school-room to record their votes, George himself marshalling his partizans, and scanning the faces of doubtful supporters. 'Who are you voting for, Sam?' Spoke out Mr H. to a sturdy Rossendalean, elbowing his way among the crowd. 'Same as yo', maister George,' answered Sam with a nod, 'Sale as yo',' and 'maister George' nodded back with a gratified smile. So it is 'same as yo', maister George' when the opinions of any present-day political or other weak-backed inhabitant are in question.

A number of stories are related of Mr John Brooks of Sunnyside. Sam Brooks, the well-known Manchester banker, and John were brothers. The family came originally from WHalléy. One of the stories I have heard is too good to be lost. When the Act of Incorporation was obtained, and government by a municipality was first introduced into Manchester, it is said that John Brooks was asked to stand as a Town-Councillor or Alderman. Being doubtful as to the expediency of taking

SOUTHPORT

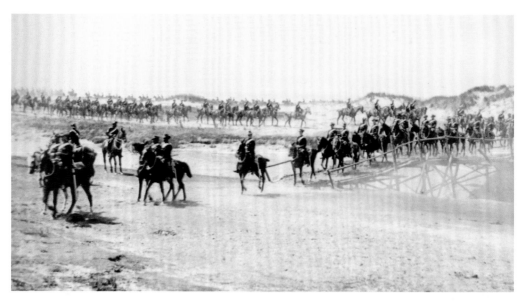

EAST LANCASHIRE YEOMANRY MANOEUVRES, FYLDE COAST

such a step, he promised to consult his brother Sam and be guided by his advice. Accordingly, he spoke to Sam on the subject, informing him that he (John) had been asked to take office as a new-fangled Town-Councillor. What did he think of it? would it be wise and prudent for him to agree to the request? 'Will they pay you for it?' enquired Sammy, with a quick interrogative glance at his brother. 'O no!' John replied, 'there'll be no pay for th' job—nothing for it but the honour of the position.' 'Humph! honour be hanged!' responded Sammy, 'let me gie thee a bit of advice, John; whenever thae does ought for nought, do it for thaesell!'

Thomas Newbigging

FIELD MARSHAL MALTOOT

A strange Rochdale character who died early in 1873, named Shaw, alias 'Maltoot' is worthy of notice. Shaw was a noted wrestler. He started business with a donkey and cart, as a carter, and he used to ornament his person with military attire on some days, and on others was to be seen with an old college student's cap, and garments of many colours, but his wooden leg gave a flat contradiction to his military assumption, and his red proboscis to his collegiate pretentions. Although some thought him to be weak-minded, he possessed native wit of no ordinary character. Passing the residence of a 'limb of the law' one day, he was asked if he could 'sup' a pint of ale. Shaw replied that he could if he had the chance. He was invited within doors, and a pint of nut-brown ale gave an impetus to his loquacity. The lawyer, proud of his possessions, showed Shaw into his library, and, amongst other pictures, drew his attention to a portrait of himself, and invited comment. Shaw, after surveying it with as much attention as a connoisseur, remarked that the attitude was not correct. The lawyer assured him that all his friends had pronounced it a remarkably good likeness, and wished to know what was the fault he had noticed. Shaw gravely remarked that the portrait represented his host with his hands in his pockets, whereas he was in the habit of having them in other people's. On one occasion, when a company of soldiers arrived in town on their way to Manchester, Maltoot dressed himself up in all the military attire he could find in his wardrobe, and strutted through the streets with the air of a commander-in-chief, with his head erect, as if he had a stiff-neck. Some privates, who were strolling up Drake Street, and must have been raw recruits, saluted him with the profoundest respect, evidently thinking, from his gay attire and peacock appearance, that he must be a field marshal or general who had unfortunately lost his leg in some disastrous engagement in defence of the liberties of his beloved country. The 'general' condescended to recognise, in the usual manner of warlike chiefs, the military honour paid to him, and, in addition, graciously

NUT AND BOLT FACTORY WORKERS, ATHERTON

smiled upon his subordinates. Appearances are apt to mislead, and our great dramatist has informed us that 'the world is still deceived with ornament', and so it was here, for if these warriors had been better acquainted with Rochdale, and its celebrities, they would not have mistaken 'Maltoot' for a general or field marshal, but would have known that he was simply a driver of asses. Shaw had some little experience of prison life, and on one occasion, being questioned on the internal arrangements, remarked that they were excellent and that he held the strong opinion that every Englishman ought to be confined once so that he might thoroughly appreciate the admirable arrangements which were made for the good of those who sometimes did ill. When the new Town Hall was opened he joined the procession in his donkey-cart; and it is stated that in the evening he sought admission to the banquet given on the occasion, having his wood leg highly ornamented in *blue and gold*, and tied round with the gayest of blue ribbon; for he was a 'true blue', and had a great contempt for Radical opinions and doings. It is right to say that the 'Blues' were not, however, very proud of their odd acquisition.

William Robertson

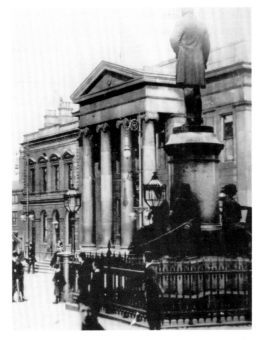

OLDHAM TOWN HALL

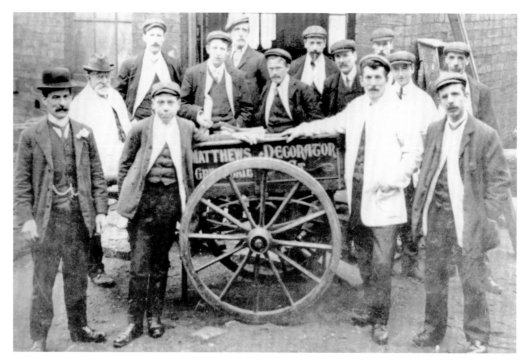

MATTHEWS AND SONS, PAINTERS, OLDHAM

DIVIL OF A CAT

When a new employee began work at the mill in Leigh, he or she was expected to pay a tooting, of a shilling or more, and to this the other workers in the same room put a penny or twopence each, and when Old Pee was known to be well out of the way, a back-tenter would be sent to Isaac Massey's for halfpenny bottles of pop, and to Spedding's for two-penny pork pies or Eccles cakes.

When new half-timers began work, as they could not pay a footing, they had to suffer the penalty of being bumped. That is, two or three got hold of their heads, and two or three of their feet, and the rest pressed on the stomach, and bumped them on the floor.

The older hands delighted too, in playing tricks on the new-comers. Sometimes they were told to go to a carder for 'strop oil', or 'left-handed screw-key', etc.

Tricks were sometimes played on older folk too. Irish Peter was a good-tempered, innocent sort, and always ready to oblige. One day after dinner, when a number of spinners and strippers and grinders were waiting round the door for opening time, one of them said, 'I don't know heaw Peter theere does his work, he looks as wake as a cat.' Peter protested, and said he was stronger than he looked. 'Get oaf wi' thee, I'll bet a sixpence a cat could pull thee through th' lodge,' said the first speaker.

'I'll bet sixpence it connot,' said another, 'if Peter will agree to let it try to-morrow dinner-time.'

Peter agreed. A cat and a rope were brought, and the two were tied together, but in addition, unobserved by Peter, another rope was tied to him, and thrown over the water to two men, who caught it.

At the word 'Ready', the cat was thrown into the lodge, and it and Peter were pulled to the other side.

When he stood dripping on the bank, Peter looked at the cat and said 'Surely it's the Divil.'

Mary Thomason

THE GREAT BAZAAR

Saturday night, October 28th, 1905, witnessed many sighs of relief. 'I am glad it's all over' was the general comment of the workers; 'But is has been so nice we should not mind another,' added others. 'It has been one of the nicest bazaars I have ever been to.' 'Everybody seems to have enjoyed it.' 'Did you ever see such a

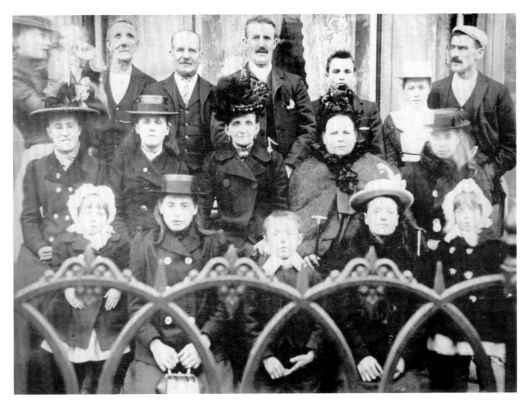

AFTER WORSHIP, WIGAN

complete clearance!' 'What a crush on Saturday; the fun was fast and furious.' 'Didn't the entertainments go well?' are amongst the many remarks we heard.

The decoration of the room was put in the hands of Wilkin's, of Liverpool, and a very pretty effect was produced by the red and white Japanese colours, with umbrellas, fans, kakemonahs and lanterns. The stalls were put up by Mr Heaton, and we are most thankful to him for his kindness.

What a lively scene there was on Wednesday evening, when the stall-holders' materials were coming in and were being arranged, and when at three on Thursday they were ready for the opening, one could not but be struck by the array of lovely work. The ladies had indeed been giving their time, and their cleverness was exemplified by the display of dainty articles; but what of the men? They did remarkably well on their stall, but one noticed that with very few exceptions the work was not homemade. A friend who some time since went to another bazaar, commented on this fact, and said she was astonished to find there, how well the young men had worked wood carving, metal work, and all those occupations, they had turned to useful account, and furnished their stall with their *own* work. We are not grumbling, are perfectly satisfied in fact; but we should like to see more of our young men taking up these hobbies.

Three o'clock on Thursday brought torrents of rain, but we had a large company notwithstanding. The Rector having set forth the objects of the bazaar, called upon T.E. Withington, Esq., of Culcheth Hall, to open it. This he did in a few well-chosen words. On Friday and Saturday the bazaar was opened by Mrs Johnson, and Rector Smith, of Lowton, respectively. We were most happy in our openers—the hearty good humour of the gentlemen, and the charming grace of the lady were 'par excellence'.

Sales were brisk on Thursday, and when the amount was totalled at night we were well satisfied with the £85 handed in to the Treasurer. The 'Japanese Alliance', evidenced by the pretty costumes worn by the ladies, added considerably to the attractiveness of the bazaar. Plenty of amusement was provided by a shooting gallery, under Mr J. Peet's charge; art gallery; arranged by Mrs James Garton, and the entertainments in the infants' room. The latter were—Mr Pilling's Pierrot Troupe, Choir Concerts, Egyptian Hall of Mystery

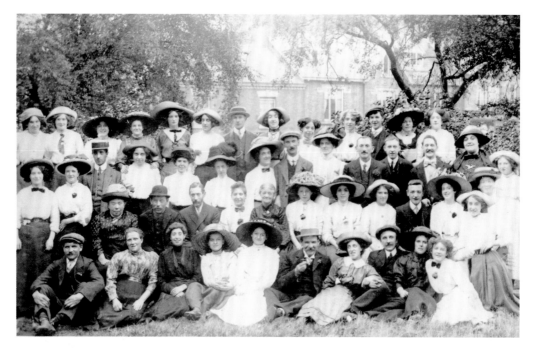

SALFORD CHURCH OUTING

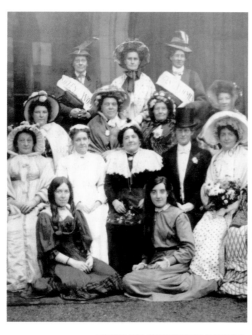

CHURCH CONCERT PARTY,
BLACKFORD BRIDGE, BURY

(arranged by Mr Caldwell, of Leigh) and Recitals by Revd J. and Mrs Rushby-Smith.

These were well patronized, and realised a good sum; and we have pleasure in acknowledging our indebtedness to those who gave so much time and trouble to insure their success. Friday was rather a quiet day, but Saturday made up for it, and we were packed out. Happily we were almost cleared out, too—very little being left.

As a result, the amount in hand towards the Organ Fund is £200. Very good! And a nice little spur to move us to complete the amount required.

Golborne Parish Magazine, December 1905

MR BALFOUR'S CAPITAL JOKE

The great political battle at Burnley may be said to have begun last night, and the prospects of the Liberal party could not possibly be brighter. Mr J. Spencer Balfour, the member for the borough, arrived last night, and though no special steps had been taken to inform his constituents of the exact hour, thousands of people congregated in Manchester Ward and St James's Street for the purpose of giving him a reception such as no former member had ever received. Manchester Road was completely blocked, and inside the capacious stationyard several hundreds of privileged persons

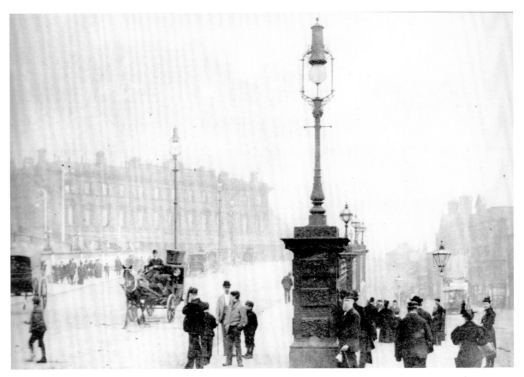

LONDON ROAD STATION, MANCHESTER

had gathered. Mr Lord, the Liberal agent, Mr John Yeadon, and Mr Fox were here as busy as bees making arrangements for the procession. One group consisted of Alderman Thornber, Councillors Holmes and Bradley, and a little further away were the genial faces of Councillors Hargreaves and Hartley, the latter being accompanied by Mr Thornton. Soon up came the carriage containing Mr Ogden, Councillor Amistead, and Mr Parker, the Liberal candidate for the Kingswinford Division of Staffordshire, mixed in the crowd were Dr O'Sullivan, the leader of the Irish party in Burnley, Alderman Burrows, and Mr J.C. Waddington. These gentlemen afterwards went to the station and joined Mr J.S. Collinge (the president of the Liberal Association), Aldermen Collinge, Lancaster, Greenwood, Mitchell, Councillor Macfarlane, &c. The train appeared punctually at 6.35, and when

MR BALFOUR WAS SEEN

in a first-class carriage, loud cheers proclaimed to those outside the station that Burnley's member had arrived, and the handshaking was tremendous. He was literally besieged by persons anxious to give him a hearty welcome. At last he made his exit from the station, and his appearance was the signal for a louder outburst of cheering. Accompanied by Miss Freeman, Mr and Mrs Van Neck, and Mr J.S. Collinge, he drove away. Having traversed Halsted Street and got into Manchester Road, a splendid scene met the gaze of Mr Balfour and his party. There was no street decoration in honour of the visit, but there was something better. Stretching from the end of Halstead Street to the Bull Hotel, a distance of nearly half a mile, there was a mass of humanity, and this brilliant scene left no room for doubt as to the result of the election. Through the throng of people the carriages, which were led by the Borough Brass Band, could only move slowly; and as Mr Balfour drove through them the enthusiasm of the onlookers was most intense. Mr Balfour bareheaded repeatedly acknowledged the cheering and the waving of pocket handkerchiefs and hats from the thousands of persons who had congregated in Manchester Road. Every window had its occupants and the garden walls of gentlemens' residences were used as coigns of vantage. He was cheered all the way to the Thorn Hotel, where he addressed a few words to the assembled crowd from one of the windows. His remark that he was proud to be their member elicited a loud cheer, and then he made

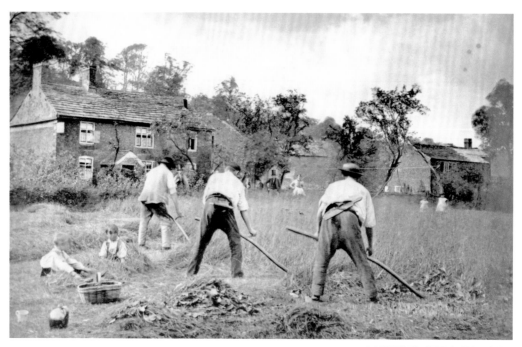

MOWING AT DAISY NOOK

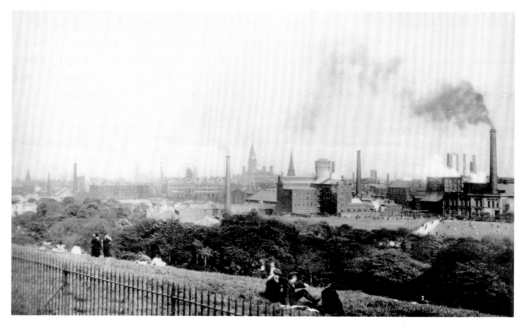

BOLTON

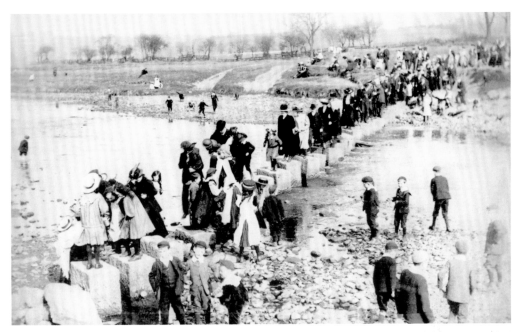

GOOD FRIDAY OUTING, BURNLEY

A CAPITAL JOKE,

which was greatly appreciated by the throng. He said from what he could see and hear that was by far the most successful garden party he could have. When he further stated that he was not so vain as to suppose that the reception had been given to him on account of his own merits, but rather because of the great cause which they were there to champion, and under the great leader whom they served, the cheering was so loud and prolonged that it was some time before he could proceed. He declared the election was the most important this century had seen, and afterwards addressed the ward workers in Salem School, where his reception was quite as enthusiastic as that he had received outside. Mr J.S. Collinge presided. Mr Balfour began, 'My friends, fellow-workers in the great Liberal cause, comrades in the big Liberal army, to-night we begin our campaign.' The effect of these words was electrical, the cheering was deafening, and there was a loud cry of 'Shame' when the speaker said there was a desire on the part of their opponents to choose a day of battle the most inconvenient for the working classes. After the meeting Mr Balfour proceeded to the cricket field, where he distributed the prizes won at the Victoria Club sports.

Northern Daily Telegraph, June 1892

THE FAIREST VALE IN ENGLAND

The Southerner's knowledge of Lancashire when not lamentably meagre is grotesquely inaccurate. Cotton, he knows, is manufactured there, for do not the papers occasionally have paragraphs dealing with a shortage in the supply of the raw material, a boom or strike in the industry, or some great gamble in 'futures'? But beyond that he knows nothing definite. It is probable that he may also at some time have picked up a so-called Lancashire story, wherein the novelist, speaking out of the fulness of a day's sojourn in Oldham, has written of Lancashire's 'terrible destiny', of the slavery of her factory system, her poverty and grime, her shocking housing conditions, and the gross darkness and despair in which her people walk! And so, whenever the County Palatine is mentioned in conversation, he thinks shudderingly of foul smoke and the darkness of the pit.

There is, indeed, scarcely anything in which Lancashire is misunderstood so much as in her physical features. Speaking of his comely heroine, the writer of a well-known story says: 'One glance at her face would have made the dullest landscape in Lancashire look bright'—a form of gratuitous comment with which one often meets from those who know little or nothing of the county. It would be just as pertinent to say that Yorkshire

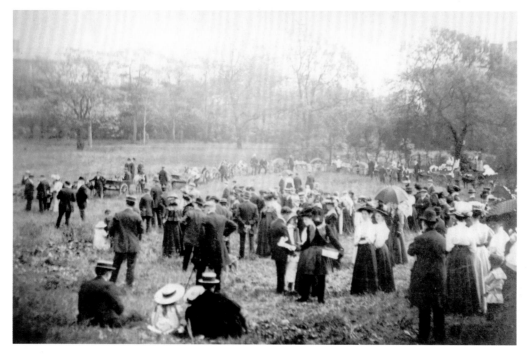

DONKEY PARADE, WERNETH PARK

is an abomination of desolation on the strength of a visit to Sheffield, or that London is a place of poverty and misery for the reason that it has an East End.

Writing in 'Baily's Magazine' recently, Mr Ernest Phillips put the case for Lancashire very well. He had ventured to compare a scene on the Lune with a reach of the Thames at Henley, and a group of Southern people had been surprised at his temerity. 'But,' said Mr Phillips, 'I held my own, and silenced my critics with one or two facts they had overlooked. Did they remember, I asked, that the whole of one side of Lake Windermere was in Lancashire? Did they remember that the Valley of the Lune, which no less an authority than Ruskin declared was the fairest vale in England, was also in Lancashire? Did they remember that the whole of Lake Coniston was in Lancashire, and that for thirty years Ruskin lived on the shores of that lake and beneath the shadow of Coniston's Old Man, as the mountain is called? And did they remember that the River Duddon, which Wordsworth immortalised in a whole series of poems, was a Lancashire river? To be sure they did not remember these facts. They had imbibed the popular conception of Lancashire.'

Mr Phillips might have made his list much longer, and especially might have mentioned the whole of the historic Ribble Valley, with Pendle, WHalléy, the River Hodder, and the wooded glens about Stonyhurst as equal to anything in the country, but enough has been said under this head to show that whoever contends that Lancashire has no natural beauties, traduces one of the most attractive counties in these Islands. The fact of the matter is that Lancashire, as Mr Phillips indicates, has never, like Yorkshire and some other holiday counties, made a loud boast of her many beauties; she has, instead, rested her reputation upon her tireless industry, her labours for reform, her efforts for civil and religious liberty, her wealth, and her enterprise.

Frank Ormerod

A SINGLE BLIGHTED ROSE

Lancashire is not the best possible place for a garden, and to be within five miles of a large town is certainly no advantage. We get smoke on one side, and salt breezes on another, and, worst of all, laden with heavy chemical odours, which is more deadly than either smoke or salt. Still we are tolerably open, and in the country. As I sit writing at my library window, I see, beyond the lawn, field after field, until at last the eye rests on the spire of a church three miles away.

HOUGHTON VALLEY

A long red-gabled house, with stone facings, and various creepers trained round it, a small wood (in which there is a rookery) screening us from a country road, and from the west, lawns with some large trees and several groups of evergreens, and the walled garden, the outer garden, and the orchard; it is to these that I invite you. Exclusive of meadow-land there are only some four acres, but four acres are enough for many gardening purposes, and for very great enjoyment.

These are certainly what the American poet Bryant calls 'the melancholy days, the saddest in the year'. The late autumn flowers are over; the early spring ones are still buried under the soil. I could only find this morning a single blighted monthly Rose, a Wallflower or two, an uneasy-looking Polyanthus, and some yellow jasmine against the house—and that was all. Two days of early frost had killed the rest. Oddly enough, however, a small purple flower caught my eye on the mixed border; it was a Virginian Stock, but what it was doing at this unwonted season who can say? Then, of course, the Arbutus is still in bloom, as it has been for the last two months, and very beautiful it is. There is a large bush of it just as you enter the walled garden, and, though the pink clusters of blossom are now past their best, they are more welcome than ever in the present dearth of flowers. Can any one tell me why my Arbutus does not fruit? It has only borne one single berry in the last four years; and yet the Arbutus fruits abundantly in other places in Lancashire, and at Lytham, close to the sea, I saw clusters of berries only the other day. Sometimes I fancy there is a better chance of the fruit setting if the pollen is from another tree, and I have lately planted a second Arbutus for the experiment. I am very fond of the Arbutus; it carries me back to the days of Horace, for we remember how his goats, wandering along the lower slopes of Lucretilis, would browse upon the thickets of Arbutus that fringed its side.

Lastly, the Chrysanthemums are in flower, though not in the inner garden. Some I have tended and trained, and they are now looking handsome enough in the porch and vestibule of the house. Some I have planted, and allowed to grow as they like, in front of the shrubbery borders; these have failed very generally with me this year—they look brown and withered, and the blooms are small, and the stems long and ragged, while many have entirely disappeared. The best of them all is Bob, with his bright, red, merry face, only surpassed by a trained Julia Lagravière in the porch. Another favourite Chrysanthemum of mine is the Fleur de Marie, with its large white discs, all quilled inside and feathered round the edge. Fastened up against a wall, I have seen it, year after year, a mass of splendid snowy blossom. The Chrysanthemum has three merits above almost

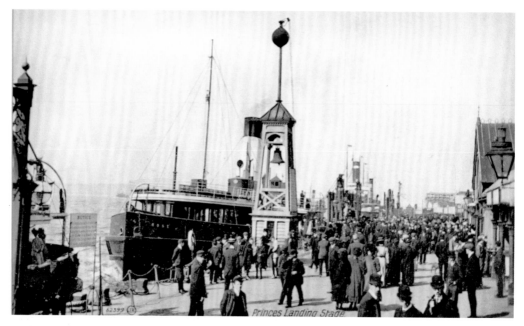

HE LANDING STAGE BELL, LIVERPOOL

every flower. It comes in the shortest and darkest days; it blooms abundantly in the smoke of the largest cities; it lasts longer than any flower when cut and put into water. If flowers have their virtues, the virtue of the Chrysanthemum is its unselfish kindliness.

In the outer garden, we have been busy with the fallen leaves, brushing them away from the walks and lawn, leaving them to rot in the wood, digging them into the shrubbery borders. This work is finished now, and we have swept up a great stack for future use at the end of two years. The Beech and the Oak leaves we (in opposition to some authorities) hold to be the most valuable, but of course we cannot keep them distinct from the rest. These fallen leaves—of which we make our loam for potting purposes—what endless moralities they have occasioned! The oldest and the youngest poets speak of them. It is Homer who compares the generations of men to the generations of the leaves, as they come and go, flourish and decay, one succeeding the other, unresting and unceasingly. It is Swinburne who says in his poems—

Let the wind take the green and the grey leaf,
Cast forth without fruit upon air;
Take Rose-leaf and Vine-leaf and Bay-leaf
Blown loose from the hair.

During this open weather we have been getting on with our planting. Those beds of Rhododendrons just under the drawing-room windows have become too thick. They are all good sorts—John Waterer, Lady Emily Cathcart, and the rest—and must have sufficient room. We move a number of them to the other side of the house, opposite the front door, where till now there has been a bed of the common Rhododendrons, and this in turn we plant as a fresh bed elsewhere.

There will be now some space to spare in the hybrid beds, and I shall plant in them a number of roots of the Lilium candidum—the dear old white Lily of cottage gardens. They will come up each year from between the Rhododendrons, and will send their sweet subtle odour through the open windows into the house. And as I write I am told of a recipe showing how, in the Wortlore of old, the firm white petals were esteemed of use. You must gather them while still fresh, place them unbroken in a wide-necked bottle, packed closely and firmly together, and then pour in what brandy there is room for. In case of cut or bruise no remedy, I am told, is more efficacious, and certainly none more simple.

Henry A Bright

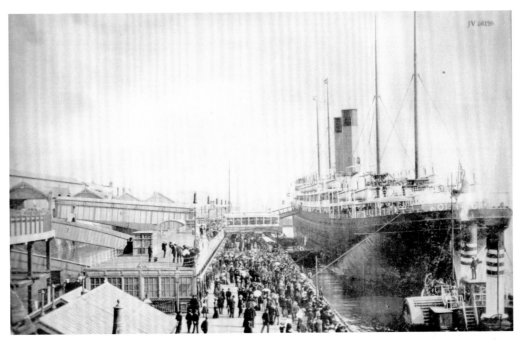

LINER AT LANDING STAGE, LIVERPOOL

THE RELUCTANT STOKERS

When I was in my mid-teens in around 1890, all the talk was of going to America to start a new life. Job prospects at home in Manchester were not bright, and we knew that we had on our doorstep, in Liverpool, one of the world's greatest seaports. One day my brother and I decided to take the plunge, and bought a one-way ticket to Lime Street. We wandered the docks until we saw a ship with the sign 'Stokers Wanted' at the bottom of the gangway, and decided that that was the one for us. The first thing we had to do was get rid of our white collars and cuffs. 'They'll never believe we're stokers in these things,' my brother said, so we tore them off and threw them in the Mersey. Then we went back to the ship, where some of the toughest looking men we had ever seen were coming and going up and down the gangway, and we began to get cold feet. We went into a seamen's cafe on the waterfront, run by Chinese, to talk over the situation. It was a rough place, and over in the corner there was a hole in the floor, from which a hand would occasionally emerge with a plateful of food, which it would send spinning across the floorboards to the customer's table. This was all a strange world to us, and it didn't take us long to decide that the sailor's life was not for us, after all. Our only problem then was getting back from Liverpool to Manchester with no money—and explaining to our mother, when we got home, what had happened to our collars and cuffs.

Oscar Hudson

SHARPS AND FLATS

At Littleborough on one occasion, two old women put in an appearance to hear a performance of 'The Messiah'. After looking down the printed list of solos and choruses in the oratorio, one of the old dames was heard to exclaim, 'Whaw, there's no comic!' evidently under the impression that no concert could be complete without a humorist.

A good many of these stories relate to music and musicians. Mr Nelson Jackson, the well-known entertainer, tells a story of two cornet players in Bolton who were engaged to augment the band of one of the local theatres on the occasion of the visit of an operatic company. Never having met any Wagnerian music before, they were floored when confronted with a piece of music written in six flats. 'What shall we do?' asked one,

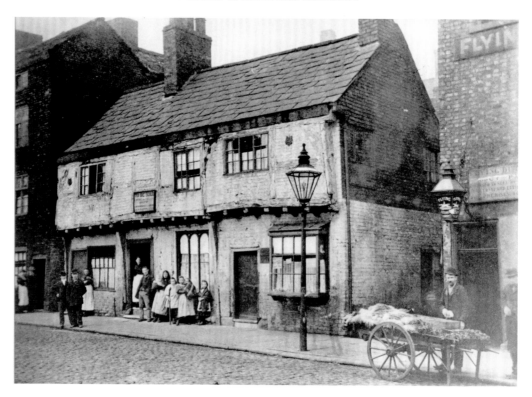

GREENGATE, SALFORD

'I've never sin aught like this before.'

'I know,' said the other with sudden inspiration, 'thee tak' three an' I'll tak' three!'

'I thought you could play,' remarked a conductor to a piccolo player who had been engaged under similar circumstances in another part of the county.

'Aah, an' I thought so too till I coom here,' replied the inefficient, 'an' we're both sucked, aren't we!'

A woman once bought a piano for her husband, who was 'very musical'. Subsequently meeting the man from whom she had bought it, she said, 'Hey, eaur Bill says he con play on o't white keys now, an' he wants to know if it would do it ony harm if he played on't black uns too.'

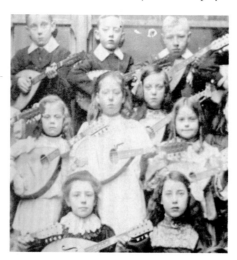

LEIGH MANDOLIN COLLEGE *Frank Ormerod*

The mention of 'black uns' and 'white uns' reminds one of the vamper at a public-house 'free and easy', who was baffled completely by a man who went to the piano and hummed over the tune of the song he intended to sing. 'It's no use! I've tried it on't white uns, an' I've tried it on't black uns, an' I've tried it on't white uns an' black uns together, but I cornt hit it. Tha must be singin' between t' cracks!'

Another of these musical stories is told of two Besses-o'th'-Barn bandsmen who were up in London for one of the Crystal Palace contests. While strolling about the East End they came upon a sign over a shop written in Chinese characters. 'What's ti co' them?' asked the one of the other.

'I dunno,' was the reply, 'but I think if I'd mi cornet wi' me I could play it!'

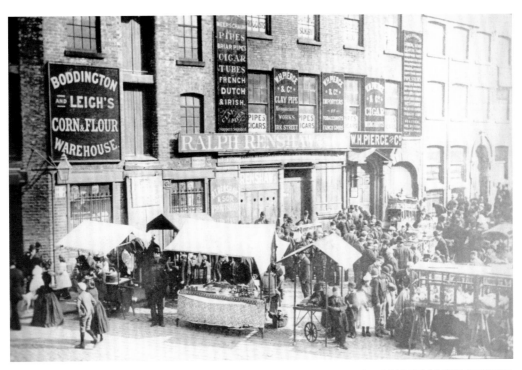

SHUDEHILL POULTRY MARKET, MANCHESTER

SALFORD SATURDAY NIGHT

If we wish to gain a general idea of the life of the poor, it is easily obtained by an inspection of the business portion of the district in which they live. There are few places more readily accessible for this purpose, or more characteristic, than Chapel Street, Salford, and its immediate neighbourhood; and the contrast between these and the aristocratic emblazonments of Market Street and St Ann's Square—though separated only by a walk of two or three hundred yards—is of the sharpest conceivable. You have only to leave the Exchange on a Saturday evening, walk along St Mary's Gate and down Blackfriars, and in three minutes you are in a totally new and strange world. The business, the people, and their manners and appearance afford the keenest contrast to those you have just left. By-the-by, is there any especial fitness in the name of Chapel Street which should cause it to drift into the supply of these particular wants? Certainly there are, or were, several of the same name in London which were the perfect counterparts of this one, doing exactly the sane trade and for the same class of people; one we well remember was the favourite resort of the people of the famous Brill district of Somers Town, and was as like ours on a Saturday night in its general characteristics as one pea is like another. This, and the district which supported it, have been swept away by the great St Pancras railway station.

The Salford Chapel Street is very thronged, crowded even, this evening. It is fairly warm, and the mill-lasses trouble less than usual about their head-gear, having for the most part none at all, and, judging from the frequent screams of laughter, seem to be thoroughly enjoying their fashionable parade. They would seem to have few troubles; but the pale anxious faces of the many mothers dragging their poor little babies about, who have to look two ways for Sunday, tell another tale. Some of them are accompanied by their lords and masters; but we fancy the majority of the latter are in 'another place'. Not but what there are plenty of men about, of all ages; but, with the exception of the young people, they and the ladies do not seem to run in couples to so great an extent as might be wished. Too many of these poor women wander up and down, looking at the tempting viands displayed, in a painful state of incertitude as to the best and most economical way of spending the two or three shillings at their disposal. See how carefully they examine the bits of 'scrag' at the butcher's, and turn over one by one (with hands not always made the best of by scented soap) the odd slices pared off and laid in little heaps, with a view to the possibilities of a stew, in which potatoes shall play the leading part,

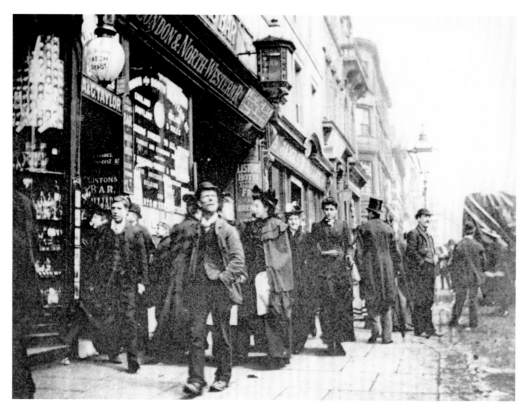

MARKET STREET, MANCHESTER

and the bits of meat have to be fished for. A sheep's head (or 'Ships Jimmy') makes an excellent Sunday dinner, properly dressed and cooked—especially if one can be so fortunate, and funds will run to it, as to obtain a 'pluck' therewith, that is, liver, lights, and heart. See you, there are grand possibilities in connection with a 'ship's yed and pluck!' Nowadays, since the era of dear meat set in, butchers have become artful, and mostly sell the head and other items separately; but in the old days, when fine fat shoulders were generally sold at a nominal price to farmers and such, who had many hungry labourers to feed, the head and its appurtenances were usually sold together for from fifteen to eighteenpence, and then what a glorious feed there was! The liver, lights, and heart were all sliced, put together in a great brown dish, with onions and plenty of potatoes on top, and baked; and when the man returned from his Sunday morning's walk or (very occasional) church, and came within scent of the savoury steam which arose, it was enough to make the hardest heart leap for joy. At present our poor, barring exceptional opportunities, must content themselves with a portion, perhaps the head; but even this involves some cookery, and if there is one thing more than another which the average English poor woman shirks especially, it is the practice of intelligent and economical cooking.

The shops are not destitute of temptations for those who can afford a trifle for the Saturday night's supper, which is always a minor occasion of feasting among our labouring people and poor, if the fates are in any way propitious. You may take your choice of the steaming hot pig's-puddings, of toothsome pieces of fish dipped in the thinnest of flour-and-water and fried in—well, you had better not be too curious about the oleaginous liquid in which it is fried. No wise man inquires too curiously into the mysteries of the kitchen. You can have these or slices of hot pudding, peas, or otherwise, and very miniature hot pies of variously unknown composition; or you can indulge in the inexpensive herring, the red one, or the yellow 'Digby', specially provocative of early thirst on the morrow, and therefore not by any means to be despised. Of small matters for the morrows tea, the most noteworthy are the winkles at a penny a gill, and the odoriferous spring onions, with which a dirty little humorous maiden of about ten years, selling on the kerbstone, is tempting the passengers by yelling out, 'Want any wall-flowers, a penny a bunch?'

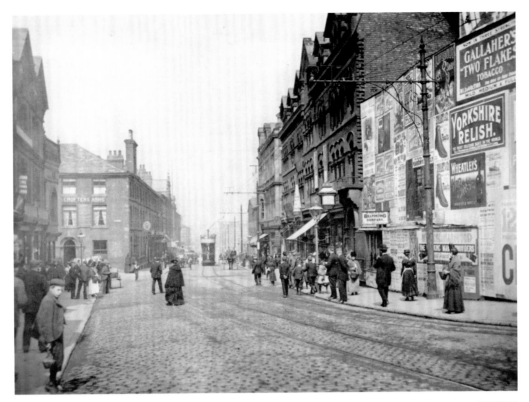

WIGAN

We hinted at the beginning of this paper that the chief articles of commerce in this district on Saturday night appeared to be old clothes, and we really think they must be, for no other articles are exhibited in such abundance. These, however, are not to be found in shops, except a few hung out in a languid and tentative manner at the pawnbrokers.

We must look for them on that piece of waste ground round the church, which, on business nights—Saturday and Monday—presents one of the most curious spectacles in the Manchester district, and is known as 'Flat-iron Market'. This name nearly drove us to despair. We went, on our first visit, with a vague expectation of finding flat-irons hanging everywhere in strings like ropes of onions at the great Birmingham fair, and our first object was to see them; but alas! they were conspicuously absent. The things became a worry to us, and we hunted up and down in every corner for a full hour before we found two or three of the wretched things hiding forlornly, which were nothing to make a fuss about after all. Why will names be so persistently misleading? For instance, we have been to Whitstable on various occasions, and have seen ere now a fleet of thirty or forty oyster-boats dragging their anchors and churning and grinding each other to pieces on a wild stormy morning; but we never saw an oyster in that world-renowned town. These old clothes are everywhere; in heaps upon the ground all along this side of the church, in heaps all along the other side; and in addition to this host of sellers 'by private', there are four or five enterprizing merchants with carts and lurries, from which they are selling by auction as fast as

OLDHAM

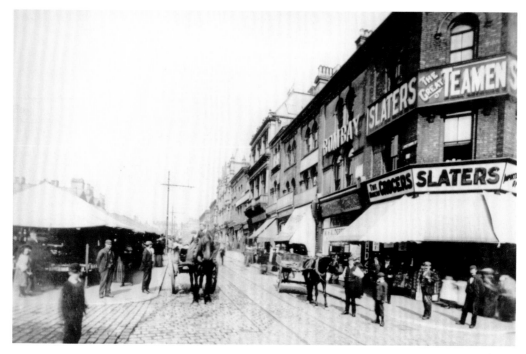

VICTORIA STREET, BLACKBURN, ON MARKET DAY

their tongues can wag. Do you want coat, waistcoat, trousers, baby-clothing, underclothing, hat—chimney-pot, pudding-cup, straw, or any other fashion? Do you want shoes or boots of any sort or description, clogs or all leather, of any size from a baby's to some big enough for a cradle? Here you can be suited in a minute and at your own price. 'Here you are!' shouts one of these merchants from his vantage ground on cart-top. 'Here you are. Here's a beautiful workman's coat, fit to go to a meeting in or to a dog fight.' Puts it on and looks respectable at once. 'I'm not sellin' things to-night; I'm givin' 'em away. I'm not goin' to ask you eight shillin's for it; no, nor six, nor five; I'll sell it for half-a-dollar, an' I'll take no less. Who'll have it? Well, y'are a poor lot to-night! The Pig and Whistle must a had you fine this arternoon. Here, I'll take two shillin' for it, and if I ever sells it for less, s'elp me, Moses!' A bidder cranes forward, it is rolled up, tossed to him, and a waistcoat brought out. 'Who'll have it for a shillin'? Nobody? I'll take tenpence, ninepence; here, I'll take fivepence.' This also changes hands, and trousers follow for eighteenpence. See how much can be done by a judicious expenditure of three shillings and elevenpence! These garments, mind, are whole and wearable.

This young man opposite, perched upon a handcart, deals in somewhat humble wares, and his stock is less magnificent in amount. He is a specialist, and sells baby clothes and general underlinen, the display of some of which excites unseemly mirth and irreverent observations. 'Here's a lovely babby's frock, beautifully spotted all over like candy-rock, an'll make yer babby look as smart to-morrow as the peacocks at Belle Vue! Do I want sixpence for it? No; nor yet fivepence, nor fourpence. I'll take threepence: An eager-faced woman presses up, buys it, and an all-round white pinafore follows for fourpence. A shirt is then displayed, of which it is difficult to tell how it can possibly hang upon anyone. Shoes there are in quantity sufficient to stock a dozen shoe-shops, many in a grievous state of dilapidation and past all possibility of resurrection, but most of them ingeniously patched in every possible place, and all polished in a style which would make the fortune of a professional shoe-black. A young man here is evidently not an easy customer to deal with, and he exhibits a prudent and careful hesitancy worthy of all praise. Silently he listens to any vaunting of the merits of a pair of boots in his hands. Carefully he examines the tops, the elastics, the soles, the welts, the patches, then quietly replaces them upon the stall and stands looking at them with a wistful, ruminating air which indicates the nicest balancing of mental pros and cons. Another young fellow bent on boot-buying is assisted by his mother, who evidently has a nervous dread lest he should spoil the symmetry of his appearance by buying them a size

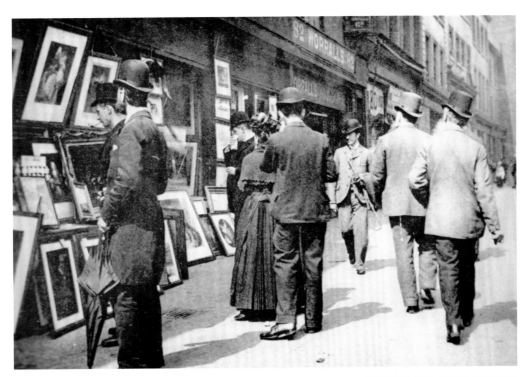

DEANSGATE, MANCHESTER

too large. As he puts up his clogged foot for comparison, she is quite certain 'them be too big, a lot'; but the vendor smiles gravely and says politely, 'No, these boots are not a big boot.'

Much might be said, and much moralizing might be done concerning the wrecks of elegant ladies' shoes which are lying about, and much speculation might be indulged in respecting the some-time wearers of these and the phantoms of once gay dresses which crop out here and there from the heaps of rubbish; but this is neither the time nor the place for a sermon.

We must just glance at the thousands upon thousands of old tools displayed upon the ground for sale. Philosopher Teufelsdröckh opines that above all things 'Man is a tool-using animal', and if anyone should feel inclined to doubt his dictum, let him come here and take a look at the endless array on exhibition of tools for every conceivable purpose under the sun. How in the world all the vendors get a living out of these rusty agglomerations is past fathoming. There is no puffing, no noisy offering of wares, and one sees few customers; yet there must be a great and constant demand for these mysterious odds and ends, judging by the extent of the supply.

The oil-cloth men are always in great force, and do a big trade. 'This is a beau-u-tiful piece,' says the humourist among the auction-sellers; 'a splendid piece, one I painted myself, and therefore I don't care whether I sells it or not. I should prefer to put it in a frame and hang it up in my own droring-room. It's several yards long, and I'll sell it you for a bob. A bob, did I say? No, for elevenpence, for tenpence. Who'll buy? Sold again! And here's another piece fit for your floor, or for a table-cloth or a bed-quilt, or for hangin' up for an hornament, and I'm just agoin to sell it to you for less than the hartist got as made the design and painted it!' And so on.

Provision is made here for all sorts of wants. Pots, pans, marvellous chimney ornaments, fearfully and wonderfully coloured prints—including a full-length portrait of Gladstone that would make him regret his popularity could he see it—strange and highly-coloured drinks of unknown concoction, slabs of sliced ham exposed so freely to the winds and dust of the streets as to make the man of tender teeth shiver in his shoes, and last, but not least, is the medicine-man. Perched upon a four-wheeled trap, with a felt-hat upon his head of such extraordinary width and height that we have never but once in our lives seen its equal, dressed in a great-coat of unknown antiquity trimmed with 'astracan' collar and cuff.s, and wearing a portentously long beard,

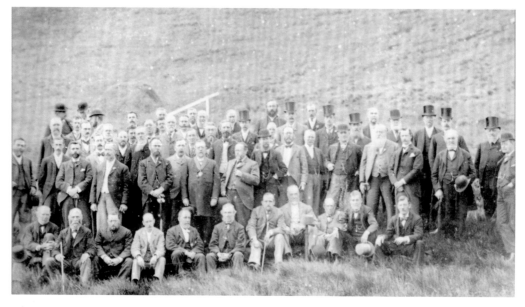

CUTTING THE FIRST SOD, ROODEN RESERVOIR

his stout figure is one of the most characteristic in the market. Above his head is a great chart, displaying with awful literalness and fidelity the interior organs of man; ranged about him are bottles filled with mysterious and all-potent liquids, and we expect that, like Sidrophel, he will undertake to

> Cure warts and corns with application
> Of med'cines to th' imagination;
> Fright agues into dogs, and scare
> With rhimes the tooth-ache and catarrh.

It must not be supposed that no provision is made for the amusement of our poor people. There is undoubtedly a sound of revelry to-night—rather too much of it. A couple of banjoists in the Pig and Flat-iron close by are adding to their allurements a terribly husky song done in snatches by one and the other alternately; some descendants of Messrs Hippolitus and Co., the gladiators (of the Royal Circus, Pompeii), have a show hard by; a rather wan-looking conjuror in full evening dress with a terrific amount of shirt-front is beseeching the people to walk up; and the gorgeous dobby-horse establishment, all gold and ormolu, is attracting young and old alike.

The beer is now getting abroad. A big fellow, drunk as a lord, comes staggering up, and tumbles clean over a perambulator with a baby in it, and is mildly expostulated with by the mother. We think it about time to be moving.

Walter Tomlinson

THE MANURE WORKS

Like other towns in Lancashire and Yorkshire, Rochdale has undergone great changes, and has experienced great difficulties in being relieved from its sewerage and refuse matter. Some fifty years ago, it was a source of profit to property owners, as it was common with the neighbouring farmers to give a liberal sum per annum for the privilege of removing the midden-steads. Soon after the passing of the Police Act of 1825, the rapidly extending population made the ownership of the midden-stead less profitable, and the town had to undertake the duty of removal, which was done by contract. The contractors found no doubt, for some years, it was profitable to sell the manure. The last contract by the town was for £1,300 a year. The neglected and illconditioned state of the midden-steads was such that it led to a low state of habit, and was a lively cause

BETWEEN PARADISE STREET AND HIGH STREET, LOWER DARWEN

of the spread of disease through the town. In 1864, Mr Alderman Taylor (chemist), wrote at the request of Mr Alderman Mansell, who had the management of this department, to the Scavenging Committee, detailing a method by which, in his view, that which was a nuisance, and expensive, might be turned into a profit, and so arranged as not to be a cause of the spread of disease. This proposition was not at once received; indeed not until three years after was it seriously entertained. The growing difficulties were such, that the committee resolved that a trial should be made of the scheme proposed, and also of any other plan that might be suggested. A twelve month's trial was then made, and the scheme which is now in general use was adopted. This plan, which has received the name of 'the Rochdale system', we shall now briefly describe. Its first principle is, that all excreta and refuse of the house shall be removed at least weekly; that the refuse be separated into its constituents of ash, cinders, vegetable matter, iron, glass, pots, &c. The ash and excreta are then manufactured into manure by a special method devised by Mr Alderman Taylor, and the other refuse used or sold; so that the great nuisance of modern towns called the 'tip', is not required, and that which has been hitherto a great cost to towns, will become a source of profit. Repulsive as it might seem, yet, it is nevertheless a most interesting sight, especially to farmers, and all persons interested in the sanitary questions of the day, to see the method of dealing with this refuse of towns. The works are situated at the junction of Entwistle Street and Smith Street, and are well worthy of inspection. From every part of England eminent visitors have expressed their surprise and appreciation at the effectiveness and completeness of the scheme; and, amongst official visitors, the special Inspector of the Local Government Board of England, and the special Inspector of the American Government have declared it to be the best in England or America. This manure, which was at first used with some doubt and fear by the farmers, is now bought in large quantities, and there are most abundant testimonials of its great value.

On the date we write, October 28th, 1874—in the week previous there were removed 84 tons of excreta and 143 tons of refuse, from 4,434 closets and ash-places. The quantity of manure made was 74 tons. The number of houses thus relieved from the refuse was 7,995, and 116 mills.

The work is accomplished by twelve horses and twenty-four men; twelve horses and eight carts in collecting, and sixteen men in the manufacture.

William Robertson

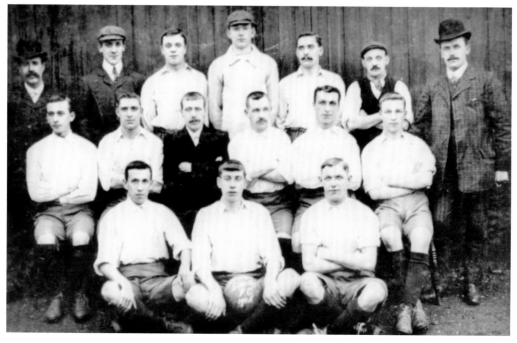

ACCRINGTON STANLEY, 1905

A BRIGHT AND BRISK COMMUNITY

We must now betake ourselves again to a steam tram car, and proceed to Accrington, four miles away from Haslingden. Still have we with us on the journey, in great part, the lines of houses and flagged footways, but we are receding from this more hilly country to one of an undulating character, and on uneven ground of this kind we find that the town of Accrington has been built. In 1836 it consisted of two straggling villages, old and new, with about five thousand inhabitants; it is now an incorporated town with something like forty thousand residents, its population having increased at such a rate that it was quadrupled in a space of

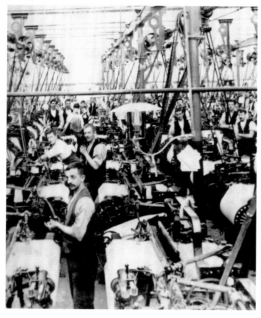

COTTON WEAVERS

thirty years. Like some other Lancashire towns, the date of its incorporation is comparatively recent, and it is interesting to note that in the selection of its armorial bearings, its history and growth appear to be symbolised. It was once part of the forest of Accrington, and is now eminently a place of manufactures, to which it owes its growing prosperity. Once again we are in a place where cotton is spun and woven, and where also it is dyed and printed, this latter operation being an important feature among its industries. So in the borough arms we find that the shuttle and the printing machine are in evidence, as also is the running stag, reminiscent of the forest times. The printing operations are represented by two cylinders from which issues a piece of calico, upon which is depicted a parsley pattern, a delicate reference, perhaps, to that design already referred to, and which made the name of one of the Peels famous, for it was at Church, near Accrington, that, 'Parsley Peel' had a printworks,

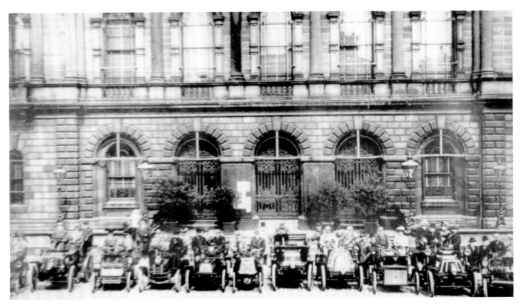

AUTO CLUB OUTING, BLACKBURN, 1912

and in later years the name of Jonathan Peel, one of his sons, and also a calico printer, was among the most notable in the Accrington Country.

Alighting from the tram car in the main street of the town one gets the impression of being in a bright and brisk community. The buildings are of stone, and some of them of architectural distinction, one of the characteristics of modern manufacturing Lancashire being a disposition to spend money freely in ornamental directions. Especially is this shown in their municipal buildings, and equally, too, in their places of worship, so, among other evidences, we find that in Accrington a sum of ten thousand pounds in each case has been spent upon two dissenting chapels and their schools. Recreation grounds, too, in the form of parks, are to be reckoned among modern expressions of refinement, and in this direction, too, Accrington has taken its part. Among the working folk the proportion of weavers to spinners appears to be larger than in many other places, for while in the Oldham district we find about seventeen thousand looms to nearly eleven millions of spindles, here in the Accrington district there are over twenty-nine thousand looms to less than four hundred thousand spindles. The fabrics are numerously varied, and include jacconettes, cambrics, printers, plain calicoes, stripes, mulls, sheetings, fine twills, waste twills, pure shirtings, and dhooties. In addition to these industries there are in Accrington some very large works for the construction of textile machinery of various kinds.

Had we time to linger in this neighbourhood a steam train car, whose destination is Clayton-le-Moors, two miles away, would be an inducement to travel in that direction, the name being so suggestive, but we must rather take to the car which is moving towards Church, which lies a mile distant on the way to Blackburn. There is little or no break in the continuity of the buildings that line the way, and at Church we are again among mills, and once more we change our car for one which will take us to Blackburn, about four miles away. For a time we are on a pleasant highway, which gives us views to the right over an open country and across undulations to higher ranges. On the left, withdrawn from the road on the slope of a hill—were the circumstances favourable—we might seek out and find that 'Peel Fold', described as a fair specimen of 'a yeoman's house of the seventeenth century, with large low rooms and mullioned windows', which rises from a mighty stone base of a length of three hundred feet. The cost of it was fourteen thousand pounds, and it is said that its foundation stone is the largest block quarried since Cleopatra's Needle was dug out of the earth. They had to cut a road from the quarry to find way for the block, and thirty-five horses were required to draw it to its resting place.

John Mortimer

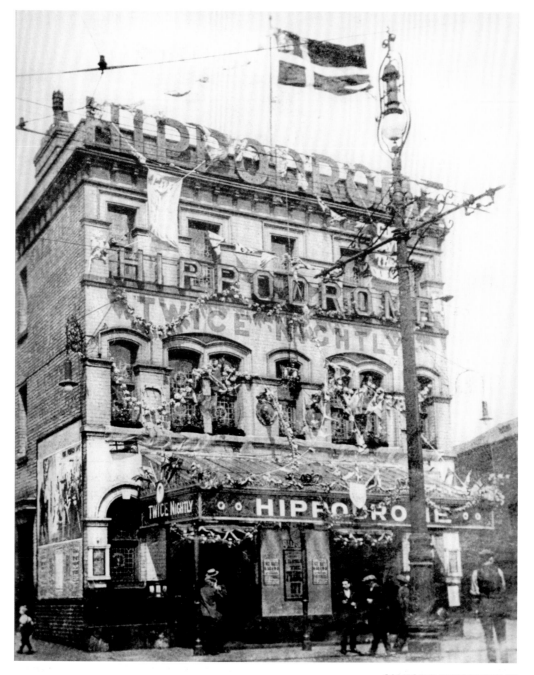

SALFORD HIPPODROME

FESTIVE BURNLEY, 1890

Even a century ago, a white Christmas prompted Lancashire folk to feelings of nostalgia and memories, real or imagined, of the good old days. 'We don't have the Christmases we used to,' we say today, looking out on green moors and a watery sun. And that, it seems, is exactly how folks had been feeling in the 1880s, and '90s. This is how the *Burnley Express and Clitheroe Division Advertiser* reported the festivities on 27 December 1890:

Christmas Day opened somewhat dull, with all the signs of an approaching fog, but early in the afternoon snow began to fall, and continued to fall until late at night. This, however, had very little effect on the

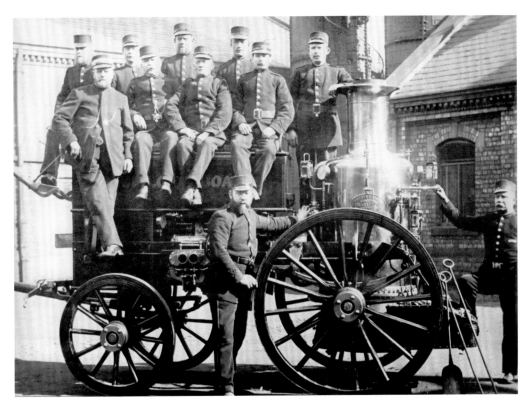

LEIGH FIRE BRIGADE

holiday attendances at the football matches at Turf Moor or the numerous church and chapel tea parties in the evening. During the day the bells of the various churches rang out merry peals.

The thaw of the preceding two or three days deterred some from skating, though many hundreds indulged in this pastime at Lowerhouse and Foulridge, and in many respects Thursday was what many people delight in calling 'An old-fashioned Christmas'.

It sounds as if the workhouse tried its hardest for its 420 inmates. Some 150 of them were in the infirmary, but 190 adults and 80 children sat down to 'the usual substantial Christmas dinner' of roast beef and plum pudding in a hall cheered by a tree laden with presents, 'evergreens in abundance and prettily constructed devices'. The *Express* reported that 'At the close of the repast four children recited set speeches of thanks (which had, as usual, been prepared by the master, Mr Adam Haworth) and the motion was agreed to with acclaim'.

The big news in the Burnley area that Christmas included a major fire at Mount Pleasant Mill and a spinners' strike at Padiham, though the workers were back on duty on Boxing Day. No doubt for the families involved in those two stories there was not a lot of extra cash around for feasting and presents, but the town centres of Burnley and Nelson were buzzing with commercial activity, for all that. In St James's Street, Burnley, there were Christmas shows of beef and mutton at the butchers' shops of John Hartley, Samuel F. Nowell, A. Holgate and William Collinge, while in Manchester Road the joints hung heavy outside the shops of Edwin Johnson and H. Holdsworth, whose offerings included eight prize heifers from Dumfries arid Burnley, twenty prime wethers from Penrith, twenty grand Scotch wethers, two grand calves, six pigs described simply as pigs—Mr Holdsworth obviously did not feel passionately about pork—and one hundred geese and turkeys of splendid quality. But when it came to fowl, a lot of people headed for the poultry market, where Messrs T. and J. Moor boasted a show of the finest Norfolk turkeys, prime fat English geese, ducks and chickens, rabbits, hares and game.

There was no shortage of present ideas, either. At John H. Dickinson's in St James's Street you could buy

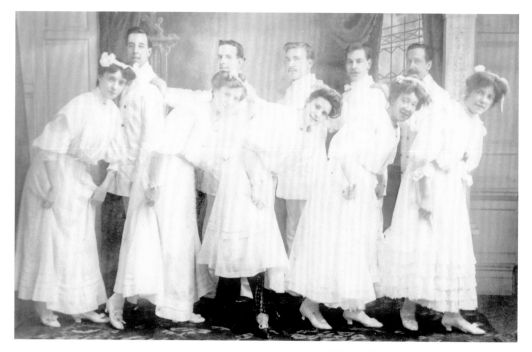

A1 COMEDY ENTERTAINERS, BOLTON

a nine-carat gold ring for 5s. and a man's gold signet ring with a real stone for 4s. 6d. Altham's Tea Stores, apart from putting on a special Christmas cake offer with every half-pound of tea sold, carried a wide range of fancy goods, toys and novelties, while out in Nelson, Oddie Hartley's Railway Street Bazaar offered— ALL THE RAGE!!! ALL THE RAGE!!!—the New Japanese Decorations, including spiders, flying cupids, skeletons, frogs, lizards, snakes, butterflies, beetles, spiders' webs, locomotives, steamers and engines. Burnley consumers with latent Green tendencies bought their Christmas mincemeat and loaves at Robert Ogden's of Manchester Road, where Health Brown Bread was the speciality. Taylor's of the Market Place made no medicinal claims about their Christmas cakes, game pies, fancy boxes, fondants, chocolates and crystallized fruits; but in Nelson, townsfolk who had failed to stay healthy by eating Ogden's bread could perhaps have found relief in Old Brown's Cough Mixture, available at a discouraging 1s. 1½d. a bottle at W Preston's chemist's shop in Scotland Road.

The top Christmas shows in Burnley in 1890 were the pantomime at the Gaiety Theatre and Mr D'oyly Carte's Comic Opera Company with *The Gondoliers* and *The Yeomen of the Guard* at the Victoria Opera House. The thought of a band of London-based theatricals spending the run-up to Christmas in the Burnley of 100 years ago is irresistible, but at least they were home by Christmas Day, when Gilbert and Sullivan gave way to a Grand Sacred Concert at the Opera House. This was just one of any number of events held on the 25th. Many of them had a religious orientation—others, like Burnley's 12-1 demolition of an under-strength Wrexham in a friendly at Turf Moor, decidedly not; but we can certainly conclude that folks got out and about on the big day far more than we do today.

The promoters of that panto at the Gaiety took full advantage of the fact that the honest, legal and decent approach to advertising had not yet been invented. 'Altogether the most brilliant and powerful galaxy of talent ever seen in one production,' they said modestly of the cast of *Little Red Riding Hood*, which included such top-liners as—dah-dah-dah-daah!!—Miss Vivian Fay Grenville—ex of the Royal Aquarium, mark you—as Boy Blue, the Sisters Millar (the Scottish Nightingales), the Brothers Lisbon (Champion Skaters) and the Lilliputian Rifle Brigade. Even after exhaustive research, I am unable to determine whether the principal boy from the Royal Aquarium was a fish or merely a mermaid. Whatever, one feels that she would have been far better equipped for that other grand Lancashire show venue of old, Saul Street Baths in Preston.

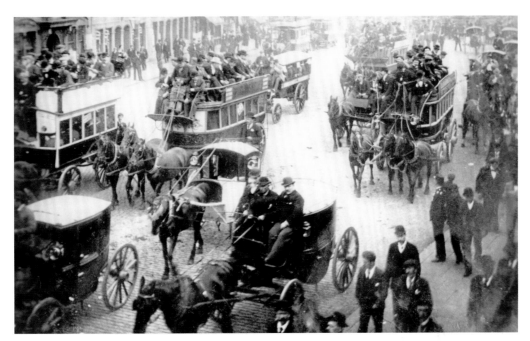

BIG MATCH DAY, TRAFFORD ROAD, MANCHESTER

Out at Padiham National Schools there were Roars of Laughter Nightly at Professor Kershaw of Southport's Highly Popular, Pictorial, Musical and Mesmeric Entertainments, and the Queen's Hall in Nelson offered such delights as an afternoon Grand Floriated Carnival and Plantation Ball—no, don't ask—on Christmas Eve, and an evening dance on the 25th.

The Mechanics' Institute was another popular spot. Burnley Vocal Union's *Messiah* was poorly attended, but there was plenty of interest in the Concert Union's Special Saturday Pop on the 20th, when Lester Barrett, the King of Comic Vocalists, topped the bill with such ditties as *You Can't Think of Everything* and *He Couldn't Take Two of Us.* 'Visitors to the Isle of Man will recall with pleasure the furore he created during the past season,' blared the promoters, in perhaps a nineteenth-century example of that phenomenon whereby a home-grown singer or group can be treated with the utmost indifference here but is eternally Very Big in Japan. Whatever the demands on Mr Barrett's talents, he was still not too busy to return to the Mechanics' the following Saturday to head a bill of seven in a Great Comic Carnival.

Finally, that 12-1 Burnley win. You'd have thought the crowd of 3,500 to 4,000 would have gone home happy enough with that, but not a bit of it. Most of the Wrexham internationals didn't show, and one of the ones who did was too old to count, grumbled an *Express* correspondent. There speaks the true voice of the Turf Moor faithful, then as now; and, it being Christmas, I bet the pie stall was closed, too.

John Hudson

ST PAUL PLAYED FOR SWINTON

To quite understand the sporting side of the Lancashire character, one has to remember that the inhabitants are a *hardworking* people who take few real holidays; indeed, their ingrained devotion to work contrasts very strongly with what one is accustomed to see in some other parts of the country. It may be said that they live to work, not work to live, and it is an open question whether they know what enjoyment in its truest sense really means. They have always been addicted to wild and boisterous sports, and always there is a strenuousness and hungriness in their methods of play which one never meets with in the South. They take special delight in the sterner pastimes, with the result that a game like football is much more popular both to take part in and to watch than cricket and some of the gentler sports. In saying this, one is not forgetting how well cricket, and

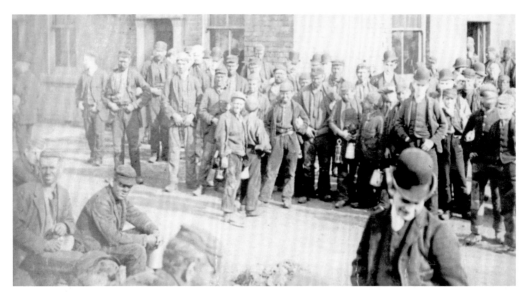

WIGAN COLLIERS AND PIT BOYS

county cricket especially, is followed and patronised. But the Lancashire man's explanation of this would be that he took interest in cricket simply because it happened to be impossible to play football all the year round, and, also, because one is an admirer of skill wherever he may find it.

One often hears lamentations from the pulpit and elsewhere on the degeneracy of a manhood which devotes itself so whole-heartedly to football, and certainly it is not a pleasant thought that so many have deserted the playing fields in order to look on and yell at Scottish champions bought to make an English holiday. But, on the other hand, it may be argued that the football craze has done much to stop the pigeon-flying, dog-racing, and gambling that used to take place on Saturday afternoons, and that the men who follow football are a much more sober lot than formerly. Instead of going from the shop and factory to the alehouse when they have finished work, as in the old days, they now go home, wash, dress, and have dinner, and spend the afternoon in the open air and in places where there are few if any facilities for getting drink.

There is no doubt that the love of the game at the present day amounts to a passion, and that there is hardly a section of the community but is carried away with the prevailing enthusiasm. The fortunes of the clubs and the traffic in players are everywhere discussed; old and young, men and women, all being absorbedly interested in watching the progress of the various clubs struggling for places in the League, or fighting for the distinction of going to the Crystal Palace to compete for the English Cup.

Some amusing instances of the extent to which football monopolises boys' thoughts were given at a Sunday school convention held at Preston some time ago. A class being asked who Paul was, one boy promptly answered, 'Full back for Swinton.' One teacher, explaining the miracle of the loaves and fishes, asked if his pupils had ever seen twenty thousand people together. 'Oh, aah,' replied a boy, 'When Blackburn Rovers played Preston North End.'

On one occasion a group of loafers were standing at a street corner in Blackburn discussing the prospects of two men who were that day being tried on a charge of murdering an old man in a neighbouring town. It was a case which had greatly excited the community, and every edition was eagerly bought up. Presently a lad came flying down the street from the newspaper office with a bundle of papers under his arm containing a telegram to the effect that one man had been sentenced to be hanged and the other had been acquitted.

'What's the verdict?' cried one of the loafers, who had, the lad knew, no intention of buying the paper.

The youngster was evidently a football enthusiast. 'One each!' he shouted as he dashed round the corner.

Some exceedingly funny remarks are heard on the football grounds. In one match a young dentist playing for one of the teams was making a dash down the field when one of the spectators roared out, 'Goo on, Joe.

LANCASHIRE COUNTY CRICKET TEAM, 1880

If tha scores a goal I'll have a tooth drawn!' On another occasion, when Preston North End were playing in an English Cup semi-final, a little man had the misfortune to get to the match late and had to be content to stand behind a group of tall Prestonians. It was in the days before football grounds were banked up, and all the little man could do was to watch for the ball as it was occasionally kicked high into the air, and listen to the shouts all around him of 'Play up, North End!', 'Play up, North End!' The little man stood it as long as he could, and then yelled, 'Play up, oather end! It doesn't matter. I con see nowt!'

The devotees of cricket are also very keen, although the game is not fostered to the same extent as in the neighbouring county of Yorkshire. The story goes that one young fellow, who had been playing as substitute in a match, was approached at the close of play by the captain, who asked if he would play again the following day. 'Well, I should ha' bin wed to-morn,' was the reply, 'but I con put it off!'

Cricket, as everyone knows, was the ruling passion of Crossland, the famous Lancashire bowler. It is told of him that he once met J.W Carmichael, the East Lancashire amateur bowler, in one of the main streets of Blackburn, and began to berate him for his part in a match in which the East Lancashire club had sustained defeat. 'Yo' should tak' yo'r time when yo'r bowling,' said the veteran. Then, running to a provision dealer's shop, in front of which stood a basket of potatoes, Crossland returned with a handful, and immediately commenced to bowl them down the street to show the amateur how to 'do it'. The shopman was soon upon the scene, and it was not until then that Crossland realised that he was bowling stolen potatoes.

Crossland was unusually blunt in speech, both on and off the cricket field, and many stories are told of his witty sayings. On one occasion when playing at WHalléy, a clergyman came to the wickets to meet Jack's fast expresses. Crossland, on being told who he was, said, 'Well, here goes his bloomin' pulpit!' And sure enough, the first delivery uprooted the middle wicket, and the reverend gentleman retired to the pavilion amid suppressed laughter. Another well-known story was that relating to a Nantwich publican, who was hit on the leg by one of Crossland's fastest deliveries. On the instant he walked off the pitch. The umpires shouted to him to return, explaining that he had not been given out. 'Well,' called back the publican, 'whether I'm out or not, I'm going out!'

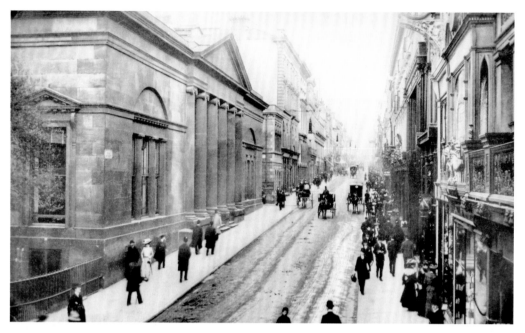

BOLD STREET, LIVERPOOL

In the course of his reminiscences, when bringing to a close his political representation of Bury, Sir Henry (now Lord) James told a cricket story which might also stand as a good example of juvenile impudence. One day Sir Henry was appealed to for a subscription to assist in starting a lads' cricket club. The subscription was sent, and the matter quite forgotten, when by post one morning came a letter. It proved to be from the same lads, who explained that they had not, after all, got enough money to start a club, and so had decided to spend what they had collected in an outing to Belle Vue. They had, accordingly, been to Belle Vue, but had spent there rather more than the collected money came to. Under the circumstances, and knowing that he was a gentleman who would not care to see any club with which he was connected in debt, would he kindly send along the balance!

Frank Ormerod

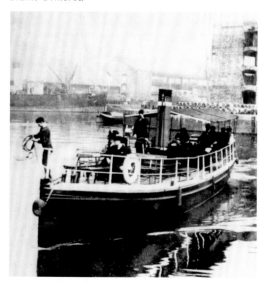

SALFORD DOCKS

MANCHESTER MEN, LIVERPOOL GENTLEMEN

One day, a number of brakes and waggonettes filled with men were making a tour of London streets for sight-seeing purposes. The excursionists were in lively mood, and their voices and laughter carried far beyond their immediate neighbourhood. As the company drove past St James's Barracks, a well-dressed man was seen to halt and take great interest in the procession. When the last vehicle came abreast of him he shouted eagerly, 'Where do you come from?'

'We come fro' Rochda,' shouted back one of the trippers.

'Hooray!' exclaimed the stranger, forgetting his 'fine' town manners and wildly waving his hat, 'I come fro' Owdham mysel'!'

But, strange to say, the Lancashire man at home is an entirely different being. He is undemonstrative

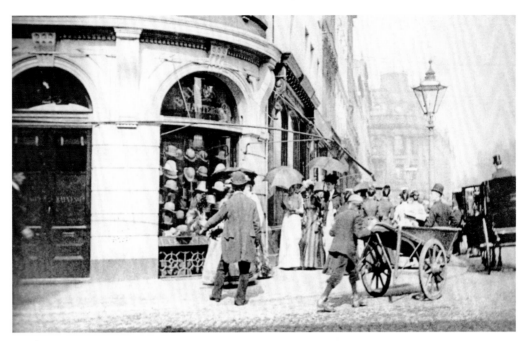

ST ANN SQUARE, MANCHESTER

towards his fellows, and loves to ridicule every place but his own. The largest towns set the example. Manchester 'Men' and Liverpool 'Gentlemen', for instance, are always trying to 'take a rise' out of each other. At the time the Manchester Ship Canal was projected, the feeling amounted to open hostility, and even now Liverpool, pluming itself on its long existence as a port and its superior seagoing knowledge, makes out that Manchester, for all its docks and shipping, does not yet know the stern from the stem of a boat, but always speaks of the 'round end' and the 'pointed end'!

When the Midland Railway Company built their splendid new hotel in Manchester, the Liverpudlian was equally sarcastic, and one of his newspapers appeared one morning with the following paragraph:

> George W Fibabit, a man and a brother from the State of Ohio, visited Manchester with a native of that village. As they left the Central Station the Mancunian pointed to the new hotel and said, 'What do you think of that?' George W paused, deliberately surveyed the building from roof to basement, and replied, 'Vury fine, vury fine; seems a bit big, though!' 'Ah!' replied the gratified native, 'you see, a great many people come to Manchester.' 'Wal,' drawled George W, 'that is so, but it's vury extensive for such a purpose.' 'Oh, come now,' said the Manchester man, with a patronising smile, 'in America you have hotels nearly as large: George W stood still. 'Ho-tel!' he cried, 'is that a hotel? I thought it was the ticket office of the Midland Railway!'

Not long ago a writer in one of the Blackburn papers remarked upon the strange aloofness existing between Preston and Blackburn in political as well as in commercial and social relations. 'I cannot remember,' he said, 'that the Members of Parliament for the over-Ribble town have ever spoken in Blackburn, and if the Members for Blackburn have ever addressed meetings of Prestonians, the occasions are so rare as to have escaped recollection.'

In country districts this peculiarity is even more pronounced. Everything is done to make the inhabitants of a neighbouring place look ignorant and foolish. One part will be known for having built walls round a field to keep the cuckoo from flying away; another for having inhabitants so 'gawmless' as to have attempted to rake a pond on a moonlight night under the impression that a big cheese was floating in the water; while the people of nearly every town or village are dubbed with some playful name, such as 'monkeys', 'rough yeds', 'trotters', and so forth. When there are no other means of disparaging a place, reports will be spread of its abnormally inclement weather. Railway porters are supposed to have informed strangers that the first station

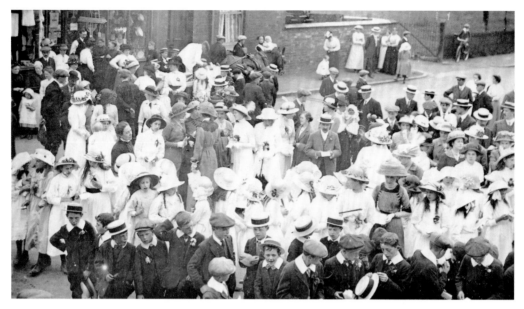

GATHERING FOR THE WALKS, PRESTON

they arrive at where it is raining they had better get out, as that will be the town they are seeking.

There are many places of which it is alleged that the inhabitants were formerly obliged to notch a stick to keep count of the days, and one village has still the reputation of having inhabitants so benighted that they cannot tell the day of the week without some extraneous aid, and have to put seven potatoes in the window sill and take one out every day. When they come to the last they know it is Sunday, and can don their best clothes.

Frank Ormerod

WALKING DAY

The day of all the year for the Children, and on July 29th, this year of our Lord, 1905, what long faces there were in the early hours of the morning. Little eyes were early open, and peering furtively round blinds to find dark clouds and rain. What disappointment, and anxious watching of the weather ensued! As is so often the case, it was all needless, for we were favoured with a delightful afternoon and evening.

Contrary to our usual custom, we are going to give a fairly full description, that in after years people may look back, and see how matters were arranged at the beginning of the twentieth century.

The children gathered in Church for a short service at 1.30, and then assembled in the Rectory grounds for the marshalling of the Procession, and a brave show it was too. It did one's heart good to see it, for somehow or other we all have an innate love for these things. At the head of it was our gorgeous banner, with the life size figure of our Patron Saint (St Thomas), carried by some of our stalwart young men, with a bevy of little maidens beautifully clad in blue and white, with bouquets of white flowers, and carrying blue and white streamers from the banner. Nothing could have been prettier, or have made a more effective vanguard. Next we were delighted to see such a fine turn out of the young men, then the Golborne Band enlivened our march with martial airs, and after them followed by Sunday School Children, Young Women's Bible Classes, in full force, and many members of the Congregation. Some of the older ones having walked for 20, 30, or even upwards of 40 years. One of the latter trudged the whole round with us, and then came on the field in the evening, although she is in her 85th year. The arrangement of the procession was most effective, being composed of two long files, with the Teachers and flag carriers in the centre, making a third file. One fact always strikes one in these affairs, and that is the dullness of the men and boys—their clothes we mean of course—sober blacks and browns and greys make the greatest contrast to the rainbow colours of the ladies. What a pity we can't wear flowing robes of many colours, then were our Procession gay indeed. However we

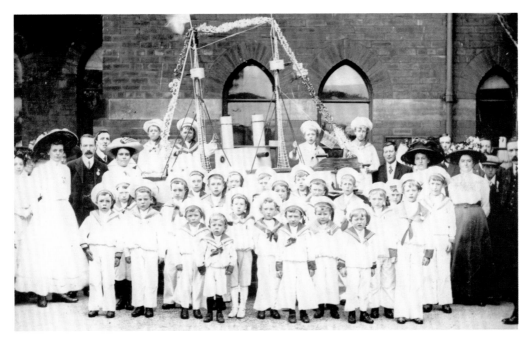

CORONATION PROCESSION SAILOR BOYS, BURY, 1911

understand we were much admired as it was. Arriving at the Schools, some of our good friends had been busy preparing for the inner man, and no invitation was needed to fall to. Then we adjourned to Mr Rothwell's field, and again we owe him a debt of gratitude for being so good as to lend it.

We were very pleased to see so many of our people there—besides those 'processing' about 250 paid for admission. We don't know that we need describe at length the proceedings, everybody knows what takes place on such occasions: Band, swings, nuts, sweets, gossip, dancing, skipping, racing, games; fathers, mothers, uncles, aunts, cousins, and nieces, all sorts and conditions of men, women and children, running, jumping, tumbling, and scrambling, joking, laughing, talking, and having a good time in general. And now nothing remains but to offer what nobody wants, but everybody likes, i.e., thanks for the labours of love, which contributed to the enjoyment of all, both old and young.

And so ends another historic day in the annals of our children, more important to them than the grandest of State processions; long may they live to share in the like.

During the evening the Rector presented Young's 'Analytical Concordance to the Bible' to Mr Aaron Collier, as a tribute of respect and esteem from the members of the Parkside Young Men's Bible Class, and other friends, on his relinquishing the work on account of his removal to Abram. Again we would thank him for his five years' faithful service, and wish him God-speed in his new sphere of labour.

Golborne Parish Magazine, September 1905

CALL THE CHILD MARY ANN

Among the stories told by the clergy, are many which indicate that the ceremony at the baptismal font can have its distinctly humorous side.

One Lancashire canon the writer knew, a man greatly beloved by his people, never hesitated to exercise a genial autocracy when he considered it would be for the good of his flock. Sometimes he carried his authority to great lengths. When parents presented their children he might, for example, refuse to give them the fancy names they desired. 'Gwendoline Cicely!' he would exclaim when some plain woman of the working class presented her infant and attempted to make both herself and her offspring ridiculous, 'Tut, tut! That won't do. Call the child Mary Ann.' And 'Mary Ann' she had to be.

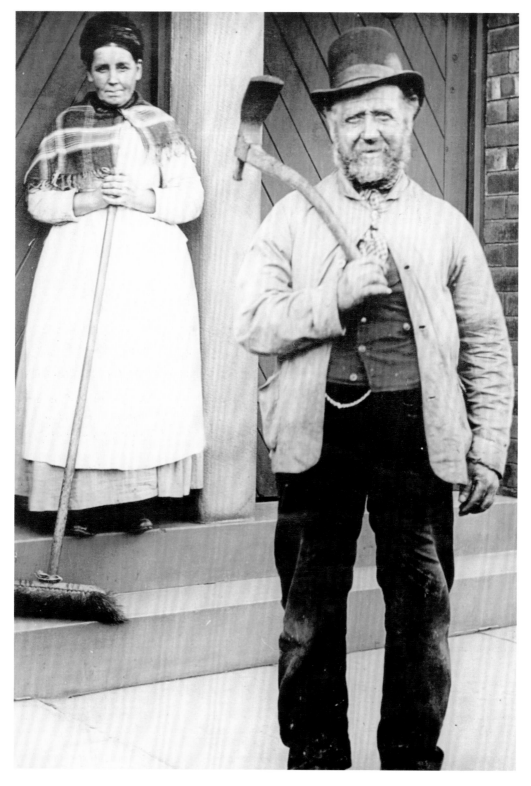

CHURCH CLEANER AND ODD-JOB MAN, WIGAN

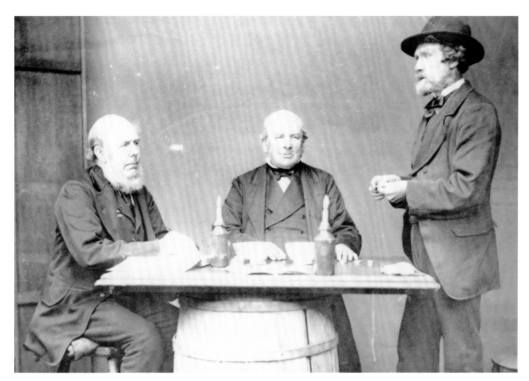

DIRECTORS OF SUN MILL, CHADDERTON

Once, at a Rochdale church, when the vicar asked the sponsors to name the child, he was told 'Ananias'. 'And whatever made you choose such a name?' asked the astonished Vicar. 'Don't you know that Ananias was a person who was a great liar?' 'Well, we wanted a Bible name,' was the innocent reply, 'an' we thought that would do as weel as ony.'

At another church known to the writer, a christening parry put in an appearance and said the name they had chosen for the infant was 'Luke'. 'Let me see,' said the Vicar, 'I have christened you two other boys, have I not?' 'Yes,' replied the parents, 'and we had them called Matthew and Mark.' 'Well,' remarked the Vicar, 'bring me John to complete the list, and I will return you all the fees you have paid.' John followed in due course.

Frank Ormerod

MASTER WAS A TURNCOAT

At the time of the Home Rule split, the present writer witnessed a scene in a Lancashire county constituency which it would be difficult if not impossible to parallel in the South. A meeting had been called at an isolated village among the hills on the Lancashire and Yorkshire border, to be addressed by the Unionist candidate and presided over by the local factory master, at whose mills all those in the place were employed. While the villagers had remained loyal to Gladstone, the factory master had followed the lead of Bright and Chamberlain, a circumstance which seemed to be very hotly resented. Indeed, the factory master had no sooner risen from the chair than he was loudly hooted, twitted unmercifully about being a 'turncoat', and eventually howled down by an audience which packed the village schoolroom to the point of suffocation. The fact that the factory master knew each individual personally, and could, were he so disposed, make the ringleaders feel the weight of his displeasure, made not the slightest difference. Outside the mill, the man who employed them was purely and simply a political enemy, and they no more dreamt of hiding their feelings in his presence than he did of taking vindictive action later on. He had his opinion, and he recognised that they, also, had a perfect right to their own. He smilingly took the repeated rebuffs, and finally both he and the candidate had to swallow their discomfiture and leave the meeting in the hands of the villagers who yelled with delight as the two gentlemen drove away.

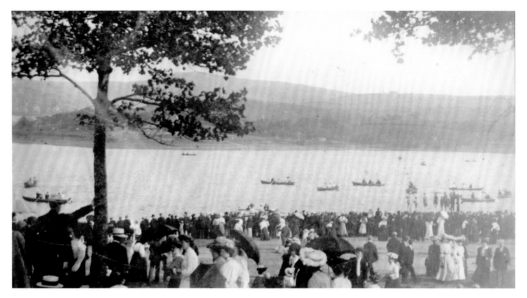

HOLLINGWORTH LAKE

With many electioneering experiences in the Midlands and the South to look back upon, the writer can safely say that he never saw anything to equal that scene. Giles generally adopts a much more discreet attitude. He may hold strong private opinions, and intend to vindicate those opinions at the polls, but when the farmer or landowner who employs him has something to say on political matters he generally listens with some show of deference, at all events.

Frank Ormerod

HOLLINGWORTH LAKE

The lake is a sheet of water covering 90 acres, originally constructed by the Rochdale and Manchester Canal Co. as a feeder to that channel of communication. Later works, however, have rendered its existence no longer necessary for that purpose, and within recent years it has fallen into the hands of a company by whom it has been transformed into a resort of pleasure. Lying about three miles from Rochdale, its shores may be gained either by highways from Smithy Bridge and Littleborough Stations, or by following the windings of two pleasant footpaths running from the town. One passes out of the top of Yorkshire Street, by way of Hamer Mill, and leads through the Hamlet of Clegg; the other, by Milnrow Road and over Uncouth Bridge.

The Lake cannot be called either 'grand' or 'lovely'. Its surroundings neither awe by their frowning majesty, nor captivate by their fairy witcheries. Here are no rugged mountains, snow-topped and grim; no far stretching forests of beech, and oak, and pine; the nightingale makes not her home upon its shores in leafy bowers perfumed with odours of richest blossom, nor does the sighing wind breathe sweetest music through the groves. In short, it is neither Loch Lomond nor Lago Maggiore. But one is not obliged to be always viewing the bluest of blue skies in Italy, or watching the descent of Highland squalls, with their wonderful changes of light and shade, and Hollingworth has merits of its own. We do not expect to be at Venice when we go to Greenwich, nor at Naples when we voyage to Blackpool. And so, though Hollingworth is neither a Derwentwater nor a Killarney, it may, and does possess attractions of a special nature worth viewing. It is homely; it is pleasant; and it is the Lake of south Lancashire and the Riding; the charming spot where on gala days gather thousands of workers in this teeming district. Leeds sends excursions; Manchester makes holiday here; contingents flock from Bradford, Bury, and Oldham, and not a district among the moors but is proud if its amateur instrumentalists can score well at a Hollingworth brass band contest. On a summer afternoon, there is wonderful natural variety at Hollingworth. Its elevated position unfolds a wide panorama. Over the

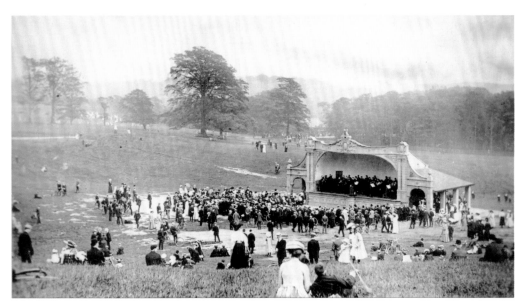

THE BANDSTAND, HEATON PARK, MANCHESTER

sombre hued Blackstone Edge and russet tinged moorlands of Wardle, light and shade play strange antics. The heather on Whittaker Moor is bathed in colours an artist would give his eyes to catch, while to the south-west over the murky atmospheric tinge which tells where Rochdale is, the champaign country rolls towards Manchester in undulating waves of meadowland, absorbing the brilliant sunshine and throwing back hues attuned in harmony with the amphitheatre of surrounding hills. Upon the Lake itself, float or dart craft of every description—the racing skiff, the pleasure boat, the fishing punt, and the snorting ferry steamer—glide in every direction, leaving in their wakes long lines of glittering, sheen, while on the western bank linger crowds for whose patronage numerous caterers of sweets, and toys, and tea, clamour in on uncertain voice. For those of more robust appetite, the many hotels which fringe the lake offer every accommodation.

The lovers of aquatic sports have formed a rowing club in connection with this lake, and the members number about 50. Henry Newall, Esq., JP, is the president, and Mr Wm. Lord, the secretary. They have a boat-house on the north side of the lake neatly fitted up. They possess eight and four-oared gigs; four and pair-oared racing cutters, and skiffs, and canoes.

The Beach Hotel is a commodious inn, built of brick, and occupying a commanding site. Here are large refreshment rooms, and overhanging the water, a spacious dancing stage, capable of accommodating some two thousand persons. This is brilliantly lighted with gas, and at night presents a most lively and animating appearance. Round the hotel are grounds fitted up for *al fresco* sports.

Crossing the lake from one landing stage to another by means of a paddle steamer, we reach the Lake Hotel and pleasure grounds. The hotel is a picturesque building, constructed somewhat after the fashion of a Swiss chalet. The neatness and excellence of its accommodation have given it a name far beyond that of mere local celebrity. The Lake Hotel stands within large and tastefully laid out pleasure grounds. Drives, lined with shrubbery will be found along the shores of the lake, while at the back of the hotel is a well-kept bowling green, and, beyond that again, flowery arcades and summer houses, where one may ruralize at leisure. Standing at the edge of the lake is a very handsome building, the lower floor of which is used as a refreshment room, the upper floor forming a fine billiard room, with commodious balcony, from which the sports on the lake can be conveniently witnessed. In front of the verandah of the hotel is a dancing stage, a scene of gaiety on summer evenings when the lake is aglow with the setting sun, and joyous sounds of laughter come rippling over the water.

William Robertson

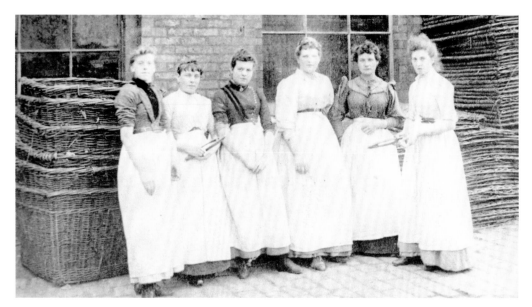

MANCHESTER WEAVERS

THE ANCOATS BELLES

The best time for seeing the Ancoats belles to advantage is perhaps on Saturdays, about 1 p.m., when they pour out from the great mills in which their skilful fingers have been busy during the week. The sense of freedom at the prospect of an interval of rest and change after the week of monotonous toil, and the consciousness of the possession of the wherewithal to make the best of it, result in great exuberance of animal spirits; and the observer passing along, say, Union Street at the hour named, cannot but be struck with the gaiety and cheerfulness of this great stream of busy workers set free for a time to follow their own devices. On the part of the majority there is a total absence of that conventional restraint which marks the deportment of their sister belles of St Ann's, and the good-humoured banter of each other and of the passers-by is plentiful.

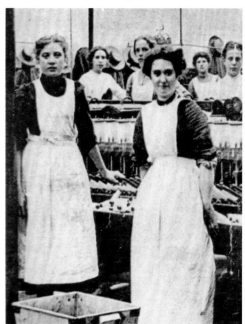

SPINNERS AT J. AND J. HAYES, LEIGH

Compassionate hearts and liberal hands are probably not uncommon among the hard-working damsels. At any rate, on this particular day of the week the halt, the lame, and the blind muster in great force along the route.

Itinerant vendors offer tempting inducements to capitalists on the look-out for an investment. Here one glib-tongued orator offers a specific for corns and warts. If the next may be believed, no one need be troubled with toothache who is willing to lay out a penny at his establishment. Broken glass and crockery-ware can be repaired and made as good as new with a penn'orth of what the next merchant deals in.

Spy Magazine, September 1891

FIDDLIN' AND DOANCIN'

It may be said of hunting in many parts of Lancashire nowadays, that it is, in its mounted form, more or less the pastime of factory masters, and there is little of the old-time display attached to the sport as formerly carried on by the squire and the landed proprietor. As

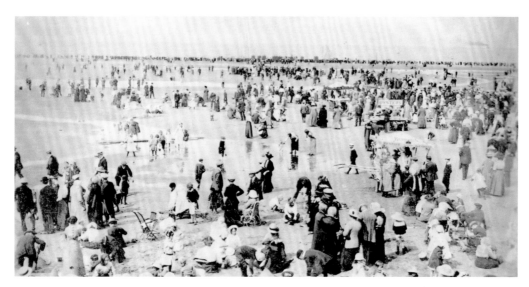

BLACKPOOL BEACH

a spectacle it has decidedly lost in attractiveness. Instead of the scarlet and other bravery which used to give such a festive appearance to the hunters, and which was so effective as the riders streamed over hill and dale, there is now a tendency to dress in more sombre garments, and to wear the attire one generally associates with a canter in the park. The explanation, no doubt, lies in the fact that busy men of affairs do not give up the whole of any day to the sport, and so adopt a dress which allows them to do three or four hours' work at the mill before mounting their horses and starting for the 'meet'.

Indeed, one often wishes that the participants in many outdoor games had a little more of that sense of colour which is displayed to such effect in the South-country. The absence of it, however, may be due less to an artistic defect than to that deplorable utilitarianism which finds no virtue in anything that is not 'serviceable', and which would sacrifice every feature of the landscape to build cheaply or add a few extra yards of tillage to field or meadow land.

No chapter devoted to the recreative side of the county life would be complete without mention of the great annual holiday of the factory folk, called in some places the 'Wakes', and in a few towns the 'Rushbearing'. At this time—about a week in the month of August or September—hundreds of thousands released from spindle and loom eagerly rush to the seaside, and there spend every day and every hour of the day in the merriest, maddest revel.

Leaving out of the question whether the holiday is or is not wisely spent—and it is a mistake to imagine that all spend their savings in the reckless, improvident fashion set down by the superior person who sometimes writes to the newspapers—there is no doubt that these high-spirited and strenuous people enjoy a carnival of pleasure which is the envy of workers in other parts of the country. For one thing no other industrial community is catered for in such a royal fashion as are these spinners and weavers of the North. It is their numbers rather than their individual purses that entertainment managers in Lancashire watering-places keep in view, and these numbers make it possible for the greatest concert, theatre, and music-hall artistes in the country to be seen and heard at the smallest possible expense. At Blackpool, for instance, where something like a cool million of money has been spent in providing gorgeous palaces of pleasure, the nimble sixpence will buy ten times more entertainment than it will at Brighton or Margate or any other place frequented by Londoners of the working class.

All places of amusement reap a rich harvest at this season, but more particularly do those places flourish which adequately gauge the Lancashire people's love for 'fiddlin' and doancin' '. They have, indeed, a passion for dancing. There is no county where the lads and lasses dance so much and dance so well, and when on a holiday they are ready to dance morning, noon, and night. At every place where there is a little space and a band one can find them dancing—on the piers in the morning, at one or other of the recreation grounds in

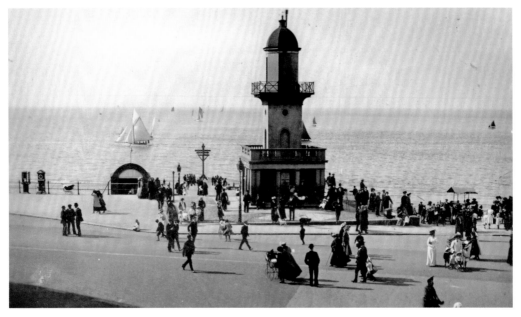

LOWER LIGHT AND PROMENADE, FLEETWOOD

the afternoon, and at splendidly-appointed public assembly rooms in the evening.

The places where these energetic holiday makers can 'have a jig', as they would term it, have of recent years become more and more palatial, and some of them are supplied with orchestras which would do no discredit to a State ball. For sixpence the clumsiest lad who ever carried a 'baggin'-can' is allowed to scrawl his hobnails across a floor of beautifully polished oak, and gyrate to the strains of an incomparable Waldteufel waltz. And

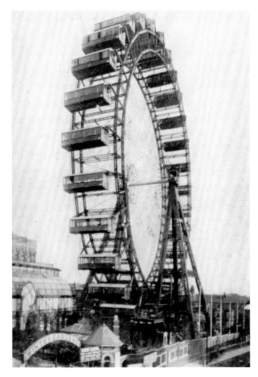

GIGANTIC WHEEL,
BLACKPOOL WINTER GARDENS

while the MC will be in immaculate evening dress, and carry a wand in his white-gloved hand, some of the male dancers are probably wearing cycling clothes and caps, and carrying under their arms parcels and umbrellas. And to complete the picture, the typical 'Owdham Roughyed' will be found in the intervals between his jigging' drinking glasses of beer, calling loudly for 'Margit Ann', and playfully shouting to a pal that he will 'come o'er and give him a punce i't nose!'

Frank Ormerod

ONCE EVERY PRESTON GUILD

Beyond the village of WHalléy the Calder falls into the Ribble, which is then on its way to Preston and the remoter estuary. Meanwhile, if you follow its course it will take you to Ribchester, 'a small but ancient town', interesting to antiquarians because of its Roman origin. They say it once had a temple dedicated to Minerva—a goddess friendly to spinners—it has now two weaving sheds, where jacconettes and shirtings and other cotton fabrics are woven. Eleven miles further along the beautiful valley of the Ribble, overlooked by Longridge Fell, you come to Preston, of which we have once

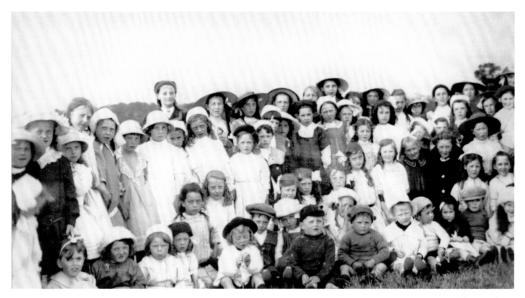

PRESTON FIELD DAY

before had distant sight. 'Proud Preston' it has been called, formerly a 'priests' town', with much antique lore associated with it, a town upon which royal charters have been bestowed in rich largesse, no less than fourteen of them being counted up between the time of Henry II and that of George IV. Preston is surrounded with a country of fair landscapes, above which it is lifted somewhat. It has several public parklands, and through a beautiful cultivated space of this kind on the south the tidal Ribble flows on its way to the spacious docks, where vessels may arrive and depart by a waterway which widens out along twelve miles, to a broad sand-margined estuary and the further sea. Of the streets of the town Fishergate is the most important and is not without picturesque features. There you come upon the Town Hall, a grand building, towered and spired, with its arcaded front, traceried windows, sculptured enrichments, and other architectural expressions of the Gothic kind. Overlooking the market place you have a building of classic mould, massive and imposing, known as the Harris Institute, and dedicated to 'Literature, Arts and Sciences'. The lofty pillared portico is approached by a long flight of steps, and in the tympanum overhead you have carvings representing 'The School of Athens in the time of Pericles'. The whole was a noble gift to the town, and among other purposes is used as a Free Library and Museum. Once in every twenty years Preston breaks out into special festivity in celebration of its 'Guild Merchant', a very ancient institution, with its enrolments of free burgesses, who had the monopoly of trading in the town to the exclusion of 'foreigners', with other privileges, which were jealously guarded even to the end of the seventeenth century. With the growth of the years the 'Guild Merchant' became obsolete as an active organisation, but the celebration was retained in festive form. Of one of these functions held more than a century ago it was said by a local poet that,

> Feasting and dancing, and Music and noise,
> Are the soul of a Guild and the chief of its joys.

The last celebration was in 1882, and the ceremonies continued for a week, with processions of trade and friendly societies and other pageantry. Whatever may have been the tastes and tendencies of 'Proud Preston' in the old days, the most marked feature of the present time is its devotion to trade and manufactures. Its population numbered at the last census over one hundred and eleven thousand within the parliamentary borough. It is largely industrial; it has iron and shipbuilding works, and spinning mills and weaving sheds. Within the cotton trade it had very early association. It was here that Richard Arkwright was born and worked as a barber, and here he set up and exhibited his first 'spinning engine'. The first cotton mill in Preston was erected in 1777 and has been succeeded by many others, as the visitor will perceive as he approaches the

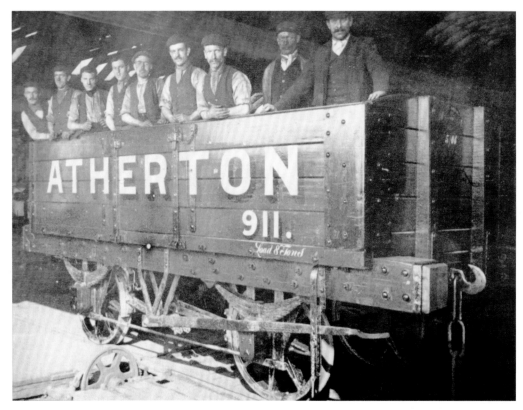

WAGON SHOP, GIBFIELD COLLIERY, ATHERTON

town, the tall chimney shafts being in evidence there among the towers and spires. In the Preston district they spin and weave in large quantities, the spindles being in number about one million seven hundred thousand, and the looms about fifty-two thousand. The fabrics are numerous and not to be particularised within convenient limits, but there is a certain leaning to goods of the cambric, muslin, and jacconette kinds, together with a production of shirtings of the India and China orders. They weave less, but spin more in Preston than they do in Blackburn, but in their manufacturing aspects there is much in common.

John Mortimer

RECKONING MONDAY

After they had received their fortnightly wages on Saturday afternoon the colliers had two days' respite from work before them, Sunday and Reckoning Monday, and most of the men let themselves go. In some homes the frying pan was constantly on the fire and in some cases the men, and sad to say, a few of their wives, were more or less drunk during the whole of the two days.

Some of the men called at the nearest ale-house before bringing home their wages and the poor wives waiting for money to go and pay for the food of the past fortnight, in order that they might be allowed some for the coming week, sat anxiously at home. Sometimes children were sent to ask father to come home, but oftener than not they were given a penny or twopence to spend and told to go off back home. Then the wives would go themselves to the alehouses, and alas, sometimes remained to drink and keep their husbands company. Those wives who would not drink, but insisted on their men coming home, often received a thrashing.

On the Tuesday morning following Reckoning Monday women were to be seen with black eyes. If the women had themselves been drunk, the neighbours said it served them right; but they resented a decent striving woman being thrashed for nothing, but trying to persuade her husband away from drink, or for taking the money from his pocket while he was drunk and unconscious. Sometimes in cases of this kind the

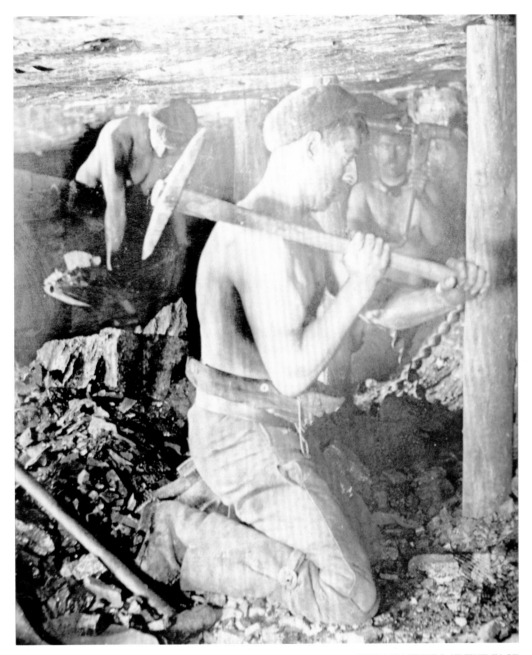

WIGAN MINERS AT THE FACE

women would tell their children to go and 'pon' the wife-beater; and, collecting pan and kettle lids, old tin cans, and sticks, the little boys and girls would take up a position before his door, and to the din of their 'musical' instruments, sing:

> Heaven bless the women,
> Hell bless the men,
> Wilto, wilto, wilto,
> Wilto do it again?

This racket they would often keep up until the infuriated man came out and threw water over them, or crept out at the back door and hid himself out of reach of the din.

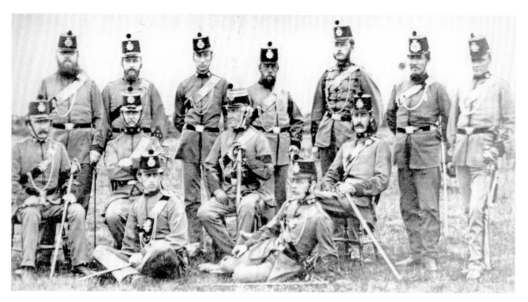

LANCASHIRE RIFLES OFFICERS

I once saw, in Coal Pit Lane, Leigh, the effigy of a man who had beaten his wife, fixed on a pole outside a bedroom window. All the people in the village went to look at it, and boys threw mud, rotten potatoes and other missiles at it. And when night came on, it was carried through the village, and then burned.

Colliers, who had been drunk from Saturday afternoon until Monday night, were unfit for work on the Tuesday morning, and lay in bed; and when they presented themselves for work on the Wednesday morning, the manager or underlooker would tell them that, as they had played a day or two for their own pleasure, they must play two for the master's. This was called being 'shelved'. Sometimes men were shelved for a whole week.

Mary Thomason

A FUSILIER'S FAREWELL TO HIS MOTHER, BURY

TOUGH AND WIRY BEYOND BELIEF

'Small of stature they may be,' says one writer who understands the factory folk, 'but they are tough and wiry beyond belief, and their powers of endurance would astonish those who put them to the test of fitness.' This remark has been strikingly borne out recently by the critics of our new Territorial Forces. When the four battalions of the Lancashire Fusiliers' Brigade, recruited almost exclusively from the mill hands of Bury, Rochdale, and Salford, reached Salisbury Plain for their first annual training, their appearance did not give satisfaction to those who, forgetting the lesson the little Japanese taught the world some time ago, still believe that none but giants can handle a gun. 'There is no use in mincing matters,' wrote one critic, 'this brigade contains a terribly large percentage of immature youths, whose physical development leaves much to be desired.' But when it was seen that these same lads were as fit as fiddles after long railway journeys, stiff marches,

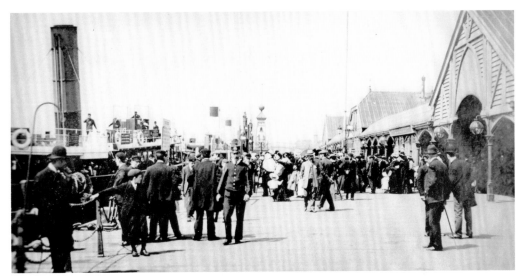

PRINCES LANDING STAGE, LIVERPOOL

sleepless nights, and long abstentions from food, the critics began to change their tune. 'They have already been well tested,' was the later admission, 'and they are a great deal better than they look. The spirit is uncommon willing, and the flesh is far from weak.'

The mention of the brawn and muscle of Lancashire men reminds one. that the 'reforming' demagogue also likes to talk of the mill folk as a short-lived people. Perhaps in a few trades, and notably those of St Helens, Runcorn, and one or two other places which are not cotton factory districts at all, the mortality does not reach a very high average, but taking the county through it will compare very favourably with any other both as to the stature and longevity of its inhabitants.

'Married at Samlesbury Church, David Heys, aged 84, to Mary Whittaker, aged 84. The groomsman was aged 78, and the bridesmaid 93 years. The bride, to show her agility, danced a minuet during the wedding festivities.' This interesting event took place a hundred years ago, certainly, but the chronological records contain a surprising number of similar entries up to the present day.

There are, contrary to the opinion of some outsiders, some fine specimens of manhood to be found in the mills. An old man of over ninety, who has worked all his life in cotton factories, was heard by a friend of the writer recently to cHallénge a much younger man to either run or wrestle. He was as hearty as a hare, his only infirmity being a little deafness.

Frank Ormerod

LOST IN THE SEINE

The reports relating to the destruction of the Fleetwood barque *Norcross*, recorded in the major portion of our issue yesterday, are still very unsatisfactory. The captain, his wife, and the pilot are now stated to have been saved; but the death-roll has been increased from seven to nine. The *Norcross*, which was built at Dumbarton and belonged to Messrs Ward, of Fleetwood, was bound from Philadelphia to Rouen laden with petroleum and had arrived in the estuary of the Seine when some of the oil exploded and then set fire to the ship. The tug *Abeille* has returned to Havre from the scene of the disaster. Her captain states that when the explosion occurred ten sailors, including the mate, were on deck, and were quickly enveloped in the flames. Two others were blown overboard, but were rescued by the tug, which also succeeded in saving the captain, his wife, and the pilot. All were conveyed to Honfleur, and the injured were taken to the hospital. The *Norcross*, when the last message was despatched, was still on fire, and was ashore near Vignefleur. .

Northern Daily Telegraph, November 1892

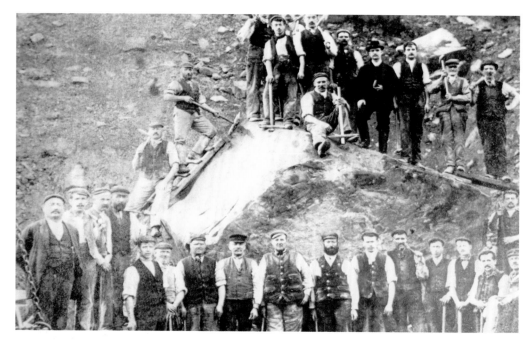

DELPH BAKESTONE PIT

PHILOSOPHERS IN CLOGS

The menfolk, 'when't wark is out o' their fingers', occupy their spare time in a variety of ways. Just as one would never dream that the fashionably-dressed girl to be seen about the streets of a Lancashire town on a Saturday afternoon or Sunday could possibly be the same he meets in shawl and clogs on Monday morning, so one can be wholly deceived in the pursuits of the men when the mills have closed their doors. There are, of course, still a few who occupy their leisure with 'a dog in a bant and a pigeon in a poke', and a still larger number who make a fetish of football, but it is the greatest mistake imaginable to jump to the conclusion, as so many people do, that the Lancashire man has not a soul above dog racing and ratting.

To take part in the geological and botanical rambles organised by associations of working men, and often led by working men themselves, would, for instance, be a revelation to outsiders; while the deftness shown in handicraft hobbies, and the amount of information at the command of some weaver or spinner student, would vastly astonish strangers to the county.

A 'factory chap' recently called at the house of the writer with a message, and, attracted by the contents of a bookcase, began to make comments on authors and their works which indicated a wide and very choice range of reading. In addition, he proved to be learned in Nature's own book, having studied birds and beasts and flowers to no little purpose. His only regret was that the factory left him so little time to follow the bent of his own inclinations, but his holidays, week-ends, and evenings in summer were all spent in solitary rambles of observation. His taste in reading may perhaps be judged from the fact that when he left he carried away with him a volume of Maeterlinck.

This case is not by any means an isolated one, and the same love of education and self-culture is found along many young women who on six days out of seven run four looms and envelop their personal charms in shawls and clogs.

A splendid compliment was paid to Lancashire working women recently by the daughter of Mr W.T. Stead, after a tour of inspection of one of the big Rochdale spinning mills. 'I was,' she said 'simply amazed at their intelligence and the knowledge they showed of subjects which are supposed to be quite beyond factory folk. I have never met such workpeople anywhere.'

Frank Ormerod

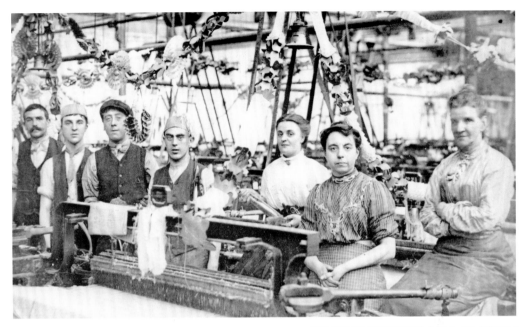

WEAVERS, VICTORIA MILL, CLAYTON

THOSE DROLL DOFFERS

The Factory Doffers of Lancashire are an institution in themselves, and one with which it is not likely we can ever dispense. I speak of them as 'Lancashire Factory Doffers', as though this class of workers was peculiar to that county, because my experience of other cotton manufacturing districts and towns is not sufficiently extensive to enable me to say whether the genus 'Doffer' flourishes elsewhere in the same perfection, and with the like characteristics.

It is scarcely possible, I think, to live for any length of time in their vicinity without being struck with the singularities which the Factory Doffers exhibit. For the information of any one reading this sketch to whom the name 'Doffer' and the office it implies are strange, I must describe the peculiar vocation of the *genus* in the labour economy of Lancashire. The Doffers, then, are lads employed exclusively in the throstle room of the cotton factory. Their work consists in removing the full bobbins from the spinning frame,—hence the name 'Doffer', *i.e.*, to doff, or divest,—and supplying their places with empty bobbins to receive the yarn as it is spun. This they accomplish with a dexterity that beats conjuring. For a stranger visiting a cotton mill there is no greater treat than to show him the Doffers at work. When the process of doffing is being performed, the machine, of course, is stopped, and consequently is not producing any yarn; so, to stimulate the boys to greater rapidity at their work, and thus increase the productiveness of the machinery, they are allowed to spend the intervals between the several doffings in exercise out of doors, or in any other way they

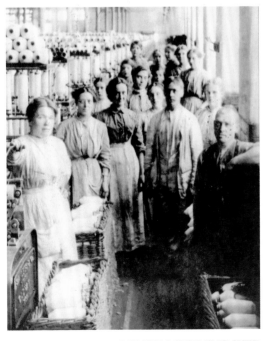

OLDHAM SPINNING SHED

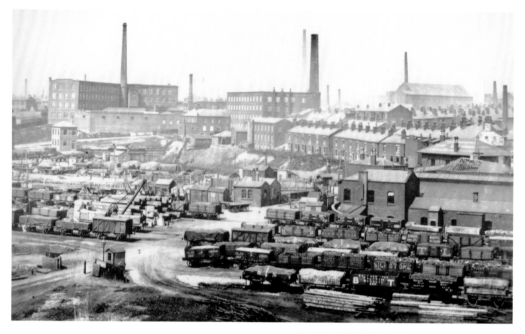

CLEGG STREET GOODS YARD, OLDHAM

choose, always provided they don't go beyond earshot of the 'throstle jobber', who is a kind of 'bo'sn' in this particular department of the mill. The quicker they perform their duties, the more time they have to themselves; hence the amount of leisure and liberty the lads enjoy, and which they usually spend in the open air outside the factory gates, but within call of the said jobber or under-gaffer, who summonses them with a whistle to their work as often as their services are required. Employers are thus wise in their generation. Liberty is one of the finest stimulants to well-doing that human nature knows, especially juvenile human nature; money reward is subsidiary to it, but that comes next, though youth holds it in scant estimation.

The complement of efficient Doffers required in a cotton mill, containing, say, ten thousand throstle spindles, is from ten to twelve; and so in proportion as the spindles are less or more in number. The number depends to some extent on the counts of yarn spun; but generally the proportion given may be taken as correct. In addition to the required staff of skilled boys, there are usually two or three new lads, or 'greenhorns', being initiated into the mysteries of the craft; these latter, who may be termed recruits, lead a hard life during their term of probation until admitted to the rank of full private in the corps. I suppose the initiatory rites to which they have to submit are almost as severe as those which we are accustomed to associate with the mysteries of Freemasonry.

'The Devil's Own', the Doffers are sometimes called. The title is a misnomer; they have more of mischief pure and simple than evil in their composition. They consist chiefly of poor folks' lads, and, as a rule, have little, thin, delicate faces, and bodies to match—they are not usually over-fed—but they possess an amount of animal spirits perfectly wonderful to observe. The spiritual and the intellectual in their case appear to predominate over the corporeal to a marvellous extent. Nevertheless, and it is a curious circumstance, though their abandonment to frolic is as complete and intense as can well be imagined, it will be noticed that they have for the most part a careworn expression of countenance that appears an incongruity when observed in connection with their years and general habits. 'Imps', I have heard them described; the nickname is a libel upon the clan. They are unwashed and unkempt human fairies; 'bobbin and spindle elves' they might with propriety be designated. They reciprocate kindnesses, and are always ready to rally round a friend in difficulty; he must be a friend, however; woe to the man who places them at a disadvantage, or attempts to circumscribe their privileges! These are the chief characteristics of the fairy; not so the imp, he is an incorrigible ingrate.

A friend has suggested to me that in the Doffer the missing link desiderated by Darwin has been found at last; judged by their mischievous pranks, one might almost be led to conclude that such is the fact. An account of all the

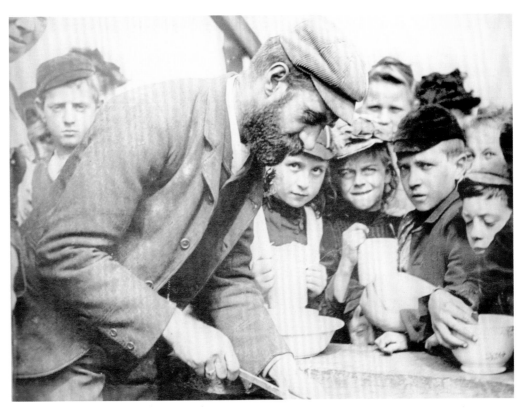

CHURCH SOUP KITCHENS, WIGAN COAL STRIKE, 1894

practical jokes of the Factory Doffers would fill a big volume; nay, I verily believe it would occupy a serial devoted to that subject alone, for their originality and fecundity in mischief are amazing. The 'Tier-boys' are sometimes compared with the Doffers. The comparison is not happy. The contrast between the two is such as to strike any ordinary observer; and the careful student of the ways of each would detect still greater differences. The training of the two, if we will consider for a moment, has been of quite an opposite kind. The Tier-boys have less liberty, and from their closer and more constant association with men in their daily employment—men who frequently lead dissolute lives—they have imbibed much of the cunning and carriage of riper years, thus detracting from the freshness, the frankness, and the loveableness of youth. In his habits, too, the Tier-boy is slower, not so agile, not so vivacious. This is due in some degree to the nature of his work; it is more deliberate than that of the other; but it also comes of his constantly wearing clogs. The Doffer, save in the depth of winter, is as often barefooted as not. I don't make this comparison in disparagement of the Tier-boy, as a boy; but as explaining the effect of the surroundings of his daily employment upon his undeveloped, but growing character, all of which serve to mould and fashion it. His surroundings are his misfortune, not his fault, and it is undeniable that these are not, as a rule, conducive to the forming of good habits. It may be said that neither are the circumstances of the Doffer such as to encourage the growth of desirable habits. That is true, no doubt, but his faults are negative to a large extent, the positive disadvantages that cling to the lot of the other are absent in his case.

I have been an eye-witness of many practical jokes by the different bands of Doffers at various times; one only I will mention that was played by a member of them upon an unsuspecting carter. He had got a cart load of coals, which he was leisurely conveying to their destination along one of the bye-streets; having occasion to call at a house on the way, he left his horse and cart standing by the road side. A swarm of Doffers from a neighbouring mill espied the situation, laid their heads together for a moment or two, and then came running stealthily up to the cart, undid all the gears save what barely supported the cart from falling so long as the horse remained fairly quiet. Having completed their arrangements they as quietly retired, and took their stand at a cautious distance behind the gable end of a house, whence in safety they could reconnoitre the enemy. It was an

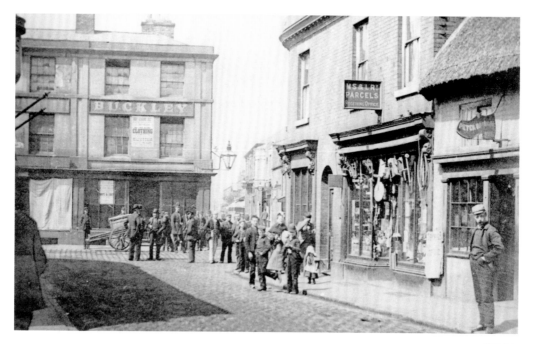

LEIGH

enjoyable picture to me who was in the secret, and for very mischief kept it, to see half-a-score of little greasy, grinning faces, peeping from past the house end, expectation beaming from every wicked eye. The unwitting carter at length appeared upon the scene, and, giving a brisk crack of his whip, had scarce got the 'awewoy' from his lips, when 'Dobbin', laying his shoulders to his work, ran forward with all involuntary trot for ten or fifteen yards, whilst the cart shafts came with sudden shock to the ground, and a row of cobs, that had barricaded the smaller coal, flew shuttering over the cart head into the street; fortunately no damage resulted—the shafts by a miracle stood the shock. The amazement of the victim of the trick may be imagined but scarcely described. He gazed with open mouth at the catastrophe, and his fingers naturally found their way to his cranium, which he scratched in perplexity. The knot of jubilant faces at the street corner in the distance soon supplied the key to his difficulty. The truth flashed upon his mind: 'Devilskins!' he muttered, and seizing one of the biggest cobs he could grasp in his hand, he let fly at vacancy; for before you might say 'Jack Roninson', the mischievous elves had vanished with a war-whoop, and ere the missile had reached the ground, were most probably knee deep in their next adventurous exploit.

The imitative powers of the Doffers are something extraordinary. To me it used to be a sight at once admirable and amusing to view them parading the streets by way of parodying the famous rifle band of the town after any occasion of competitive success. To listen to the music which they contrived to evoke from out of a few tin whistles and a waste-can, accompanied by the singing of the non-instrumentalists, was in every way calculated to awaken the risible faculties of the demurest of mortals.

What becomes of them at last is often a subject of wonder to me. They cannot all bud up and eventually blossom into cotton mill managers, or even throstle gaffers; though from the sympathy they evoke, and the licence that is accorded to them, one would almost believe that their taskmasters had a kindly recollection of the time when they were Doffers themselves. I don't know whether any of them in the course of their after life have attained to the rank of capitalists. I have not actual cognizance of such a fact; but I strongly suspect that if some of our self-made Lancashire manufacturers could be induced to write their autobiography, it would be found that their earliest experiences of the world in general, and of factory life in particular, were learnt whilst sitting astride of a buffalo boa, in front of a throstle frame. If such is the fact, it is not to their discredit, but the contrary, for certainly they might have had a worse training.

Thomas Newbigging

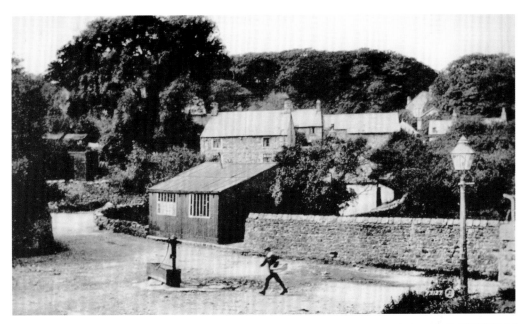

VILLAGE PUMP, HEYSHAM

ST MICHAEL'S FLOWERS

Lancashire is full of striking contrasts. The South-countryman thinks of it only as an agglomeration of factory and colliery towns, of tall chimneys belching forth black smoke, and where nothing is heard but the noise of machinery and the clatter of millgirls' clogs. Yet, away from the towns and the large stretches of moorland, lie rich lands where the best wheat is grown, the finest cattle pastured, and the noblest horses in the country are bred. Indeed, on the products of these lands, Lancashire farmers are able to hold agricultural shows superior to those of any other county, and one, at least, which is almost equal in size and quality to the Royal Show itself.

The county is disgraced in some of its towns by rivers which are little better than open sewers—cesspools of filth and abomination—but, on the other hand, there are rivers where fifty-pound salmon have been caught, and over a score of the most charming trout streams in England.

A stranger will notice, too, that while there is an 'almost absolute content with the positively ugly' in the externals of some of the blackest towns, there is a scrupulous cleanliness in the houses themselves. Inside, floors and furniture will be speckless, whatever may be the character of the surroundings out of doors. But if there is little that is attractive about the piles of bricks and mortar in the manufacturing centres, the worker has the satisfaction of knowing that just outside the ring of smoke, and within the compass of a short train or train ride, he can find unsurpassable beauties of hill

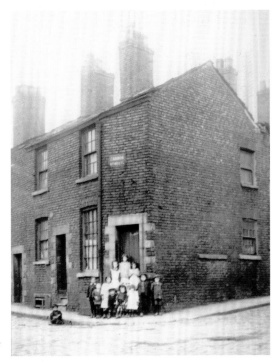

CANNON STREET AND
GARLICK STREET, OLDHAM

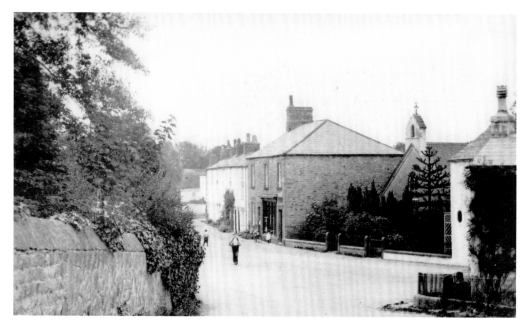

SCORTON

and dale, of country lane and sylvan glade. This rapid transformation from the unlovely to the picturesque is a matter of constant surprise to the visitor—he can turn in an incredibly short time from the unyielding pavements of a grimy town to the springy turf and the heather-clad moors, or exchange the flaunting flowers in the shops for the modest bluebells and primroses in the cloughs and dells.

'Whatever there may have been in the past, there is little room for the roses now,' says the writer of a newspaper article, on the strength of a few new mills built during a recent cotton boom, leading the outsider to believe by the tenour of his remarks that a factory accommodating a thousand or two of spindles requires the space of half a county instead of that of a decent-sized circus. That there is still room for the roses would appear to be indicated by the following little item of information, culled contemporaneously from another public print. It having been stated that the pupils of a school at Wigton had gathered 357 varieties of wild flowers, Mr John Moss, the head teacher at the National School, St Michael's-on-Wyre, Garstang, wrote to one of the London papers:—

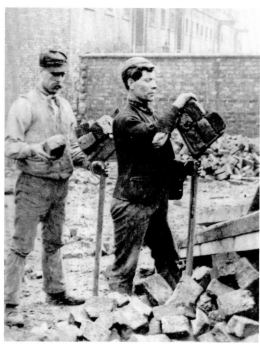

> We have for a number of seasons past been engaged in the collection and classification of the wild flowers of North Lancashire. This year we have so far gathered and classified 368 varieties of flowers, forty-two grasses, and twenty-six sedges; and we are hoping, before the season closes, to increase this number by at least another fifty varieties.

When one leaves the lowlands, he is rewarded by some of the finest moorland scenery in England. The great Pennine Chain is a magnificent range, and on its westerly side throws out some noble spurs, many of the culminating headlands being of mountainous

MANCHESTER BRICKLAYERS

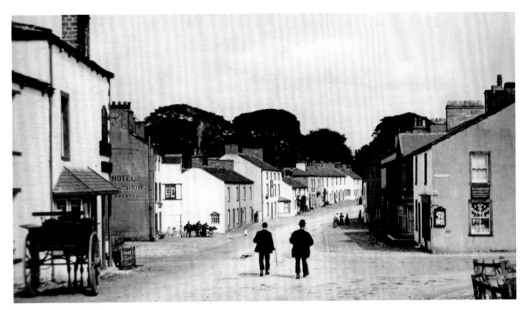

GISBURN

proportions. The moors are of large extent, and far from being the barren wastes that some imagine, are, with their ling, heather, and coarse grasses, their bright wimberry 'clusters', their tinkling rills and 'rindles'—so dear to the heart of Waugh and other writers—their nimble sheep, blending in colour with the greys of the rocky outcroppings, their bee and insect life, and their choir of larks and moorbirds, full of movement and colour. To go to the home of the grouse and the peewit, is also to find the finest of health-giving breezes. 'There is as much difference between a walk in a Leeds or Sheffield or Preston "park", and a roam over the Pennine moors, as there is between a glass of champagne and a cup of cocoa,' remarked a writer in the *Spectator* a little while ago, and, certainly, no highly-vaunted Spa is more efficacious for the reinvigoration of tired minds and bodies.

Of nearly every old-fashioned doctor living within sight of these moors is the story told of a simple and successful remedy for the benefit of some jaded patient. The story runs that an old doctor informed his patient that there was a herb growing on the hilltops which was particularly desirable for the sick man's benefit, and invited the patient to accompany him in search of it. The two started and walked mile after mile across the breezy uplands, the doctor, to each enquiry, remarking that the place where the plant grew was further and still further on. At length, it is said, the patient stopped and protested. 'I do hope it is not much further,' he said, 'for I am fearfully hungry.' Whereupon the doctor exclaimed, 'We've found it! We can turn back now,' the mysterious herb of which they were in search being, of course, named 'appetite'.

That delightful writer on South-country life, 'Son of the Marshes', is evidently one of those who cannot appreciate either the beauty or feeling of our splendid Lancashire moors. Describing a ramble in Surrey, he says:—'We have now reached the moor; but it is a Surrey moor, rich in vegetation and green turf, not a bare waste.' In other words, the place he mentions is not a moor at all, but a piece of tangled scrub, such as one finds on the Witley Commons or on Hindhead, exceedingly charming in itself, but another thing altogether to the moor as understood in the North. Contrast the words of 'Son of the Marshes' with those of a man like Mr Augustine Birrell. In his book on Charlotte Bronte, he lays special stress upon the environment of the gifted sisters, and says:

Behind them, too, lay the Haworth moors, of all kinds of scenery the most permanently impressive, though whether it is to the earth or to the sky, to the eye or to the ear we are most indebted, who but a poet can say?

The mention of the Brontes and the hill country between Lancashire and Yorkshire, recalls a remark made to the writer by a London lady to the effect that she could not possibly accept as real the characters to be found in the stories written by the gifted ladies of Haworth; they were altogether too dour and forbidding to be English people.

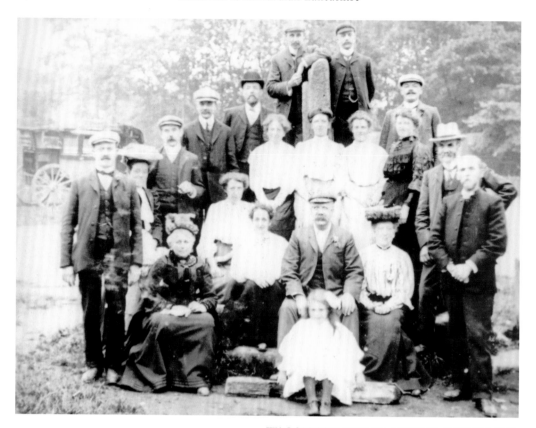

WAGONETTE TRIP TO BOLTON-BY-BOWLAND

In some of the remote, self-contained communities to be found amongst the hills dividing the two counties, where the older people still speak of an Englishman from another part of the country as a 'furriner', and where one has often heard the remark, 'Hoo's not this countrywoman', applied to the wife of a man who has come, maybe, from a remote part of the same country, there are to be found many characters quite as misanthropic, grim, and taciturn as Heathcliff; men who live silent, lonely, and perhaps miserly lives, and in the course of time become a terror to those about them. But the mistake must not be made that was made in another locality by the author of *The House with the Green Shutters*, that these characters are typical, for in the out-of-the-way places we have in mind the bulk of the people are given to take life jovially and light-heartedly. The distinct Celtic strain generally found in such parts may lead, as it usually does, to a morbid habit of revelling in the dark side of things when the occasion offers, but the other characteristic of the race easily predominates, for shooting, wrestling, boxing, swinging the hammer, and so forth, are always exceedingly well patronised. Despite what is said about the working folk of the county being stunted and degenerate, they frequently produce from their ranks men who defeat these travelling 'champions', and nothing pleases them better than 'taking down' the boastful wrestlers and boxers in these shows.

Frank Ormerod

BLACK PUDDINGS AND TROTTERS

My home town of Bury is famous in a modest way for its Bury black pudding, and its Bury 'knob' simnels. The black puddings need a little courage in tackling them for the first time, but I am very fond of them and my medical friends assure me that they are valuable feeding for those suffering from anaemia. Every maker seems to have a closely guarded recipe, but mainly they are made of a mixture of hog's blood, groats, and fat, with a seasoning of aromatic herbs. They are boiled in skins, and served with a liberal lashing of mustard. I have

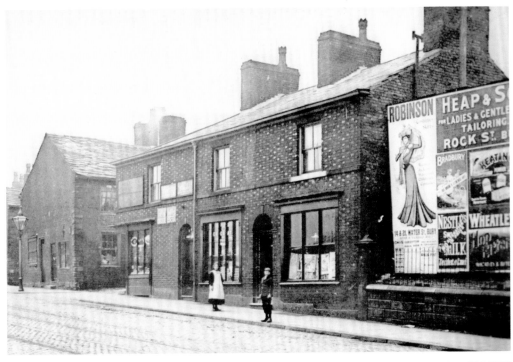

BOLTON STREET, BURY

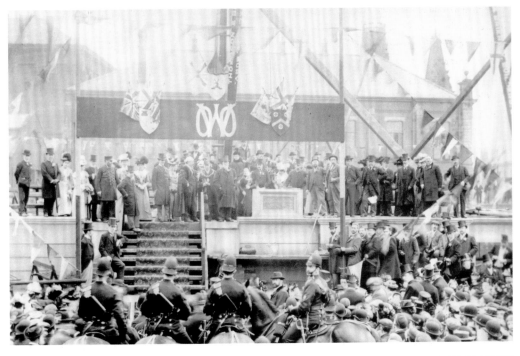

FOUNDATION STONE LAYING, BURY ART GALLERY

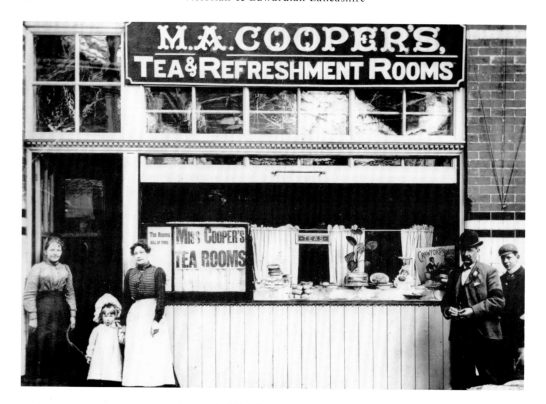

MISS COOPER'S REFRESHMENT ROOMS, BURY MARKET

seen quite well-known actresses eating Bury puddings at the outdoor stall which has stood for so many years outside the local theatre. Many of these puddings are packed to send abroad, and plenty of them used to reach the China station.

The 'knob' simnel is a very different matter, and nobody seems to know properly how it came into being. It is eaten on mid-Lent Sunday, and sent to relatives about that time. Formerly it was served in the town accompanied by 'mulled' ale. This was a potent combination of eggs, ale, and spices, heated on the fire in a cone-shaped pan which was thrust amongst the cinders. People came into Bury in waggonettes from surrounding towns, and the whole thing became such a debauch that the local Rector preached a sermon denouncing the festival, and it was stopped by the police. Now, with perfect propriety, we just nibble the knobs off the simnel.

When I was young almost every cottage had a bread 'flack' above the fireplace. This was a kind of rack made of laths and strings, though those who could afford it often had a more substantial contraption. This was used for a double purpose, to air the clothes after washing, and to dry oatcakes of which Lancashire people were very fond at that time. Hawkers came round with them, and also crumpets and 'blackstone' muffins, all of which seem to be disappearing. Oatcakes were good eating with Lancashire cheese, and they were very cheap and nutritious.

Bolton is famous for eating trotters, but is very touchy about being told so, so we won't harp upon it, especially as I fancy the love of tripe and trotters in Bolton is dying out with the spread of higher education. In my younger days they used to eat tripe from a skewer in Bolton. The tripe was cut in small pieces, like cat's-meat in London, and threaded on a skewer. You took your fiancée into the shop and ate your tripe from the skewer, leaving one arm unoccupied. Now, I think, they don't do this any more, which is a pity. I do not like to see these folk customs dying out.

T. Thompson

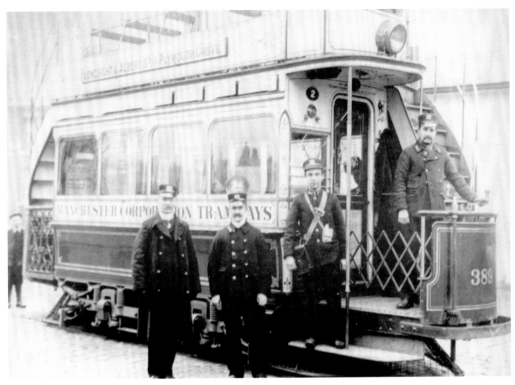

MANCHESTER TRAM, LONGSIGHT TO PLYMOUTH GROVE

TRAM RIDE TO OLDHAM

For the purposes of our further survey several lines of railway are available, but for the present we will dispense with them, and though, in the circumstances, it may seem a singular form of travelling, we will betake ourselves to the road, for in no other way can you realise so fully the almost unbroken continuity of Lancashire industrial life over very wide areas. From Cottonopolis, as from Rome, many roads do radiate, which, by main arterial channels or subsidiary branchings and ramifications, will lead you to the principal towns, to outlying villages and hamlets where industrial life prevails, or to the remotest factory in the remotest part of the county. The highway upon which we set out is the one which leads to Oldham, six miles distant, and our point of departure is Piccadilly, where we take our places upon a tram car, one of a vast number, local and suburban, traversing the numerous converging lines of that broad and busy thoroughfare. When at New Cross we emerge from Oldham Street we find ourselves in a much broader road, and get views of Ancoats, where is a dense population, and some of the earliest and largest cotton spinning mills in the county. So do we travel to Miles Platting, and thence to Newton Heath, and all the way we have a road lined with brick buildings, among which the dwellings of the workpeople preponderate. Behind these, on either side, the country is being stripped of its greenness, pierced as it is by colliery shafts, and dotted over with mills and work-shops, those of a vast railway depot being of the largest.

At Newton Heath we change into another car, and passing from the city's boundary, proceed on an ascending highway, and still between continuous lines of buildings, until we come to Failsworth, which may be taken to mark the limit in this direction of the Manchester district of manufactures. The road along which we are travelling is one which has been trod by generations of handloom weavers, who used to carry their pieces to town and take back yarn for the next weaving. At Hollinwood, further on, we are in the Oldham district, and here the mills assert themselves very prominently, with large storages of water. At Werneth, on the hill slope, there are residences of the millowners and machine makers, the mansions standing within walled and park-like spaces, with gardens about them and goodly growth of trees, in which the rooks still build. From our car we descend in a busy main thoroughfare which runs right through the town Yorkshire way.

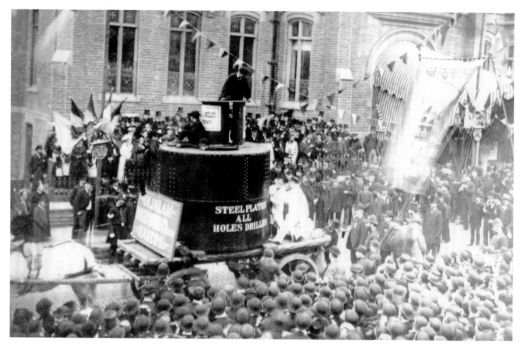

OPENING OLDHAM CENTRAL LIBRARY

Oldham, as we have already seen, owes its present magnitude to the factory system, of which it is a remarkable outcome. The hill upon which it is built is belted and crowned with mills and weaving sheds. There will they spin for you yarns for fishing nets or fustians, sail cloths or satteens, the produce of their looms being of a very varied kind, including twills, angolas, water-twist and double warp sheetings and shirtings, jeanettes, mexicans, zephyrs, velvets, velveteens and cords. Here, too, they will make for you engines, boilers, and textile machinery, some of the largest foundries and machine works in the county having their location in Oldham, among them being the great works known as Platt's, where they employ upwards of nine thousand workpeople. A walk round and about this hill, capped with its cloud of smoke, will impress you with a sense of the vigorous productive agencies with which it is crowded, and if you do not find the aspect lovely, you must certainly confess that it is lively. On the face of it you would not suppose that Oldham is a place where the fine arts would find encouraging surroundings, and yet it is not undistinguished in that direction, as some of the works of its native artists bear witness.

The manufacturing towns and villages of Lancashire have their annual holidays, or celebrations, known as wakes, and which are of varied terms of duration. The custom has a religious origin, and is referable to the building and dedication of the parish church. In its observance of this wakes custom Oldham occupies a conspicuous place. Once a year the lnills and work-shops are closed for a week, and the workers betake themselves to various forms of holiday enjoyment at home or abroad. For the

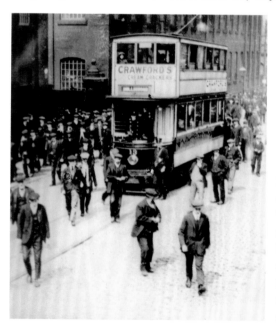

DINNER TIME, PLATT BROS, OLDHAM expenses of this great festival, during the rest of

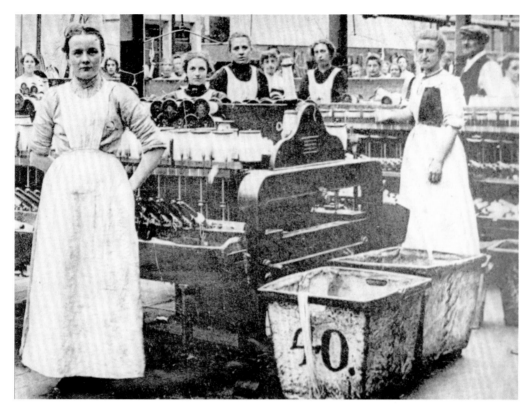

SPINNING SHED, LEIGH

the year they save money, depositing it in clubs, which are held in schools, chapels, institutes, mills, and public houses. When the season arrives these savings are withdrawn, the amount repaid in 1896 being estimated at no less than one hundred and sixty thousand pounds, of which sum it is supposed that seventy-five per cent. would be spent out of the town in excursions to places near or remote.

John Mortimer

MAYOR OF THE GROUSE MOORS

In Todmorden they are busily engaged in many ways with machinery, not only using it, but making it on a large scale; but it is with the spindle and the loom as productive agents that they are most actively employed, cotton being the sole medium of manufacture. There are upwards of forty firms there using unitedly considerably more than a quarter of a million spindles and nearly sixteen thousand looms. The fabrics they produce are recognisable in part under the names of twill sheetings, grandrills, oxfords, zephyrs, domestics, mexicans, regattas, and long-cloths. Near by they have the largest bobbin works in England. Besides cotton mills and foundries they have corn mills, size works, three coal mines, five chemical manufactories, three lime kilns, and a number of stone quarries, a very fair catalogue, and yet not exhaustive of their industries. It is a place, too, where they will point out to the stranger very substantial memorials in the form of public gifts—the Town Hall, for instance, among others—the outcome of the wealth accumulated by some of the millowners, and it is significant that the only public statue in town was erected to one of these manufacturers in grateful recognition of services rendered to the workpeople in the regulation of their hours of labour. During the past year the town received its charter of incorporation, and the people rejoiced thereat with much processioning and festivity, for when they had sought this privilege in years gone by it had been said in opposition that 'it was unusual to have a mayor and corporation for a town which consisted chiefly of grouse moors.' It was shown, however, that there is a population in the borough estimated at twenty-five thousand persons.

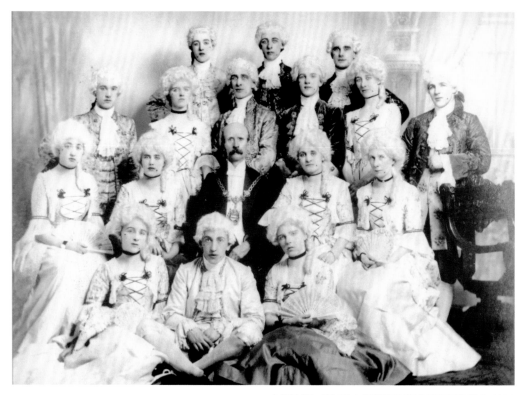

MAYOR OF BLACKBURN'S RECEPTION, 1911

Todmorden, like other towns we have become acquainted with, has within view of it a 'Pike,' known as Stoodley, overlooking the vale from a height three miles away. There, at the close of the Napoleonic wars in 1815, they erected a tall tower to commemorate the event, but it was a curious coincidence that on the day when war was declared with Russia the structure came crumbling to the ground. When peace was restored again in 1856 they restored the pike, building it up to a height of one hundred and twenty feet, and there it stands to-day as a witness of the event.

John Mortimer

COMPLAINTS AT THE CO-OP

The year 1880 seems to have witnessed a lot of trouble with the various contractors occupied in the extensive building operations, and we find numerous resolutions threatening them that if a certain work is not completed by a given date, the Committee will take the job in hand, complete it, and debit the contractor's account with the cost thereof.

A curious resolution on March 5th reads, 'That Mr Worsley's application be allowed on condition that he tells nothing that will cause annoyance to his neighbour.' Evidently the Committee had faith in a man's word in those days.

Apparently the Committee occasionally had a class of members to deal with such as exist today, viz., those who pick out one or two certain commodities, and, after comparing them with somewhat similar articles supplied by outside shops, complain of the price at the stores, for we notice the Committee stating, on March 19th, 'That, in consequence of complaints being made about the high prices charged for our goods generally, we have purchased a large number of samples from some of the leading grocers in the neighbourhood, and we find that ours compare very favourably with the best.' However, this does not satisfy the grumblers, for at the quarterly meeting following, on April 1st, we find a resolution 'That a special committee of twelve be appointed

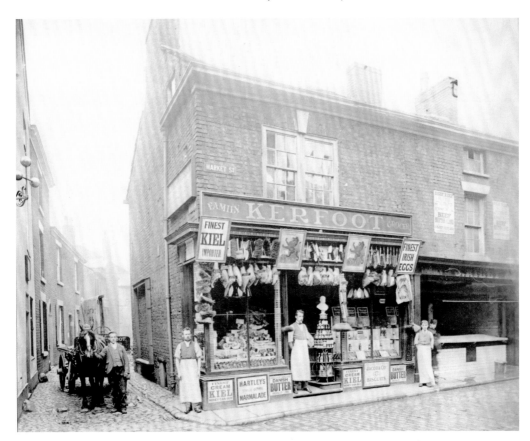

MARKET STREET, LEIGH

to investigate prices charged, and report to a future meeting.' But, look how we may, we cannot turn up any record of what this special committee did, nor even of whom it was composed, and we may therefore assume that if they did make any investigation at all, it would probably be found the Committee were in the right.

Radcliffe and Pilkington Co-op Jubilee Souvenir, 1910

BLACKBURN'S SOCCER RIOT

An extraordinary scene was witnessed at Ewood Park, Blackburn, on Christmas Day. The Rovers and Darwen, between whom great rivalry exists, were announced to meet, and 2,000 or 3,000 persons journeyed from Darwen to witness the encounter.

Seeing that the ground was covered with ice, the Rovers deputed their second eleven to face the visitors, whereupon the spectators (the admission being 6d.) demanded that the match should be played as advertised.

The Darwen second team were going on the field, but the spectators rushed at and pushed the players back into the pavilion. Then ensued a scene of the greatest excitement. The crowd's

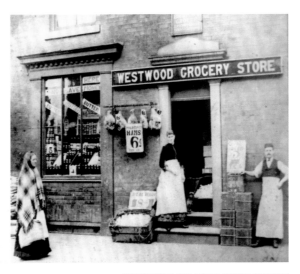

WESTWOOD GROCERY STORE

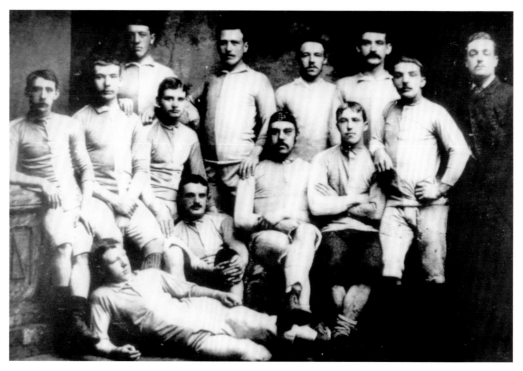

BLACKBURN ROVERS, 1882

demand for the advertised match to be played not being complied with, they pulled up the goal posts, lowered the flag to half-mast and tore the carpets off the reserved seats in the stand.

One of the windows of the dressing tent was broken, and one of the committee was attacked, while another official had a narrow escape. It was considerably after 5 o'clock before the field was cleared, although it was announced that tickets would be issued for another match.

Burnley Express and Clitheroe Division Advertiser, December 1890

SHRIMP BOATS AT BANKS

Just before commencing the tackling apprenticeship, I commenced to do a fair amount of walking, and one of my first long walks was from Tottington to Southport. My companion, W Kershaw, and I decided to walk there. I told my parents what I wished to do, and they promised to take me if they had the money, so my companion and I made up our minds one holiday week-end that we would walk to Southport. I had only half-a-crown, and my companion, like myself, hadn't much more. My mother asked me to take another half-a-crown off the cupboard, which I think may have been the rent! I took it, but intended to bring it back.

My friend and I set out early on the Saturday morning with plenty of food our mothers had baked the day before. We made for Chorley, then Rufford, calling at farms on the way. The farmers were very good to us, giving us skimmed milk and buttermilk. It was very nice roaming among the wheat, oats, and barley, and other things on the way. We arrived at Southport about 7.30 p.m., and then looked out for lodgings, which we got at the very modest sum of 6d. each. After a good night's rest and a bit of refreshment, we soon made for the coast. At that time there was no lake as we know it to-day, and Southport was more like a village; and the sea came up to the shore and right up to the banks. In those days the ships came up to Banks, chiefly with shrimps. We had a chat with a fisherman who owned a boat, and he said he would take us for a sail for 6d. each.

Homeward bound, we tramped along the country lanes in the Fylde district, with the birds, sheep, and cattle and many other interesting things on the way, which made life happy as we jogged along. As we wended our way homeward we saw a Public House called Sea View, and with the sun setting as we were walking under

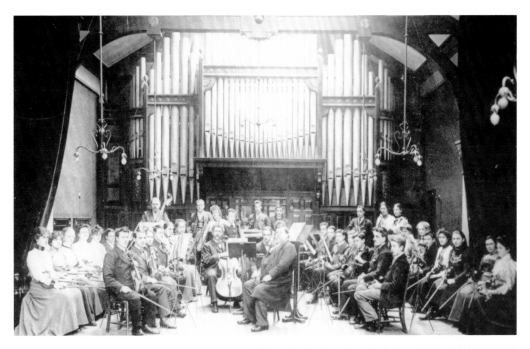

MANCHESTER COLLEGE OF MUSIC ORCHESTRA

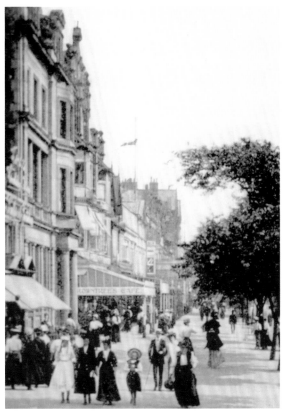

SHOPPING IN SOUTHPORT

Rivington Pike, we could see the lovely sunset miles away. On arriving home I gave my mother her half-crown back!

Ralph Rooney

GENIUS OF MUSICAL MANCHESTER

In 1857 Manchester held an Arts Treasures Exhibition; music was called in less for its own sake than as a celebration of the arts generally, and in honour of a Royal visit. The conductor of the music at this exhibition was none other than Charles Hallé, who arrived in Manchester, out of work from Paris, where in 1848 the Revolution had caused a slump in music. The orchestra and chorus formed for the exhibition were not disbanded; they were kept together for the inauguration, in the following year, of the Hallé concerts.

Until his death, some thirty-seven years later, Charles Hallé was the informing genius of 'musical Manchester'. His influence spread to all parts of the north of England. The orchestra bearing his name, and conducted by himself, became a national institution. He founded the Royal Manchester College of Music; better still, he gave birth to that tradition of culture

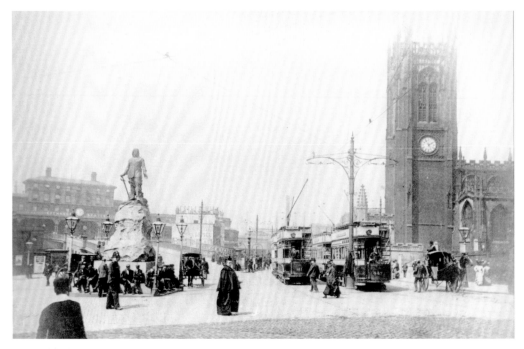

CROMWELL'S STATUE AND MANCHESTER CATHEDRAL

in music which, to this day, continues to attract to the City the best brains in the art. But, in this our post-War period, we may well pause to ask a question: were a Charles Hallé to appear in Manchester now, or a Hans Richter, would Manchester not turn patriotically aside from them and decline their gifts? Hallé, Richter, Brodsky, Hecht, Speelmann, Willy Hess, de Jong, Carl Fuchs, Max Mayer, Isidor Cohn, Bauerkeller—all of these names (I give them with the saving clause 'E. and O.E.') stand for the first pillars of the City's edifice of music. None of them is a name racy of Lancashire soil, but the county grew to know and honour them all. It was an age which actually believed in Free Trade in the arts as well as in the market-place. A chancy thing, indeed, was the building up of Manchester's musical reputation.

Under the rule of Richter the Hallé concerts became stamped through and through with the classical symphonic mark; not only did they command the support of musicians, but also, the unmusical were obliged week by week to attend the Free Trade Hall, using the arts, like the Pole ladies in 'Sandra Belloni', as a means to scale society. Every Thursday evening, from October to March, Peter Street was beautiful with the polished magnificence of carriages—required at 9.45. From the rear of the great hall, the democracy could get a fair view of Richter's portentous back. By paying a shilling, the democracy had the privilege of standing on what was then known as the 'Grid'; it was a heating arrangement, but when the democracy found itself on the point of a heavy sweat, there came with the opening of doors behind them, a cool wind full of the refreshing East. Under Richter, the Hallé orchestra did not need to advertise itself as the 'famous' Hallé orchestra; the prestige of the band was taken for granted everywhere. In those years it was possible for a Manchester man, when travelling to Vienna on the Orient Express, to walk down the corridor of the train (just before the approach to the Arlberg Tunnel), and there it was possible, I say, for him to get into conversation with celebrated men who knew Mahler. And they would more often than not tell him, on hearing that he came from Manchester, that they knew the City not on the strength of its Ship Canal, its Royal Exchange, or even its county cricket ground, but solely by reason of the renown of the Hallé orchestra. Merely to look at Richter was to travel half-way to a proper understanding of what is meant by a symphonic culture in music. He was very much himself a symphony of a man—firmly balanced, diverse but not discursive, strong yet with some warmth of human sweetness coming out of his strength.

Manchester, when Richter lived in it, knew the Schiller Club and the German Restaurant in the Midland Hotel. It knew little about French music, for Richter declared there was no French music—and Debussy then in his prime!

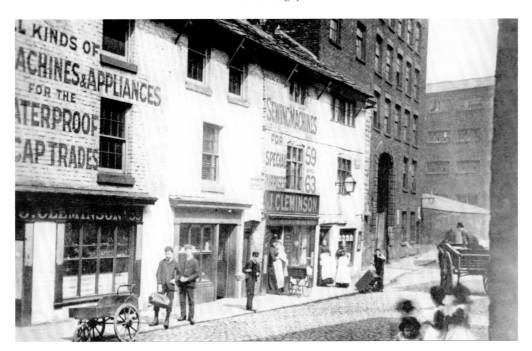

LONG MILLGATE, MANCHESTER

But Richter was capable of superb magnanimities; he introduced Manchester to the works of Richard Strauss when Strauss was generally supposed to be the Mad Mullah of music. Richter did not like Strauss's music overmuch himself, none the less he conducted the symphonic poems with genius; he did not inform the Manchester public that they could take it from him that the works were not worthy of their attention. The Harrison concerts at this date performed their useful services, though they were not a little provincial in character, and in the sort of dress clothes worn at them. And, of course, the Brand Lee concerts were always part of the musical soul of Manchester; they were founded by a man of rich Northern humour and shrewdness who knew a Kreisler when he heard one, never mind the expense. When the War came, crisis descended on musical Manchester. The Germans were driven underground, and the fate of the Hallé concerts hung in a terrible balance.

W. H. Brindley

MONKEYS AND BULLDOGS

The common speech of the various localities differs almost as widely as physique and temperament. The Rachda felly speaks very differently from the Blackburnian, and the Wiganer from the Owdham chap. As a commentary upon these variations, and also in view of the remark already made as to the haziness of the Southerner's geographical knowledge, the following some time ago appeared in the *Pall Mall Gazette*:—In last Saturday's 'Black and White', remarks a correspondent, it is noted that 'The Oldham banks paid £150,000 to the "goingaway clubs" last week, the result being that the Isle of Man is alive with Midlanders.' 'If "Black and White",' he says, 'ventures to claim Oldhall as a "Midland" town it will have to reckon with the irate Oldhamers (who, by the way, wear metal-tipped clogs with hard wood soles and rigid toes). Oldham is the most characteristic of Lancashire towns; in it, more than any other, lingers the musical dialect which charms us in the works of "Tim Bobbin", Ben Brierley, and Edwin Waugh.'

 With the remonstrance one was, of course, in agreement, but in a contribution to the *Pall Mall Gazette* the present writer pointed out that there are many variations in the Lancashire dialect, and that a student of 'Lanky', or what the people in Tim Bobbin's district call 'Tummas and Mary', would hold that the lingo spoken by the 'Owdham Roughyed' is not nearly so characteristic of the county as that used by either the Rachda Bulldog', the 'Yewood Monkey', the 'Middleton Moonraker', or even the 'Bowton Trotter'. Continuing, the present writer

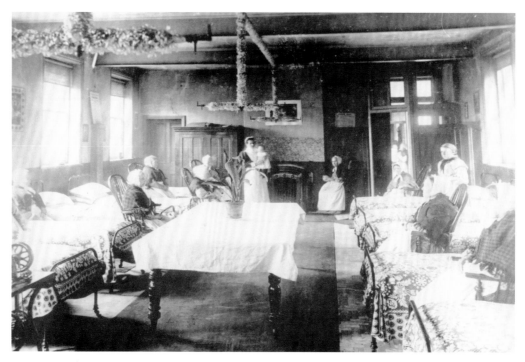

OLDHAM WORKHOUSE

said:—'As to the alleged music of the Owdham dialect, there, again, I join issue, as the sample has been too long in the smoke of factory chimneys and too little influenced by the richness and quaintness of the countryside to retain much of the charm it once possessed. Your correspondent would not find much of the "I winno, I shanno, I canno, and I munno", which is a typical Oldham variation, in the works of either "Tim Bobbin", Ben Brierley, or Edwin Waugh. Tim's writing is too archaic to be a criterion nowadays, and Ben Brierley's Boggart-Ho' Clough talk is of a stamp different altogether from that spoken at Mumps.'

Frank Ormerod

THE PETTING OF THE POOR

What is a Workhouse? Any man out of the first hundred or thousand you meet in the street would in all probability smile at your simplicy in asking the question, and tell you that everybody knew what a Workhouse was; but probably not one out of the thousand, unless he might perchance be an intelligent and disagreeable member of a House Committee, could in any way satisfactorily answer your inquiry. Is it a place of dire affliction, where people vegetate in a state of semi-starvation under the iron rule of cruel and hard-hearted officials? Is it a place of sybaritic ease and epicurean delights? Or may it be a harbour of refuge from the storms and tempests of a worrying and unappreciative world, where quiet and repose and the continual practice of contemplative philosophy are regarded as the chief good? Taken from the differing points of view in the inmates, the guardians, and the ignorant philanthropists, it may be said to have a touch of all these. Now-a-days, when the petting of the poor is reduced to a delightful science by fine ladies and gentlemen, the 'House' is not seldom a palace in outward appearance, while its interior conveniences are greater than those of many middle-class dwellings. As a house of work it is not much relished by the able-bodied pauper, who has too often become what he is through sheer laziness, and who looks upon the officials as being merely flinty tyrants; but the aged and infirm delight in pottering about and making believe very much. The contemplationists would appear mostly to limit their reveries to the possibilities of odd extras in the shape of tea and tobacco. Each great Workhouse is under the somewhat autocratic rule of a viceroy or master, and a (what is the feminine of viceroy?) matron, who are directly responsible to their House of Commons, the Board of Guardians, who again have to account

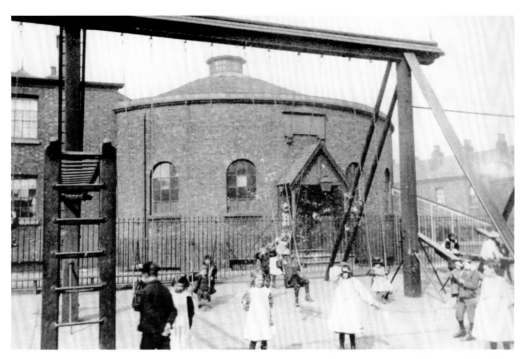

ROUND CHAPEL, ANCOATS, MANCHESTER

to that absolute monarch the ratepayer, who, as is usual with sovereigns, knows little or nothing of the people under his governance.

The building we are visiting at the present time has little of the palace about it, and is an old-fashioned sort of place. It recalls Popes 'mighty maze', but, unlike his, this appears to have been constructed without a plan—in fact, as the courteous master apologetically explains, it must have been 'taken in in numbers' and never properly bound up. Nevertheless it is roomy, commodious, and provided with all necessary appliances and comforts. Upon our arrival we are fortunate in being able to witness a somewhat rare mustering of the forces—a kind of roll-call for purposes of classification. Of course the inmates are at all times strictly registered and classified; but now and again they are all mustered and passed in review, one by one, to facilitate the checking of the register and enable necessary corrections to be made. They are all, setting aside children, sick, and inmates of the lying-in wards, divided into groups known respectively as aged and infirm, temporarily disabled, and able-bodied. All are assembled in the immense dining-hall, an exceedingly large, light room, with its lofty ceiling supported by a host of iron pillars, and its floor occupied by numberless long, narrow, deal tables and forms of spotless cleanliness. Beyond whitewash and well-kept paint there is no decoration, if we except a tremendously aesthetic dado running round the walls. Throughout its entire length runs a low partition dividing the women from the men, between whom no communication is permitted—if the authorities can

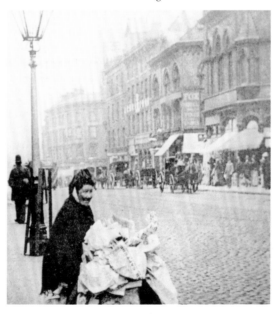

OLD MARY THE PAPER WOMAN,
VICTORIA STREET, MANCHESTER

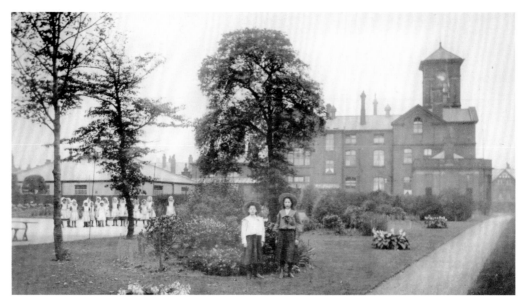

CHADWICK'S ORPHANAGE, BOLTON

prevent it. The women are uniformly dressed in a striped-blue stuff, with white apron, white cap, and grey plaid shawl. The cap of the old women is in the good old night-cap form, but that of the younger people is a little apology, coquettishly perched on the back of the head, with long loose strings crimped and brought together in front. The dress of the men is rougher looking, and more varied by the nature of their occupations.

'Silence!' shouts the Master, speaking in sharp, peremptory tones. 'Now, old women, come forward, one at a time, and tell me your age. What's your age, Jane?' 'Seventy-eight, sir.' 'Yours?' 'Sixty-one.' Then seventy-two, over seventy, and so on. One says she is sixty next July. 'Stand aside here, you are not an old woman.' Neither does she look very old. Another is over eighty; but she is still fairly hale and active-looking. Here is a bright-eyed, wiry-looking, diminutive old lady, who, when asked, says she does not know. 'Not know how old you are?' 'No, sir. My father and mother died when I was very little, and I never knew how old I was: 'I suppose you are over fourteen?' Smiles and thinks she is. 'Over forty?' 'I really don't know.' Doubtless she is over sixty. We should explain that while under sixty, both men and women (barring any special infirmity) are classed as able-bodied; but, for the matter of that, they pretty well all looked able enough. We never before saw a muster of such healthy-looking, active, and cheerful old women. Nothing during our visit struck us more forcibly than the difference in manner between the men and women as a whole during this march past. Cheerful men there were undoubtedly; but for the most part they wore an air of dull stolidity, which did not exactly degenerate into sullenness, but rather carried with it an expression of resentfulness of the position in which they were placed. The women, on the other hand, were quite the reverse. Cheerful looks were the rule, and very few wore an air of discontent. Possibly they have less to think about, less on their minds; and no doubt but they find some consolation in their petty household occupations, to say nothing of the satisfaction to be derived from their pretty caps and exceeding neatness of attire. There were two or three very bad faces among the men, but these belonged to hopelessly bad subjects—gaol-birds—fellows who divided their time pretty equally between the prison and the workhouse.

The cases of temporary disablement are not very numerous, and arise mostly from injuries to the hands or legs, the latter predominating among the men. All serious cases are sent to the infirmary. There are many very aged men; but, like the women, they are rarely decrepit, and bear their ages wonderfully well.

We must say a little more on the classification of inmates before leaving this part of the subject. When admitted, all are inspected, registered, their occupations ascertained, and their different wards assigned. They then have to bathe, their own clothes are disinfected, wrapped in separate bundles, and ticketed against the time of their discharge. The doctor sends all sick to the infirmary, and all children are sent into a probationary ward for a fortnight. The sexes are kept. strictly apart, except in the case of infants and a few very aged married couples, for whom special

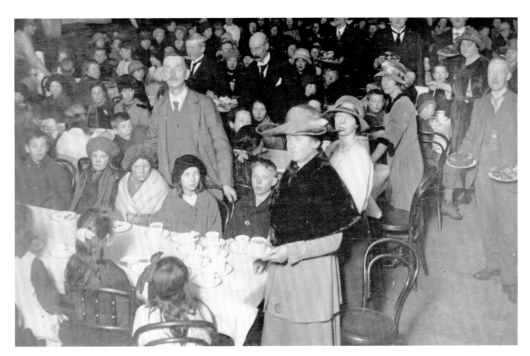

MASONIC TREAT FOR LEIGH POOR CHILDREN

accommodation is provided. Infants under two years remain with the mothers, but from that age are sent into the infant schools, and are seen by the mothers only once a month, a kind of hardship of which we fail to quite comprehend the necessity. If the women are strong and able to work during the two years referred to, each baby has assigned to it during the working hours an old woman as nurse, whose sole duty is to look after its welfare.

Let us now walk round the different wards, schools, and dormitories, first of all looking after the children. Here is the ward of those babies who are attended to by the old women, and excellently well cared for they all are. Some being lovingly nursed, some fast asleep in little cribs, and others just able to toddle, making wobbling and apparently aimless excursions from one part to the other of their little world; the fresh, bright, little faces of all offering a strong contrast to the lined and weather-worn countenances of their old nurses. Next into the infant school.

Bless the little children! How well and happy they look, despite their pretence of laborious learning, and it does one good to hear their joyous shout of 'Good morning, master!' 'Good morning, matron!' and to see them with their laughing faces come clustering round to be noticed and spoken to, and have their cheeks patted and be generally fussed with. It speaks volumes for the kindness of heart of these dread officials to see the entire absence of constraint or fear on the part of the little people. They have no dread of those policemen it is quite evident.

The boys and girls have separate schoolrooms, large, well lighted, airy, and well provided with all requisites. Whilst in their wards, we must not omit to notice the capital lavatory arrangements. Each boy and girl has a separate towel, ticketed and numbered—a clean one every morning—and in each ward there is an excellent plunge bath, which affords great delectation to the youngsters, and adds greatly to their healthiness. Some of the boys learn tailoring, others shoemaking, and the mending of the clothes and shoes is done in their shops. Other trades are carried on in different parts of the building. There are machine shops, where many kinds of things are being forged for home use; carpentering, where drawers, shelves, &c., are made; a flour mill, where is dressed the flour ground by the tramps in the casual ward; great wood sheds, where firewood is chopped not only for use in the Workhouse, but also for sale outside; brush and mat-making rooms, paint shops, and various others.

The dormitories are all alike in plan and arrangement. Long rows of iron bedsteads, each well furnished with a good flock bed, warm bedclothes, and counterpane, all, together with the walls and floors—of the most scrupulous cleanness. Indeed it would require a microscopic eye to detect a particle of dust or dirt anywhere. The men make their own beds and keep their own wards clean; women the same. There are distinct wards for

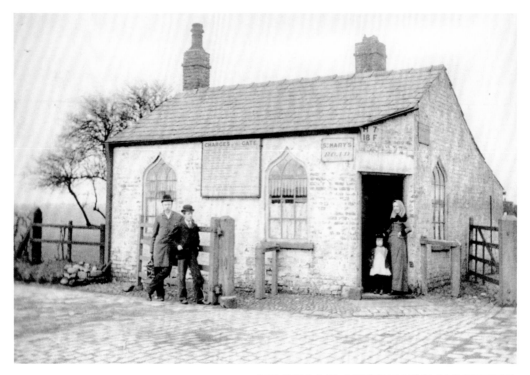

OLD TOLL BAR, MOSTON LANE, MANCHESTER

the aged and infirm, and some little extra provision is made for their comfort. The infants' beds are much the same as the others, only lower, and with some additional security against falling out affixed. A grown-up female attendant sleeps in each of their rooms to look after them in case of need.

The dietary table is prescribed by law, from which no deviation of any importance is permitted, and it is on a very liberal scale—indeed almost too liberal for the weak and aged, many of whom find it physically impossible to eat the allowance which must be given them whether they will or no. For breakfast each able-bodied inmate must have seven ounces of bread and 1½ pints of milk pottage. Three days a week each one has four ounces of cooked meat and one pound of vegetables for dinner. Some days, for supper, seven ounces of bread, one pint of tea and two ounces of cheese. Other days other things. The infirm and aged are treated much the same, except that for breakfast and supper they have less bread. The children are fed according to their ages. To-day the general dinner is suet-pudding and treacle, and each man, young or old, is expected to eat sixteen ounces of pudding and two of treacle; each woman fourteen ounces with the treacle! We never saw so much suet-pudding in our lives before, roll after roll, roll after roll, until it seemed as if we should never want to see suet-pudding again. These enormous lumps seemed to go sadly against the grain with many of the very old people, who would have preferred half the quantity of something better fitted to their needs.

The tramp-wards are very different now from those of the days when Casual Greenwood made his famous sensation. The 'professional' has not a very enviable time of it even now. As he enters he is registered and ordered to bathe—not in the general pea-soup bath of the amateur casual's description, but each man separately—then is given a warm clean night-shirt and rug to sleep in, is supplied with half-a-pound of bread and a basin of water, and shut up in a separate cell for the night, where he remains all the next day and the second night, without any opportunity of speaking a word to anyone except the officials in charge.

In the morning he receives similar provision for breakfast, eight ounces of bread and 1½ ounces of cheese for dinner, and is compelled to grind 100 lbs of wheat. The only change is on Mondays, when he gets broth. The women have to pick oakum, and they and the children get gruel night and morning. Inside each cell is a plank like an ironing-board, turned up against the wall by day, and let down upon two iron legs at night—this is the bed. There is also an iron handle or crank which he has to turn until his allotted grinding is done; and a bell for

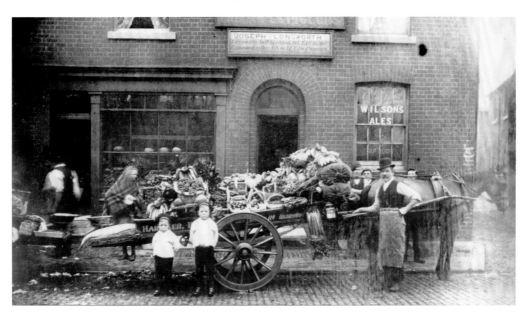

VEGETABLE CART, IRLAMS O' TH' HEIGHT

use in case of sudden illness. Altogether the tramp's lot is not a particularly rosy one at present,—and the effect of these new 'solitary' arrangements is that whereas some time ago, under the old regulations, the average was about 400 per week, we are now patronised by only about eighty.

In concluding our notice, we should like to ask why the notion of going into the 'House' is recoiled from with such unconquerable disgust by the majority of honest elderly people,—workmen or small tradesmen, who, after a conscientious life of upright work, have failed to make any provision for old age? Most of us have paid over and over again in poor-rates for any such care and help as we should receive there; and why, therefore, should not this help be looked upon as an earned right, rather than as a degrading charity? We cannot now discuss the question; but doubtless ignorance has much to do with the feeling. Few outsiders know to what an extent the old cruelties of the 'Poorhouse' have been eliminated, the cruelties of the days when the iron was made to enter with a vengeance into the soul of the pauper; and poverty, by whatever cause produced, was looked upon as a crime to be stamped out by any means available. The workhouse is now too comfortable for the lazy 'ablebodied' who will not work outside; but much might be done even yet to ameliorate the lot of those who are compelled, through no fault of their own, to spend the remainder of their lives within its walls. The separation of fairly elderly married people deserves reconsideration. The horrible sameness and monotony of the life might be relieved without extra cost; and the inelastic character of the dietary regulations might be modified with a positive advantage to the ratepayer, it being the cause of great and unavoidable waste. Much has been done, but much still remains to be accomplished.

Walter Tomlinson

QUICK-WITTED CARTERS

Speaking of a hard master and his methods, a Lancashire man once said to the writer, 'Well, I will say this for him. When he promises a chap a day's work, he keeps his promise!'

The story is told in the same district of a similar kind of master who was one day engaging a new carter. 'Have you got your character with you?' he asked of the applicant. 'Nowe; but I con soon get one,' replied the carter, and it was arranged that the two should have an interview later. Meeting the carter by chance an hour or two afterwards, the master said, 'Well, did you get your character?' 'Nowe,' replied the man, 'but I've getten thine, an' I'm noane comin':

It was a carter who was said to have made an effective retort to a lady who had been holding forth on the

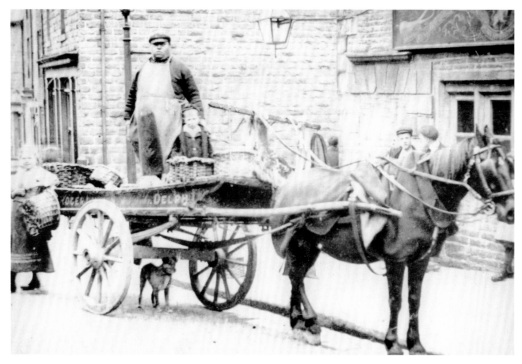

GROCER'S CART, DELPH

cruelty of putting a check rein on his horse. 'Bless yo're heart,' said the man, 'he doesn't mind a check rein, but he'd kick the cart to blazes if I wur to put him i' corsets.'

The stories of carters who are a very humorous and quickwitted class, are legion. Mr Newbiggin tells a story of a little hunchback who once asked for a job as a carter. 'Why, the horse would tread on you,' said the employer. 'Would he, though!' exclaimed the little man. 'He'd ha' to get into t' cart fust!'

The story is mentioned more particularly to draw attention to a curious difference one finds between carters in the North and those in the South. It is clear the employer mentioned hardly calculated upon a carter riding. It is not

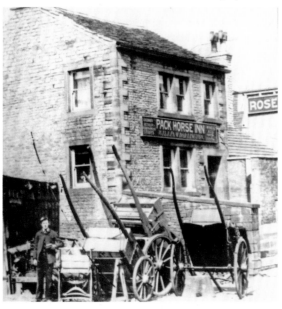

once in a thousand times that a Lancashire carter will be found riding upon his laden cart—he will, of course, ride when the cart is empty—but in London and Southern places generally he will ride whatever he may be laden with. In order to do so, he will adopt all kinds of extraordinary contrivances, evidently not at all relishing the idea of trudging along by the side of his horse's head.

Many tales are still told in the Rochdale district of a man named Fletcher, nicknamed 'Towzer', who was a notorious successor of Jehu, the son of Nimshi. Once when carting stone from one of the moorland quarries, he incited a number of others to join him in a race with their laden carts down a steep part of the hill into the village below. It was only when the race had started that the danger of the foolhardy trick was fully recognised, and one or two of the

PACK HORSE INN, DELPH carters began to repent of their mad frolic. 'Eh!'

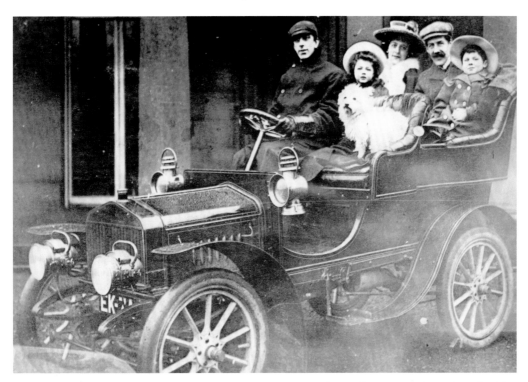

LORD CRAWFORD AND FAMILY, HAIGH HALL, WIGAN

exclaimed one of the timid ones, 'they'll o' be kilt, they'll o' be kilt!' referring, of course, to the plunging and stumbling animals in the shafts. 'Howd thi din!' said the imperturbable Jack Towzer, 'if there's one wick when we getten to't bottom tha's have it!'

After Jack had got on in the world, he drove a gig instead of a cart, but his fondness for going the pace never abated. One night, coming along the Manchester Road, a companion sitting by his side grew terribly alarmed at the reckless way the high-spirited horse was being driven. He several times appealed to the harum-scarum driver to slacken speed, but Jack, in one of his wildest moods, only urged on his horse the more. 'I'd give five pound if I wur just out of here,' said the passenger, now thoroughly frightened. 'Howd thi—noise,' said Jack, 'tha'll be out for naught in a minute.' And sure enough, they had not gone much farther before horse and vehicle collided with the hedge, and both men were flung into the ditch.

Naturally such a driver often fell foul of the police, but Jack never refused to pay for his little escapades. On the day for hearing his summons, he would walk into the police court and, without waiting for his case to be called, step up to the solicitors' table and face the magistrates. 'What have I to pay?' he would ask, thrusting his hand into the pocket of his riding breeches. 'But we have not yet heard your case, Mr Fletcher,' the presiding magistrate would remark. 'Well, never mind that. Tell me what I have to pay, I'm in a hurry.' And the magistrates, to oblige him, would call on his case, a policeman would step forward and state that he had seen the defendant somewhere or other driving furiously and to the common danger, and Jack, without troubling to ask questions, would pay the fine and walk out.

Frank Ormerod

DAY OUT FROM THE WORKHOUSE

For the first time on record the inmates of the Saddleworth Union have been entertained at a garden party, and the interesting event, which took place on Monday afternoon, was greatly appreciated by the guests. Mr and Mrs Bagnall, of Hawthorpe Hall, extended their hospitality to the unfortunate people at the House, and with the exception of a few who were too feeble to be moved, but who were not forgotten, all the inmates took part. The

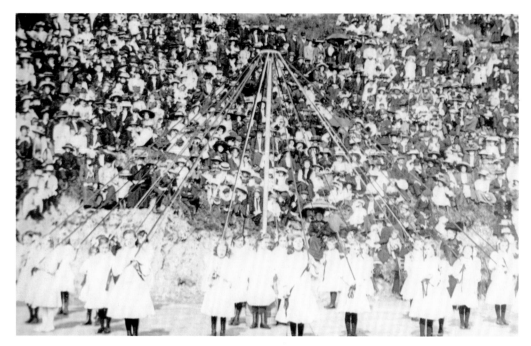

MAYPOLE, SNIPE CLOUGH

decorations which had been specially prepared for the monster party on Saturday were still hanging, and were greatly admired by the visitors, who arrived before three o'clock. Many of the inmates were too infirm to walk from the House to Hawthorpe Hall, and they were conveyed in Mr Bagnall's handsome motor car. Among those who attended the party were Mr W. Ripley, CC (Chairman of the Guardians), Mrs Rhodes (Guardian), Mr and Mrs Dewhurst (Master and Matron), Nurse Dawson, Mr and Mrs Riding (Labour Master and Mistress), and Mr G. Gartside (Farm Bailiff). A substantial tea was provided in one of the large marquees, to which the old people did full justice. A concert afterwards took place in the grounds. Mr Julius Heap played numerous pianoforte selections; Miss Lizzie Bradbury gave a capital rendering of 'Out on the Deep', and Miss Nellie Bradbury sang 'Lancashire Lassie' in a manner which pleased her audience immensely; the 'Deathless Army' was ably rendered by Mr T.E. Sykes. All the inmates were conveyed back to the workhouse by motor car, a mode of locomotion which they seemed to greatly appreciate. Quite a lot of good things were sent to those who had not been able to be present.

Saddleworth and Mossley Herald, August 1908

WELCOME TO HAWTHORPE

One of the finest and largest garden parties ever seen in Saddleworth was held on Saturday in the spacious grounds of Hawthorpe Hall and Fernthorpe, Uppermill, when Mr W G. Bagnall, JP and Mrs Bagnall entertained over sixteen hundred guests. The day proved an ideal one for an alfresco event, and the grounds were thronged during the afternoon and evening with delighted groups, who perambulated and listened to the bands, gramophone, Punch and Judy show, and other attractions. In organising the event Mr and Mrs Bagnall left no stone unturned in a desire to make it worthy of the occasion. The comfort of the guests was well attended to, and there was not a dull moment during the day. The host and hostess received the guests at the lower end of the grounds, with a word of welcome and a handshake for each, and after the formality of being 'received' each visitor was at liberty to make full use of the large lawn, the gardens, and other parts of the grounds. By a happy chance it happened to be Mrs Bagnall's birthday, which made the occasion all the more interesting. The grounds were admirably decorated for the event. From tree to tree were hung festoons of flowers, with strings of coloured bunting. Flags were floating in the breeze, and on the front of Hawthorpe Hall and Fernthorpe were festoons of artificial flowers in many hues. A large emblem bore the words 'Welcome to Hawthorpe', and another 'A

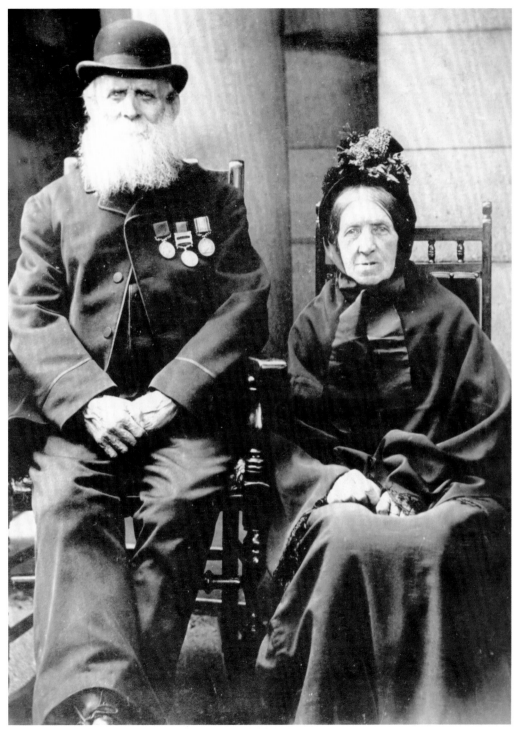

JAMES HIGSON AND WIFE, SERVANTS AT HAIGH HALL, WIGAN

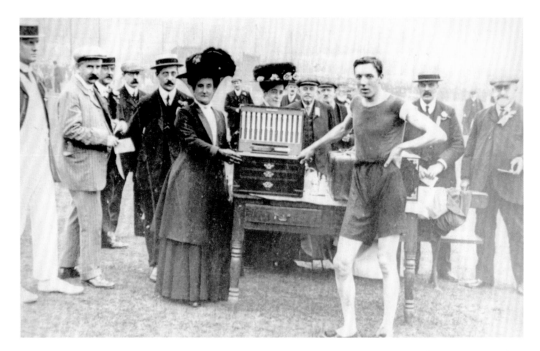

PRIZE-GIVING, ROYTON HALL PLATE

hearty welcome to everyone here'. Two large marquees were erected on the lawns, and in these the gathering of over a thousand people was well catered for with tea, sandwiches, confectionery, ices, etc. The commissariat department proved quite equal to the demands upon it, and none went short. As Saturday was a typical summer's day, dry and sunny, the scene was a brilliant one as the guests walked about the sward, the ladies wearing white or coloured dresses and parasols of many hues. Choice music was discoursed on the lawn by the Boarshurst Band and Greenfield String Band. There was a large gramophone, a ventriloquist with his dolls, and a Punch and Judy show. During the afternoon balloons were sent up, and as evening approached the grounds were illuminated by hundreds of fairy lamps, which gave a pretty effect to the scene. Dancing was indulged in, and all present appeared to enjoy themselves to the full.

During the afternoon two interesting presentations were made to Mr and Mrs Bagnall. They consisted of framed illuminated addresses, one from the Saddleworth Habitation of the Primrose League and the other from their tenants and workpeople. The first, which was in a handsome gold gilt frame, was presented by Mr Harold Cooper, and the latter was handed to the recipients by Mr T.E. Sykes.

In acknowledging the gifts Mr Bagnall said that having friends of all opinions, his wife and himself felt it would be impossible to use words which would express the deep thanks they felt to all who had united in giving them that never-to-be-forgotten appreciation of services they had been only too pleased to render during the seven years of their united connection with the districts. (Applause.)

Saddleworth and Mossley Herald, August 1908

GIVING UP THE GUARDIAN

The editorship of the *Manchester Examiner* was held for many years by Henry Dunckley whose pen-name of 'Verax' was one to conjure with for many years in the north of England. Henry Dunckley was a stylist. The Liberal view of Church and State never had a more lucid expositor than Dunckley, and the curious attempt which Queen Victoria seems to have made in middle life to raise the status of the Crown higher than England cared for, was exposed to the public and largely defeated by him. But he was not a born editor, and the ungodly used to say that the habit—in which his subordinates followed him—of escaping to Fallowfield and Withington while the night was still young was the cause of serious accidents to the *Examiner*. It was not this, however,

PEEL PARK REFERENCE LIBRARY, SALFORD

that caused the *Examiner's* final displacement by the *Guardian*. That occurred in 1886 when Mr. Gladstone was converted to Home Rule and called on the Liberal party to be converted also. The *Examiner* was strongly under the influence of John Bright, and when John Bright dissented from Home Rule the *Examiner* dissented with him. Only indeed for a few weeks. But in those few weeks the *Guardian*, strong from the first for Home Rule, had taken its warm corner in the heart of Liberalism. The rest of the *Examiner's* days were mere superfluous misery. Dunckley himself joined the company of *Guardian* writers.

Steady support from this time onwards of the cause of Home Rule developed in the *Manchester Guardian* that 'Minority mind' which has been its priceless contribution to the public life of England. Home Rule for Ireland was never a popular cause. English opinion was obdurate against it, and Gladstone pleaded in vain for about one half of what was conceded without trouble in the thaw which followed the European war. But the Home Rule cause was a school of opinion and almost of character. For ten solid years the Gladstonian Liberal had given up everything for the peasants of Connemara and Clare. Then the scene of oppression changed, but the heart did not change with it. The bias in favour of the small boy and against the big boy—more particularly if the big boy happened to be the British Empire because he, of all big boys, ought to have known better—this bias continued and the true Gladstonian was found on the side of the Boers. There were real risks in the

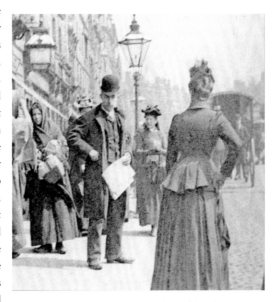

PICCADILLY, MANCHESTER

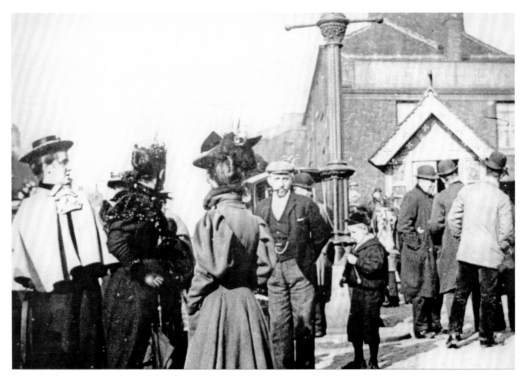

SUNDAY BEST IN GREENACRES ROAD, OLDHAM

partnership and the *Guardian* ran them to the full under Mr Scott. 'To give up the *Guardian*' became in those few years a new verb in the grammar of local speech. It was conjugated in all its moods and tenses. 'I am giving up the *Guardian*!' 'I shall give up the *Guardian*.' 'I have given up the *Guardian*; may I borrow yours for a moment?'

W.H. Brindley

FOU' AS A HEAWNT WHELP

Lancashire people are exceedingly fond of joking about a man's looks, and their caustic utterances about and to each other would be taken as deadly insults in parts of the country where their humour was not understood.

'What's to do wi' thee, this morning?' one man will say to another, 'Tha looks as fou' as a heawnt whelp,' and the person addressed will take it nothing ainiss. One person will say of another that he 'skens (squints) wur nor a pot cat,' referring, of course, to the ugly china and earthenware animals used as ornaments on chests of drawers and dressers in cottages in the country; and sometimes a proud mother, after noting how 'fine' her daughter looks when about to start out dressed in her Sunday best, will, not having any other criticism to make, take a shot at her offspring for sprinkling scent about her clothes. 'Get away wi' thi,' she will say, with a light in her eye which quite belies her words, 'tha stinks wur nor a pow (pole) cat!'

Many will no doubt have heard the story of the man who, walking down the road, met a stranger more than usually ill-favoured. Stopping in front of him, he said, 'Tha'rt a gradely fou' felly.'

The stranger, instead of resenting the personality, replied, 'Well, I cannot help mi looks, con I?

'Nowe, I guess tha connot,' remarked the man, 'but tha met stop awhoam!'

Two merry, but by no means prepossessing sisters, both maiden ladies, living at a spot in the Whitworth Valley, were also not too complimentary to each other, by all accounts.

Said one to the other one day, 'I say, Betty, it's To'morden Fair to-morn. I think I should like to goo.'

'Well, if tha goos,' said the other sister, 'I should get somebody to back thi into't place like a hawss, for if they seen thi face fust, I'm sure they'll never ha' thi within miles o't fair greawnd.'

As remarked, such things would be regarded as downright rudeness in another community. In many cases, of

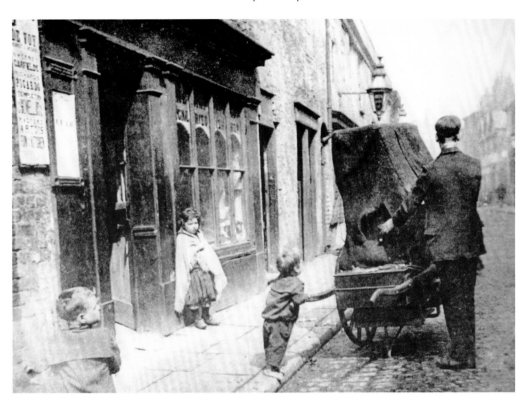

ORGAN GRINDER, MANCHESTER

course, the caustic comment is really meant. Take the one, for instance, where a number of working men were taking their dinner together in a place near Montreal. One man much given to boastful talk was asked how he liked his new job. 'Oh, very well,' he replied, 'only it's a bit dusty.' 'That's a good job,' remarked a Lancashire man present, 'It'll larn thi to keep thi trap shut!'

One day a number of footballers got into a compartment of a railway carriage where a flashily-dressed young fellow was sitting. As the native has an instinctive dislike of the masher, and also by reason of the fact that this individual did not show himself in the least accommodating to anyone else in the carriage, the newcomers sought an opportunity of 'taking him down'. One of the footballers at last noticed that the masher's cuffs were not too clean. 'I say, kid,' he blurted out, 'it's about hawve time wi' them cuffs, isn't it? Hadn't they better change ends!'

Frank Ormerod

STREET MUSICKERS

Very rarely now, in retired street-ways, do you come across the good old ramping chaunt, done in alternate couplets by a hoarse-tongued vagabond and his sturdy trull, who, whatever their defects from a musical point of view, were always certain of an attentive and appreciative audience, due to the touching or exciting nature of the matter of their song. We noted one stout, middle-aged minstrel in a quiet street in Manchester the other day, roaring out with lungs of brass a ditty which had a welcome smack, so far as tune went, of the old-time flavour, but we failed to distinguish the words. What a proper scamp he looked! Great brawny shoulders, covered with a big ragged coat with immense bulging poacher pockets; muffled up closely about the neck, despite the warmth of the day; having a sham limp, and a pretended useless arm hanging by his side, he looked far better fitted for the quarries of Dartmoor than for a musical performance. But some soft-headed people bestowed their charity upon him all the same.

Instead of the old ballads, our minstrels now mostly affect the pious lay, and drone out over and over again one or two verses of some well-known hymn; or else they get up something touching in the Christy line, something of a mournfully domestic nature. These last are particularly and pre-eminently catching. A group passes along

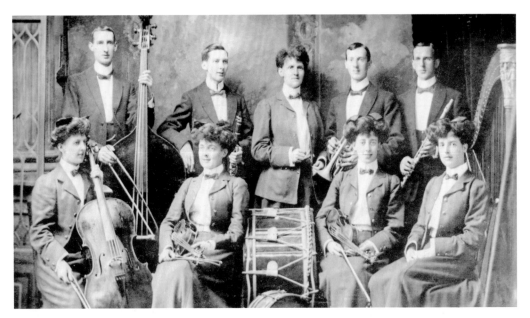

RED ROSE FAMILY ORCHESTRA

our highly respectable and retired Vernal Avenue Just now. A fellow is grinding away at a wheezy old organ, at the first notes of which we throw down our goose-quill and rush to the window, expecting to see our old friend the monkey, in his little jockey cap and laced coat. Instead of the monkey there is a poor little crippled lad seated atop of the awful box o' whistles, and we are indignant as we think of the poor child's sufferings whilst being lumped about upon such an instrument of torture all the day through. With the organ-man and child there is a short, thick-set stubby wench of fifteen or sixteen, who at once starts up one of the old plaintive nigger-songs. She has a strong metallic voice like a key-bugle, of the regular low music-hall stamp, which lakes the street echo again; but the strain fetches the people. The partner of our sorrows peremptorily demands a coin for her; our neighbour, just returned from business and contemplatively enjoying the luxuriance of his yard-and-a-half of front garden, beckons her; a young lady coming along with a bundle stops and fumbles in her pocket; the good neighbours a few doors below who contribute to the support of all organ people and tramps, without exception, call to her; and in ten minutes she had reaped a harvest.

One or two terrible humbugs in the vocal line trouble our district considerably. The 'wet night woman' has been a regular visitor for years. Given a pouring rain and abominable night in which it is unfit for anything alive to be stirring, then, sure as fate, do you hear the high notes of this sweet singer approaching you from the end of the street. She has only about three notes, two at top and one at the bottom of the scale, and you hear these alternately as she tramps along through the wet, with what appears to be a baby tucked away under her shawl. We should like that baby better and have more faith in it, if it would only grow just a little bigger; but to our certain knowledge it has remained the same size for about the last seven or eight years. Another of our blessings is a small fiend who comes round under the pretence of selling evening newspapers. He too has a special liking for wet nights, and on such occasions never has any shoes. His great forte is that unspeakable piece of dreariness known as 'Poor Little Joe', of which he knows one verse. Upon coming into the street he shouts out his news, the whiles he carefully looks about for the police, and if there be none in sight, the paper is quickly whipped under his coat and the verse of 'Little Joe' started. This we are regaled with for a quarter of an hour at a stretch, and the effect is particularly enlivening. We have serious thoughts of boy-slaughter, but hitherto have been deterred by remembrance of a remark made by a dear old lady long since gone to her rest, who, when in our younger days we were apt to deride such vocal efforts, always checked us by saying with a smile, 'Don't be so hard upon him. No doubt the poor fellow is doing his best!'

One of the sorest inflictions under which we groan and suffer, is the performance of the picco-player. Few

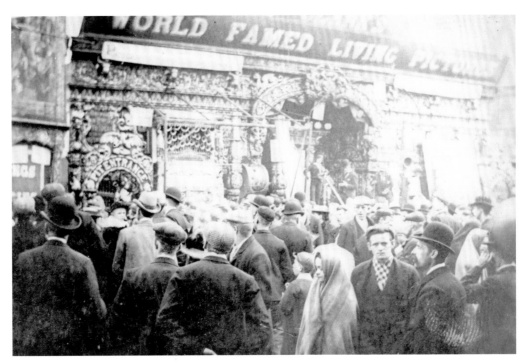

CLARK'S WORLD FAMED LIVING PICTURE HOUSE, OLDHAM WAKES

things are more aggravating or trying to the nerves than being compelled to listen by the hour together, as some of us are, to the earsplitting shrieks of this horrible little instrument. It seems possible for the hand of a master to extract tolerable music from almost anything; and we certainly heard some wonderful performances by the original picco-player who was discovered somewhere in Switzerland, or the Tyrol, years ago, and imported into London; but this is essentially one of those instruments which none but a passed master should ever be allowed to use in public. People have strange tastes and peculiar notions of charity, and we are told that one of our local performers is so successful that he lives in a big house at a fabulous rent, and gets a good living by the letting of apartments. We wish he would stay at home and live on his property.

Walter Tomlinson

LIVING PICTURES AT THE JUBILEE

If Oldham was gay by day it was gayer by night, when the principal streets were ablaze with brilliant designs in lights of gas and electricity, when every thoroughfare was thronged with an elated and admiring crowd of sightseers, not only from all parts of the borough, but from neighbouring towns and villages, and municipal and private enterprise vied in illuminating the place in the most effective manner possible. Perhaps the most generally admired of the big decorations was that which lit up the exterior of the Town Hall. Round the faces of the building blazed rows of gas lights, the pillars were hung with strings of many coloured electric glow lamps, around the block were the words 'Celebration of Jubilee of the Incorporation of Oldham', while over the upper part of the façade, in the midst of a maze of gas and electric lights, flamed a motto showing the names and dates of the first and latest Mayors of Oldham. From the roof a powerful searchlight flashed its white beam of light over the town and surrounding country. The display as a whole was a brilliant one and well worthy of the town. Another very effective show was that given at the Central Fire Station, where the principal item in a well-designed scheme of illumination was a large fountain, playing in the middle of the large yard, and on which beautiful limelight effects were produced by slides of different hues. On the face of the station buildings fronting Peter Street revolved a fiery windmill with four arms ablaze with hundreds of gas jets, which was very striking in appearance. From the tall tower of the station rockets soared skyward every few minutes. Mr E.

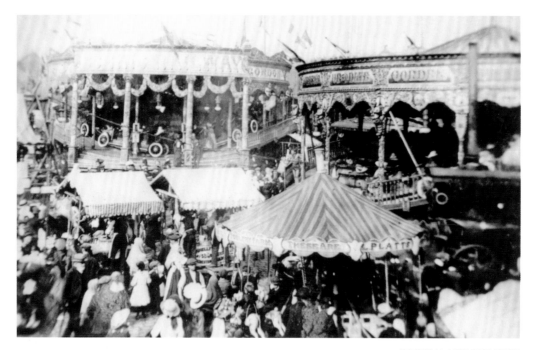

OLDHAM WAKES FAIR

Heywood, of Royton, brought his cinematograph apparatus, and threw a number of views of South Africa, scenes of fires, and other 'living pictures' on a large screen erected on the wall of the yard. From the belfry tower of Oldham Church also numerous rockets were sent up. The Free Library, the Baths, the Lyceum and Technical Schools, the handsome arch across Greaves Street at the Gas and Water Offices, were all lit up with designs of various natures, both in gas and electricity, and all combined to make a magnificent display. Nor were the tradesmen of Union Street, Yorkshire Street, Mumps, and the Bottom-o'th'-Moor, behind-hand in the general illumination. Especially effective was the display at the offices of the 'Oldham Chronicle', where there was a clever arrangement of gas lights with pretty globes around the windows and cornices, a large star at the top of the corner gable, and the name of the newspaper stretching across below. The Friendship and the Red Lion Hotels in Mumps and Bottom-o'th-Moor looked very fine, and Mumps Railway Bridge was turned to account and made the foundation of two striking mottoes in gas lights. High Street, the Old Market Place, and other thoroughfares each effectively bore their part in a magnificent spectacle.

Oldham Charter Jubilee Handbook, 1899

READY FOR TWO LOOMS

I was born on March 23rd, 1862, at Shepherd's Cottage, near Tottington Mill, a little hamlet about half-a-mile east from Tottington village, which contained a beautiful tower, and a print works. The cottage consisted of one room up, one down, and a small pantry. Four of our family were born there. My father was a foreman at the print works, earning 28s. a week; my parents could not afford to buy toys such as there are to-day, but they were very good at making what we required, and my father used to make us bats to play cricket, while my mother made the 'cricket balls' out of calico, tied with string.

I was sent to school at Tottington (Endowed School), my brother taking me to school and back, he being one year older than myself. The schoolmaster used to teach us the alphabet, which was chalked on the floor. His salary was £12 per year, and his cottage was rent free. When my brother was 7 years of age he commenced work as a half-timer, assisting the block printers as a tier boy, as block printing all over Lancashire was in a flourishing position in those days, and the machine printing was just making a little headway. Twelve months soon rolled away, and then I was called upon to do the same work, and later was promoted to other parts of the works—the

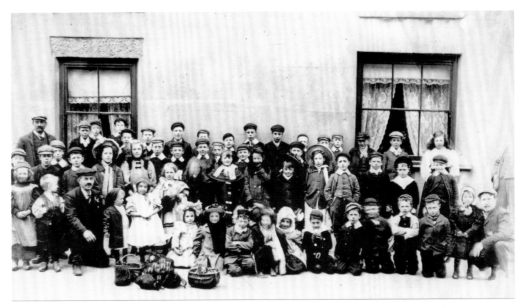

BAMBER BRIDGE OUTING TO CUERDEN PARK, EASTER MONDAY, 1908

hot room, the grey room, white room, finishing room, and warehouse with its four plaiting machines. The hot room was the place where the printed cloth was dried over cylinders, and I was one of the boy plaiters. On the 25th of the month, when all cloth was wanted out of the works, we boys worked until 1 0 o'clock at night, and sometimes all night, and sometimes we were able to sleep for two hours in turn.

When I was ten my father sent me to the weaving mill at Tottington, known as William Hoyle & Co. They had then 900 looms, and did a little spinning, and also had the Bottoms Hall Mill, which was a spinning mill. There was also another mill lower down the stream there, known as Potter Factory. When I had been learning weaving a short time I was ready for two looms, but the demand for looms was so great that my father arranged for me to

go to a local Brookhouse Mill until such times as looms were available at Spring Mill. I had two looms when 12 years of age, and three when I was 14. Then I made my way back to Spring Mill, and at the age of 16 I had four looms, and was later put to apprentice tackling.

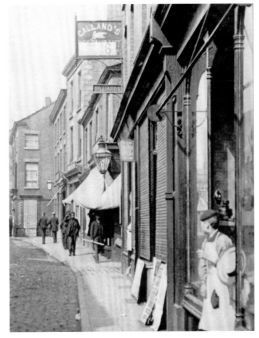

In those days a large fair used to be held yearly in Tottington, about the end of August, when the street from Tuirton Road down to the Parish Church, and as far down as the present Town Hall, was lined with stalls selling nuts and brandysnaps, etc.

The ground about the Robin Hood Hotel served as the cheapjacks' stand, and also for the shooting gallery, while the field on the left of Harwood Road was the place where the trading in cattle, horses, and pigs was done. 'Hobby' horses were in full swing behind the Printers' Arms, and a large swing boat caused merriment. The plumber's and confectioner's shops were not built then. Tottington had many more public houses than to-day, and the constable, John Wilkinson, had a very busy time. The old dungeon was often in use.

Ralph Rooney

LEIGH

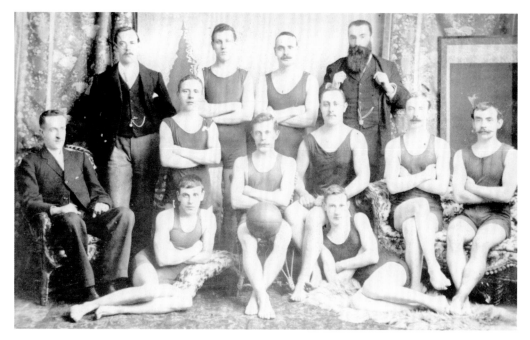

BURY WATER POLO TEAM, 1896

HOME SWEET HOMING

Lancashire people have always been particularly devoted to sports and pastimes, though it must be admitted that their tastes have not always been so tame and innocent as the showman and the acrobat seem to suggest. Up to a time much later than when that dromedary went galumphing through the land, the country villages of Lancashire were disgraced by exhibitions of brutality such as one will hope were not equalled in any other part of the realm. We refer in particular to that form of savagery known as the 'puncing match', in which men of enormous strength and great agility were pitted together in cold blood, often for quite paltry stakes, to kick each other with iron-bound clogs until one or the other was either disabled or killed. Many a victorious combatant has had to flee the country after one of these contests to escape arrest for manslaughter, or lie in hiding for weeks and months on the moors until the law has relaxed its efforts to lay them by the heels. By comparison with this 'sport', bull-baiting and cock-fighting seem peaceable occupations, and wrestling, dog-racing, and pigeon-flying merely children's games.

The 'puncing match' and the baiting of bulls are, of course, unheard of nowadays, but many of the old forms of sport are still to be found in out-of-the-way corners of the county. In colliery districts, especially, do they indulge in cock-fighting, dog-racing, trail-hunting, and wrestling; many of the wrestlers, indeed, having within the past few years cHallénged and beaten some of the best-known men in the world.

Despite the ban which the law has put upon it, there is still a lingering love of cock-fighting, for which our fathers showed such fondness. The outskirts of Rochdale were at one time very notorious for the sport, but since one or two of the old worthies passed over to the great majority, one has not heard so much of the 'cocker'. Occasionally a raid reminds the outside world of its existence, but few are aware of the extent to which it is yet indulged in. Breeders of game fowl still find the occupation a profitable one, and those 'in the know' are able to see many a good 'main' of cocks without going very far out of the sound of town hall bells. Owing to the activity of the police, however, it is becoming every year more difficult to bring off these brutal matches, and the mountainous country of Cumberland has recently become a more favoured rendezvous of the 'fancy'. Nowadays cock-fighting finds its most numerous devotees in the mining districts of South Wales, and outside these islands the United States and Canada have an unenviable notoriety for these battles of the birds.

That other old sport which so often went with cockfighting—pigeon-flying—has lost little of its popularity, it having been modified in form rather than discarded. Where it once was considered disreputable to carry a pigeon in a basket for a couple of miles and throw it up within sight of its own cote, it has now, by taking the bird across

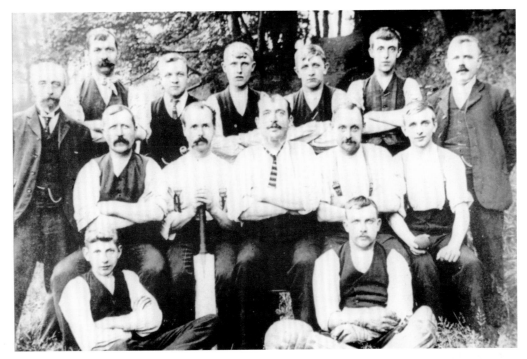

FRIARMERE CRICKET TEAM

the Channel into France, become a sport in which a person of the highest morals and tenderest conscience can indulge. Homing has become extremely popular of recent years, but, for all that, the man with the little basket of birds is yet frequently to be met with on the country roads, walking with an energy worthy of a better cause, and covering scores, and even hundreds, of miles in order to try and win a prize of a few shillings. Some of these men do nothing else for a living but train pigeons for various competitors, and not long ago the request of an old pigeon fancier that a homing pigeon should be killed and placed in his coffin was carried out at his burial

at Rochdale. The man had been a pigeon flyer for nearly seventy years, and had walked thousands of miles in pursuit of his hobby.

Many stories could be told of the keenness of the pigeon-flyer. On one occasion a question arose in a mill as to the speed at which an engine was working, and a deputation was sent to the master to ask him to slow down a little. The master questioned the statements made to him, and added, 'I never knew one of you chaps who ever had a watch fit to time an engine.'

'What!' cried one of the men in amazement, 'Sithi, this watch here is one as'll time a pigeon, never name a engine!'

It is told of a Wigan collier that a friend one day met him walking along the street with a large eight-day clock in his arms. 'What's up!' asked the friend. 'Arti flittin'?' 'Nowe,' was the reply, 'I'm nobbut gooin' deawn to't bridge to time a pigeon!'

Frank Ormerod

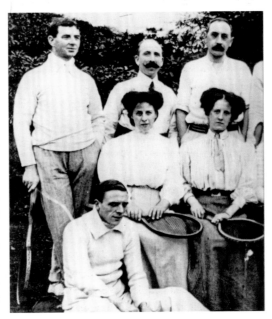

MEMBERS OF BUILE HILL PARK TENNIS CLUB, SALFORD

TOM FOY, MANCHESTER MUSIC HALL COMEDIAN

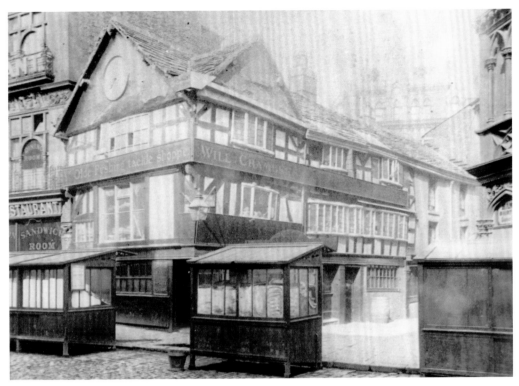

MARKET PLACE, MANCHESTER

A MANCHESTER MUSIC HALL ROUTINE

Listen—I just wanted to tell you summat while I'm here, but—ee, I do hope it doesn't go any farther. Listen. . . shhh!. . . You know, I'm going to tell you summat very private, and I don't want me mother or anybody else to know owt about it. I'm courtin'. It's reet! Aye, I am—I've started. . . Eee, but she's a bonny lass, she is an' all. Better lookin' than me, any day. I'll never forget, I met her in t' park, I were having a walk one day, and she were sitting on a seat under a tree, you know; and I went walking past, like, and I put on a bit of style, you know—I can do, sometimes, when I like—and she did laugh at me. Well, you couldn't blame her. I'll bet I'd laugh if I met me. But I was a bit frightened, tha' knows, and I blushed up a bit when she kept looking at me. . . and she says, 'Come here'. . . I said, 'nay. . . '—she said, 'Come on—come and sit down a bit, and let's whisper words of love or summat.' I Says, 'What?'—She says 'Let's whisper words of love.' I says, 'Ee—I don't know any.' Then she says, 'Come on, sit down'—I said, 'nay—I'd sooner stand here and throw mud at thee.'

Tom Foy

FLYING CLOG IN COURT

The proceedings at the Blackburn Quarter Sessions were diversified yesterday by an extraordinary scene. Four women named Perry, Smith, Greenwood and Murphy, and a rough looking fellow named Owen Brady, were being tried for robbery from the person of James Spedding at the Sawley Abbey beerhouse, Blakey Moor, and the prosecutor was describing the robbery, when Brady whipped off a heavily-buckled belt and hurled it at him with a foul expression, at the same time attempting to jump over the front of the dock. Half a dozen policemen rushed into the dock to the assistance of the warders and Superintendent Byrne, who was seated in the dock by the prisoner's side, and a scene of tremendous uproar ensued. Brady struggled fiercely to get free, but one officer got his hand into his neckerchief, while another nipped his throat in front, and held him thus until his clogs had been taken off and the handcuffs snapped on his wrists. While this was going on the woman Murphy was screaming at the top of her voice that Brady was being killed, and hurling terrible curses at the witness. The

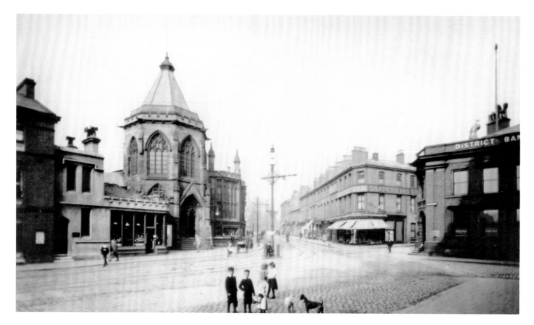

BLACKBURN

Recorder in vain endeavoured to quell the row, Brady making two more attempts to shake off the officers, and causing a renewal of the uproar. Suddenly the learned Recorder said, 'Two officers take charge of the woman Murphy,' but the words were hardly out of his mouth when Murphy stooped down and

PULLED OFF HER HEAVY CLOG,

which she threw violently at the reporters, exclaiming, 'Take that, you scribblers.' The clog just missed the heads of the press representatives and struck the witness-box with a bang. Other officers at once pounced upon Murphy, and stripped her of her other clog and handcuffed her, notwithstanding a fierce struggle in which her dress was torn right open, and a string of bitter curses. The Recorder, addressing the prisoner, said: If the jury convict you, remember I shall have to sentence you. Murphy: And so you can. I don't care a—. The monkeyfaced bastard, to swear people's lives away for nothing. Subsequently Murphy attempted to throw a heavy comb from her hair, and she struggled hard to keep the officer from dispossessing her. Perry and Smith denied having anything to do with the robbery, and said that Murphy gave prosecutor snuff in his beer, and she alone robbed him. Murphy avowed this, and said she drugged Spedding and took his money. Just as the Recorder was about to sum up Murphy yelled out to achurch cleaner and odd job nother of the witnesses, 'The longer I'm in prison the longer you have to live, for, by Jesus, when I come out I'll murder you. I'll put a knife right through you.' The Recorder, in summing up, said that it struck him as strange that in a place like Blackburn a gang of thieves could rob a man in open daylight on licensed premises, and it was a fact that called for the careful consideration of those charged with the licensing of

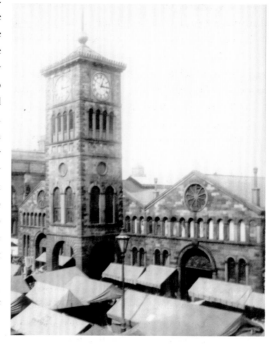

BLACKBURN MARKET

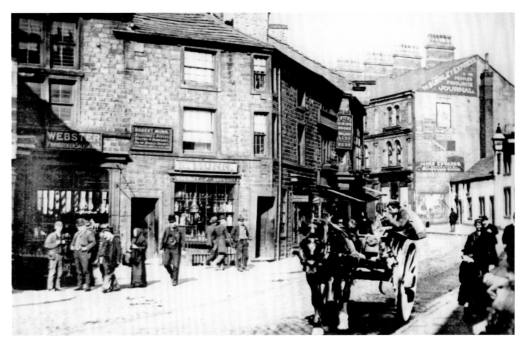

ST JAMES'S STREET, BURNLEY

public-houses. The prisoners were all found guilty. The Recorder, in passing sentence, said the prisoners had been properly convicted of a crime of the most serious description. It was absolutely intolerable that a gang of thieves should attack a man and rob him. Brady:

CUT IT SHORT:

my feet are getting cold. Murphy: So are mine. The Recorder, continuing, said that it was perfectly obvious that such a crime should be visited with severe punishment. Brady and Murphy had shown themselves to be most dangerous characters, and he felt he should not be doing his duty to society if he did not pass sentences upon them that would prevent them for a considerable time to come of committing any serious crimes. You, Murphy and Brady, the learned Recorder went on, have been convicted of theft. Brady: I will be again, too. Murphy: So will I. I will murder some of them. Brady: Give us the maximum punishment. The Recorder: I shall have to pass upon you both a sentence of severity. Murphy: Thank you, you old Jew. The Recorder: Greenwood, Perry, and Smith will have to undergo nine months' imprisonment with hard labour. Murphy: We can do that on our heads. The Recorder: Brady and Murphy, I sentence you each to seven years' penal servitude. Murphy (defiantly): Thank you; I can do that on the top of my head. As the warders and constables hustled the prisoners down into the cells below Murphy sang in a loud and not unpleasant voice, 'She is as beautiful as a butterfly and as proud as a queen,' which gradually died away as she passed along the corridors.

Northern Daily Telegraph, April 1892

THE DANES OF BURNLEY

As you walk through the streets of stone-built Burnley, along with that clatter of clogs which is a familiar sound on Lancashire pavements, you may hear speech of a dialectal order, which has in it a certain vigorous strength of that 'angular' Saxon kind, which, to the regret of some, seems destined to be smoothed down under school board influences. It is said that in this local folk-speech there are still to be found many pure Danish words which are, in their meaning, very expressive. Of the people it may be said generally, that those who know them best describe them as of a cheery, friendly nature, with a strong love for their native surroundings. From Baines we learn that 'it is a peculiarity of Burnley that wakes, rush bearings, and annual feasts obtain little attention from the inhabitants.' However that may be, amid all the smoke and grime and din of manufacturing conditions there

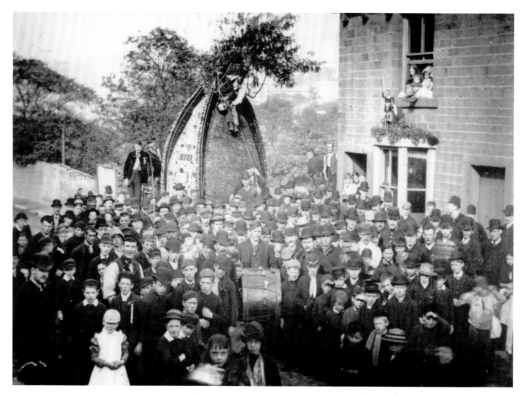

THE UPPERMILL RUSHCART

is a good deal of intellectual life and activity here, which has found expression in various literary forms, some of it dealing with local legend and folk-lore, and others taking directions of an antiquarian kind. Among the illuminating influences must be reckoned a school of art, a literary and scientific club, and a Technical School.

In Burnley, as in other towns of the same character, you notice a budding grace of architectural beauty from among monotonous and commonplace surroundings. This is displayed in the Town Hall, which is built in the classic style, and cost forty thousand pounds. Public parks, too, have they, and the latest purchase in this kind

is especially suggestive. There are many ancestral halls round Burnley, but one of the most celebrated is that of the Towneleys'. You pass the park as you enter the town either from Todmorden or Bacup. Within broad acres and among fine old trees there is a turreted hall. It is a house with a long history, and has its own traditions. The place has peculiar attractions for the antiquary and the historian, and much has been written about it. The contemplative traveller who suffers from a sense of depression as he walks the streets of a manufacturing town sadly feels himself refreshed here. The Rambler round Rossendale says: 'I never linger long in Burnley, nor did I on the morning of my ramble, but made the shortest track for Towneley Park. This park is the one

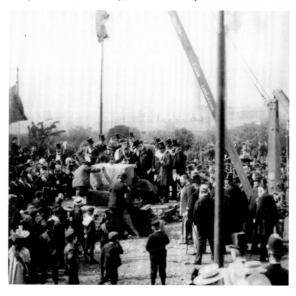

STONE LAYING, VICTORIA WING, BLACKBURN
INFIRMARY

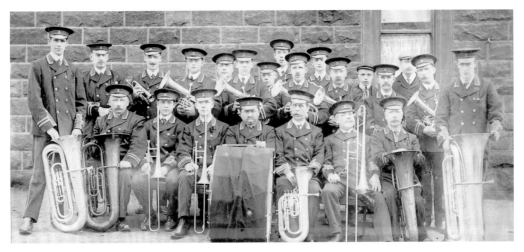

TRAWDEN BAND

redemptive feature of the smoky centre, and it is indeed a pleasure to escape from the narrow streets with their stifling atmosphere of commercialism to its broad demesne.'

John Mortimer

FOOL AT THE RUSH CART

The next house was tenanted by Charles Makin, widower, and one son, Joe, and Joe's wife, Tet, and Tet's daughter, Mary Ann, and one lodger, Isaac Rowe. This family went by the surname of Doe, but why I never could tell. It was Charlie Doe, Joe Doe, Tet Doe, Mary Ann Doe. It was a strange family, and strange things took place in that house. Many practical jokes were played upon them, for they seemed to be fair game for anyone. Two things that Charlie is reputed to have said became almost proverbial in Moston. One was, when he was laden with turf from White Moss, before he got to the end of his journey he said 'they got heavier the farther he went.' So people used to say of an unpleasant burden that it was like Charlie Doe's turf, it grew heavier. At another time, his hat having been blown off and landed into a pond, when asked why he did not fetch it out said: 'What's a hat to a chap's life.' So when anyone was asked to run a serious risk for the prospect of a trivial gain it would be said: 'It's like Charlie Doe's hat, it is not worth the risk.' Charlie used to be the fool at the Rush Cart. He would ride on a donkey or a pony, and be subject to rude and at times to more than harmless jest. His last illness was brought about by the thoughtless and dastardly conduct of some man in Harpurhey, who threw a quantity of water on him while the Rush Cart was staying for a short time at a public house there (Yeb Ashworth's) on its way round by New Cross and Oldham Road to Newton Heath. In this state he remained all day, with the result of the illness that followed. I am glad that this was not done in Moston, and I am sorry that I never heard that some Moston man did not justly chastise the coward. This house was very like the one we have just left, and the entrance from one bedroom into the other was through a hole in the partition wall. It was very aptly described by Sam Rowe, one of the sons of Jimmy Rowe, who lived there after Charlie Doe and family were cleared away. Sam used to tell us that he went on his knees twice a day, once when going to bed at night and once in the morning when he had arisen. I went up into the bedroom one day to see him go through his devotional exercise, and out of curiosity as well. Sam was the drummer in Moston Brass Band, of which I was a member. If he was not like Ou'd Ann, who went through 'like a brid', he certainly went through with great agility. As he got to the hole he dropped on one knee, and shot through like an acrobat, without the least hitch in his movement. That fully explained his going down on his knees night and morning. This young man went to America afterwards, but they never could find out that he landed there. Many enquiries were made at the time, but they never could get to know. He was not heard of afterwards.

John Ward

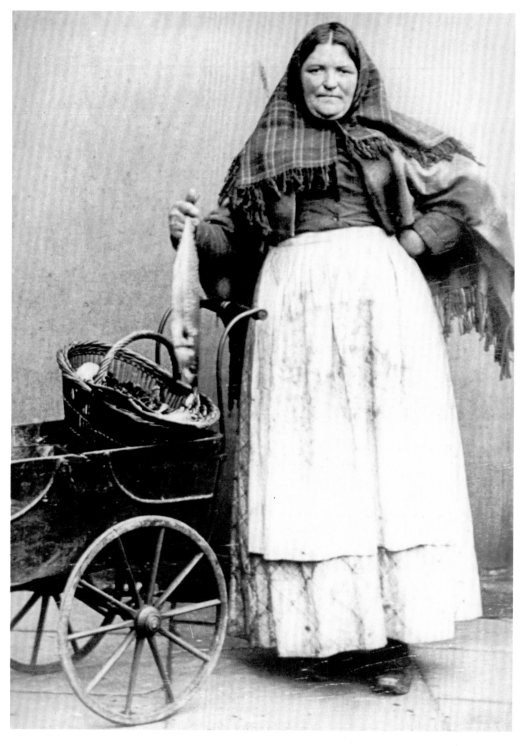

FISH HAWKER, WIGAN

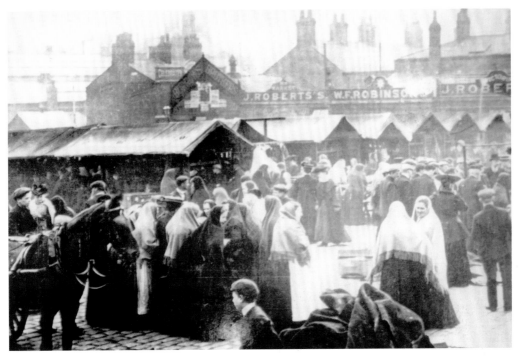

TOMMYFIELD MARKET, OLDHAM

JANE'S MONSTER GOOSEBERRIES

Jane Clough, a coarse, masculine-looking woman, whose voice did not remind one of the music of the spheres, and who used to reside at Bagslate, gave up part of her time to the study of botany, and the cultivation of 'monster gooseberries' and carnations. Jane was not by any means a counterpart of the 'Jane' so highly eulogised in the delightful song so charmingly sung by Sims Reeves as 'pretty' and 'shy', and there was no prim gallant in those days hho had the courage to invite her to meet him in the evening 'when the bloom was on the rye'. Nor was there any young Lochinvar in these parts sufficiently daring in love to whisk off our heroine on a milk-white charger, and bear her away to his home. Jane was in her element if only permitted to join a group of the wisemen who upheld the state at a street corner, and take part with them in discussing-politics, cock-fights, and a 'dradely' dog fight. As to politics, it would appear as if she had been a fore-runner of the strong-minded women of the present generation, as she took the liveliest interest in that absorbing science. She preferred the society of the masculine sex, and, as a rule, shunned that of woman kind in general. Jane was a staunch Conservative, and would always insist on heading that partys processions on great and stirring occasions, but we have not been able to find that the friends of the cause to which she allied herself ever went to the expense of dressing her on such eventful occasions in the 'blue' colours which usually distinguish the Conservatives.

William Robertson

PORTRAIT OF AN OWD SONGSTER

It is now nearly twenty years since I first made the acquaintance of the late Samuel Laycock, my much-esteemed father-in-law. At that time I was full of poetic fervour, and formed one of a small band of youthful contributors to the 'poet's corner' of several of our local weeklies. Having written a short piece which somewhat took the fancy of Laycock, I was invited to meet him at his house in Talbot Road, Blackpool. It was there I saw, for the first time, the author of 'Bonny Brid' and 'Bowton's Yard'. I well remember the feeling of surprise which I experienced when meeting him. His portrait I had never seen, but from his writings I had formed an idea in my mind that the author must be a fine, robust, rollicking sort of a Lancashire fellow. To my utter astonishment I found him to be a thin, slim and wiry person, delicate and frail as a spring flower. He seemed all nerve and brain, his fine

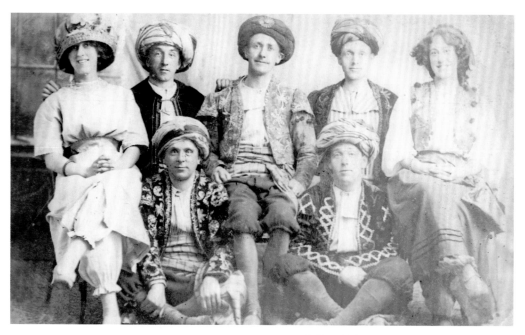

DAN HARDIE'S PLAYERS, MORCAMBE

and well-developed forehead being the most conspicuous part of his body. We had a long walk together, and I received from him some sound advice and sympathetic encouragement. But what most impressed me at that time was his childlike simpliciry, the transparency of his mind, and the gentleness of his heart.

Some people, who had but a slight acquaintance with and superficial insight into Laycock's character, have misunderstood and misjudged him by mistaking the innocent simplicity of his manner for personal vanity. That this was a mistaken impression of the real open-hearted man no one knows better than the writer, who for the last ten years of his life got as close to the inner life of Laycock as any living being. So enthusiastic and frank was he in conversation, that it would have been almost an impossibility for him to conceal from his listeners the thoughts that were passing through his mirror-like mind. Frequently have I seen him become so earnest, and throw so much of his soul into his conversation, that he has had to stop speaking from sheer physical exhaustion. He had a most gentle and mellow voice, and, when a lad, he used to sing in a village choir. It was the winning and child-like simplicity of his manner which revealed the deep sincerity of a kind, innocent, and open heart. A more generous and sympathetic man it would have been difficult to meet with.

There was, however, one striking peculiarity about Laycock's face which was somewhat comical to the close observer of his facial expression. He had a most peculiar twitching about one of his eyes. Of this he was quite conscious, for I remember his telling me an amusing incident arising out of it. On one occasion he was in the company of a number of his friends. Among them was a lady who was evidently not acquainted with this nervous movement of his eye. Mistaking it for something of a different character and meaning, she became quite indignant, and left the room in disgust, concluding that he had been making too free with her by his frequent and unseemly 'winks'. On the matter being afterwards explained to her, quite an outburst of laughter was evoked, in which Laycock joined heartily.

Between my first and second visit to Laycock there was a break of about ten years, but all the while I continued to be an admirer of his writings. The second time I saw him was at his house in Foxhall Road, Blackpool, where I met for the first time the subject of his tender and deeply-touching poem—'Welcome, Bonny Brid'. From this time my visits to his house became very frequent, and much as I admired the author of this beautiful poem—'Bonny Brid', I gradually grew fonder of the subject than of the writer of the piece. Eventually I persuaded the 'Brid' to leave her cozy Blackpool nest, and so my friendship for the poet became exceeded by my love for his daughter.

Sim Schofield

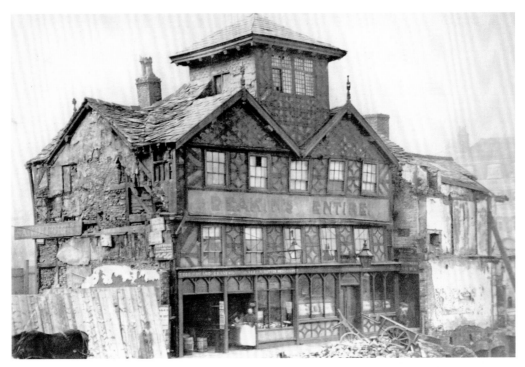

SLUM CLEARANCE, MARKET PLACE, MANCHESTER

NO LAST WORD FOR FEYTHER

'There is not a people on the face of the earth possessed of the same humour, expressed in brief sentences—humour which shakes a man with laughter as a consequence of saying half a dozen words,' remarked Mr George Milner, speaking of Lancashire men at the unveiling of the statue to Ben Brierley, in Manchester, some time ago, and those who know the county best will agree with him.

Certainly one has never met with anything like the same quality of wit and repartee in any other part of England. The Lancastrian is at his best in humorous comment and criticism, and no one can put a point more succinctly. This side of his character, and his natural outspokenness, invests every public meeting with piquancy, and makes doubly interesting any company where men's affairs are being discussed.

Mr Henry Brierley, the Registrar of Wigan County Court, when opening a bazaar in Rochdale on one occasion, told a story of a Wigan boy whose father had died. Meeting the lad shortly afterwards, the Vicar asked what were his father's last words. 'Feyther didn't have no last words,' replied the boy, 'Mother wur wi' him to th' end!'

A former Rochdale alderman was one morning standing on the station platform when a newspaper lad came along. 'Here, my boy, have you got a copy of "Great Thoughts"?' he asked. 'There are no "Great Thoughts" in Rochdale this morning, sir,' replied the lad with a grin.

Frank Ormerod

BOWEN'S SHOP

There is still standing in a narrow street leading from the Market Place in Manchester a mutilated relic of the past. Within our memory it has always been known as the 'spectacle shop', kept by old Bowen, a well-known optician; but he did not occupy the ground floor, which has always been tenanted by publicans and fish sellers. 'Sinclair's' still provides the jaded palate with the delicious but costly bivalve; and in the Wellington Inn public-house liquors are dispensed in large quantity on market days, but the old optician with all his knick-knacks is gone, and the property is tumbling in decay.

The Book of Olde Manchester and Salford, 1887

NEW YEAR'S DAY CONCERT, WHALLEY

GOOD-BYE, OWD YEAR

Good-bye, Owd Year, tha'rt goin' soon, aw reckon:
Well, one thing's sure, tha's been no friend o' mine;
Soa go thi ways to thoose tha's treated better;
Thoose tha's supplied wi honour, wealth, an' wine.
Aw've watched thi marlocks ever sin' tha coom here,
An', that bein' so, aw couldn't help but see
Tha's had thi friends, an' these tha's nursed and petted,
While tryin' t' throw cowd wayter on to me.

Be offl An leov thi reawm for somb'dy better;
An' tak' thi pampered favourites wi thi to';
Clear eawt ole th' hangers-on theaw has abeawt thee,
An' give us th' chance o' tryin' summat new.
What! Me ungrateful? Here, neaw, just one minute;
Doest meon to tell me 'at aw owe *thee* owt?
Neaw, here's a plain, straight-forrud question for thee:
Come, shew me what tha's oather sent or browt.

Well, let that pass, aw bear no malice, mind thee;
Tha'rt clearen' eawt, an' one thing's very sure,
'At when we hear th' church bells ring eawt at midneet,
Tha'll tak' thi hook, an' trouble me no moor.
Still, one thin-rayther plagues me, neaw aw think on't;
Heaw wilta get fro' Blackpool, 'Eighty-Nine?
We've noa trains leov as late as twelve o'clock; but,
Praps tha meons to walk, as th' neet's so fine.

At onyrate, sit deawn, an' warm thi shanks weel;
Tha's getten twenty minutes yet to stop.
Sarah, bring up another cob o' coal, lass,
An' bring this pilgrim here a sope o' pop.
Wheer are thi friends to-neet, those pets tha's favoured?
They're dinin' off a goose at th' Queen's Hotel.
There isn't *one* to shake thi hond at partin';
Au've ole these kindly acts to do misel'.

Neaw, sup that pop, an' eat this bit o' parkin;
Tha's far to goa, an' noan mitch brass to spend.
Shove him a moufin in his pocket, Sarah;
He'll need it ere he gets to th' journey's end.
Aw'm noan a very *bad* sort, after ole, mon;
A chap may love his enemies, tha sees.
Aw think he'll find that moufin rayther dry, lass;
Tha'd better let him have a bit o' cheese.

Neaw wheer does t' find tha's met wi' th' nicest treatment?
At th' sea-side cot? Or 'mongst thi wealthy friends?
Well, never mind; but get thi coat an' hat on;
Two minutes moor, an then eawr campin' ends!
Neaw what's to do? Come, come, tha'rt cryin', arto?
Aw've touched thi feelin's, have aw? Well, o reet!
Tha met ha feawnd thi *friend* eawt twelve months sooner:
But time's neaw up! Well, 'Eighty-Nine, good-neet!

Samuel Laycock

SOURCES AND PHOTOGRAPHIC DETAILS

TEXT

The page numbers given below relate to pages in this book and not the page numbers of the source books.

The main sources for descriptive text are Frank Ormerod, *Lancashire Life And Character* (Edwards & Bryning, Rochdale), pp. 7, 17, 27, 31, 45, 48, 51, 53, 56, 62, 63, 69, 83, 89, 96, 102, 113; John Mortimer, *Industrial Lancashire: Some Manufacturing Towns And Their Surroundings* (Palmer, Howe & Co., Manchester, 1897) pp. 15, 39, 58, 75, 77, 107; Walter Tomlinson, *Byways Of Manchester Life* (Butterworth & Nodal, Manchester, 1887) pp. 32, 84, 97.

Other works used are: T. Thompson, *Lancashire For Me* (George Allen & Unwin) pp. 10, 72; Thomas Newbigging, *Lancashire Characters And Places* (Brook & Chrystal, Manchester, 1891) pp. 18, 64; William Robertson, *Rochdale Past And Present: A History And Guide* (Schofield & Hoblin, Rochdale, 1876) pp. 20, 38, 54, 111; Mary Thomason, *Warp And Weft: Cuts From A Lancashire Loom* (Leigh Chronicle, 1935) pp. 21, 60; Henry A. Bright, *A Year In A Lancashire Garden* (privately published, 1874) p. 28; John Hudson, *A Lancashire*

Christmas (Alan Sutton, 1990) p. 41; Ralph Rooney, *The Story Of My Life*, (Bury Times, 1947) pp. 80, 100; W. H. Brindley; *The Soul Of Manchester* (Manchester University Press, 1929) pp. 81, 94; John Ward, *Moston Characters At Play*, (Charles H. Barber, Manchester, 1905) p. 109; Sim Schofield, introduction to *Warblins Fro' An Owd Songster* (W.E. Clegg, Oldham, 1893) p. 111; Samuel Laycock, *Warblins Fro' An Owd Songster* (WE. Clegg, Oldham, 1893) p. 114.

Periodicals and newspapers: *Northern Daily Telegraph* pp. 14, 24, 63, 105; *Goldborne Parish Magazine* pp. 22, 50; *Spy Magazine* (Manchester) p. 55; *Radcliffe and Pilkington Co-op Jubilee Souvenir*, 1910 p. 78, *Burnley Express and Clitheroe Division Advertiser* p. 79; *Saddleworth and Mossley Herald*, pp. 91, 92; *Oldham Charter Jubilee Handbook*, 1899 p. 99; *The Book of Olde Manchester and Salford*, 1887 p. 113.

Other sources: Oscar Hudson, personal reminiscence (c. 1958) p. 30; Tom Foy; transcript of music hall routine (c. 1912) p. 105.

ILLUSTRATIONS

Credits and information in page order. For key to initials of sources, please refer to the end of this sectin. Photograph, include works by the noted documentary photographers Wickham of Wigan and Coulthurst of Manchester, the first from Wigan Heritage Service archives and the second from the Salford Local Historv Library. When dates are known, or can reasonably be deduced, these are given.

Endpapers: front, Day trip from Barrow to Fleetwood for Blackpool, 27 May 1912; JH; back, Whit walks; JH. Title page i, Weavers at Victoria Mill, Clayton, Manchester; DPA. Page ii, Mother and child, Leeds and Liverpool Canal, Wigan; WHS. Leigh Technical School opening, 1894; WHS. Page iii, Kerfoot's grocery shop, Market Street, Leigh; WHS. Page iv, Women picking coal, Chanters Screens, Atherton; WHS. Page l, Men's Bible class, St Andrew's church, Wigan, 1891; WHS. Page 2, Deliveries leave Dronsfield Brothers' Atlas Works, Oldham; OPA. Kirk & Co., shuttle makers, Blackburn, c. 1900; BDL. Page 3, Oldham Cycling Club at Royal George Inn, Greenfield, c. 1890; OPA. Butler Green post office, Washbrook, Chadderton, c. 1890; OPA. Page 4, Potters Yard, Oldham; OPA. Fire-fighting team, Pearson and Knowsley Pit, Ince, c. 1910; WHS. Page 5, Odd-job man, St Andrew's Church, Wigan; WHS. Page 7, Tree planting, Hollins Garden Suburb, Oldham, 1909; OPA. Page 8, Mill girls with their snap baskets and cans, Wigan; WHS. Page 9, Mill children and their overseers, Wigan; WHS. Page 10, Infants at Richard Evans School, Ashton-in-Makerfield, c. 1892; WHS. Page 11, An evicted family, Ashton-in-Makerfield, c. 1900; WHS. On the sands at Morecambe, with tower at left, c. 1910; JH. Page 12, Promenade and clock tower, Morecambe; JH. Page 13, Children's corner, Whitworth Park, Manchester; SLH. Gas explosion, Coppull Lane, Wigan, 1886; WHS. Page 14 , Street life, Rochdale Road, Manchester; SLH. Fruit stalls, Blackburn Market, c. 1906; BDL. Page 15, Moorcock Inn, 'Bill 'o jack's', Greenfield, Oldhaln; OPA. Page 16, Mr Fearnley's clog shop, Astley, c. 1910; WHS. Page 17, Dog show at Upholland Show, 1905; WHS. Page 18, Whalley Range, Manchester, c. 1906; JH. Page 19, Cycle procession, Trafford Road, Manchester; SLH. Promenaders on Lord Street, Southport, c. 1910; JH. Page 20, East Lancashire Yeomanry manoevres, Fylde coast, early 1900s; BDL. Page 2l, Workers at Johnson and Davis, nut and bolt manufacturers, Bolton Old Road, Atherton, 1884; WHS. Oldham Town Hall; OPA. Page 22, Matthews and Sons, painters and decorators, Oldham, 1909; OPA. Page 23, Church and Sunday school group, Wigan; WHS. Page 24, Salford church outing; JH. Concert party, Blackford Bridge Congregational church, Bury, c. 1906; PC. Page 25, London Road Station, Manchester; SLH. Page 26, Mowing at Daisy Nook, near Oldham, c. 1890; OPA. Bolton panorama, c. 1906; JH. Page 27, Stepping stones, near Burnley, Good Friday; JH. Page 28, Donkey parade, Werneth Park, near Oldham, June 1910; OPA. Page 29, Houghton Valley, c. 1910; BDL. Page 30, Princes landing stage bell, Liverpool, c. 1910; JH. Page 31, Liner at the landing stage, Liverpool, c. 1910; JH. Page 32, Old houses, Greengate, Salford; SLH. Mandolin College, Market Street, Leigh; WHS. Page 33, Shudehill poultry market, Manchester; SLH. Page 34, Market Street, Manchester; SLH. Page 35, Hallgate, off Market Street, Wigan; WHS.

Working men at leisure, Oldham; OPA. Page 36, Victoria Street, Blackburn, on market day, c. 1906; BDL. Page 37, Deansgate, Manchester, near St Mary Street; SLH. Page 38, Cutting the first sod, Rooden Reservoir, July 1894; OPA. Page 39, Between Paradise Street and High Street, Lower Darwen, before slum clearance, 1870; BDL. Page 40, Accrington Stanley FC, 1905; BDL. Unknown cotton weaving shed; JH. Page 41, North-east Lancashire Auto Club at Blackburn Town Hall, 1912; BDL. Page 42, Salford Hippodrome; SLH. Page 43, Leigh Fire Brigade with Shand Mason appliance; WHS. Page 44, A1 comedy entertainers, Bolton; JH. Page 45, Sporting event crowd, Trafford Road, Manchester; SLH. Page 46, Wigan colliers and pit boys, c. 1890; Page 47, Lancashire County Cricket Club first XI, 1880; BDL. Page 48, Bold Street, Liverpool, c. 1910; JH. Salford Docks; SLH. Page 49, St Ann Street and Square, Manchester, 1890s; SLH. Page 50, Gathering for the Whit walks, Preston; JH. Page 51, Blackford Bridge Congregational church sailor boys, Bury coronation procession, 1911; PC. Page 52, St Andrew's church cleaner and odd job man, Wigan; WHS. Page 53, Directors of Sun Mill, Chadderton; OPA. Page 54, Hollingworth Lake, c. 1906; JH. Page 55, The bandstand, Heaton Park, Manchester, c. 1906; JH. Page 56, Manchester weavers; SLH. Spinners at J. and J. Hayes, Leigh, 1900; WHS. Page 57, Holiday crowds on Blackpool beach; JH. Page 58, Lower light and Promenade, Fleetwood; JH. Gigantic Wheel, Blackpool Winter Gardens; JH. Page 59, Preston field day, 1913; JH. Page 60, Wagon shop, Gibfield Colliery, Atherton, c. 1906; WHS. Page 61, Wigan miners at the face, c. 1900; WHS. Page 62, Lancashire Rifles officers, c. 1880; LFM. A Fusilier's farewell to his mother; LFM. Page 62, Princes landing stage, Liverpool; JH. Page 64, Workers at Delph bakestone pit; OPA. Page 65, Weavers at Victoria Mill, Clayton, Manchester; DPA. Spinning shed, Oldham; DPA. Page 66, Clegg Street goods yard, Oldham, c. 1900; OPA. Page 67, Mr Haworth serving at St Andrew's church soup kitchen, Wigan coal strike, 1894. Page 68, Leigh town centre; WHS. Page 69, Village pump, Heysham; JH. Cannon Street and Garlick Street, Oldham, c. 1900; OPA. Page 70, Scorton village; JH. Bricklayers in Manchester; SLH. Page 71, Gisburn village; JH. Page 72, Wagonette trip to Bolton-by-Bowland, 1906; BDL. Page 73, Bolton Street, Bury, c. 1900; BML. Foundation stone laying, Bury Art Gallery, 1900; BML. Page 74, Miss Cooper's Refreshment Rooms, Bury Market; BML. Page 75, Manchester Corporation tramcar, Longsight to Plymouth Grove. c. 1903, OPA. Page 76, Opening Oldham Central Library; OPA. Dinner time at Platt Bros. Oldham: ONA. Page 77, Spinners at J. and J. Hayes, Leigh. 1900; WHS. Page 78, Alderman S. Crossley's, Mayor's Reception. Blackburn. 1911. BDL. Page 79 Kerfoot's grocery shop, Market Street, Leigh; WHS. Westwood Grocery Store, near Oldham, OPA. Page 80, Blackburn Rovers FC, 1882; BDL. Page 81, Manchester College of Music Orchestra; OPA. Lord Street shoppers, Southport; JH. Page 82, Cromwell's Statue and Manchester Cathedral, 1909; SLH. Page 83, Long Millgate, Manchester; SLH. Page 84, Oldham Workhouse, OPA. Page 85, Children's playground and Round Chapel, Alcoats, Manchester; SLH. Old Mary the paper woman, Victoria Street, Manchester; SLH. Page 86, Chadwick's Orphanage, Bolton; JH. Page 87, Masonic treat for poor children of Leigh; WHS. Page 88, Old toll bar, Moston Lane, Manchester; SLH. Page 90, Three Pigeons pub and vegetable cart, Bolton Road, Irlams o' th' Height, Manchester, 1904; SLH. Page 90, Grocer's cart, King Street, Delph, c. 1900; OPA. Pack Horse Inn, Delph; OPA. Page 91, Lord Crawford and family in their car, Haigh Hall, Wigan, 1906; WHS. Page 92, Maypole dancers, Snipe Clough, Oldham; OPA. Page 93, James Higson, lodge keeper and gardener, Haigh Hall, Wigan, and Mrs Higson; WHS. Page 94, Presentation to the winner of the Roytol Hall Plate; OPA. Page 95, Messrs Hobson and Lewis at the Reference Library, Peel Park, Salford, 1893; SLH. Piccadilly, Manchester; SLH. Page 96, Sunday best clothes in Greenacres Road, Oldham; OPA. Page 97, Street organ grinder and audience, Manchester; SLH. Page 98, Red Rose Family Orchestra, Preston; JH. Page 99, Clark's World Famed Living Picture House, Oldham Wakes; OPA. Page 100, Oldham Wakes Fair, Tommyfield, 1913; OPA. Page 101, Jimmy Charlton's Easter Monday treat, an outing, for Bamber Bridge children to Cuerden Park, 1908; JH. A shopping day in Leigh; WHS. Page 102, Bury water polo team captained by S. Cheetham, 1896; BML. Page 103, Friarmere cricket team, Delph, c. 1905; OPA. Members of Buile Hill Park tennis club, Salford; SLH. Page 104, Tom Foy, Edwardian Manchester music hall comedian; DPA. Page 105, Wellington Inn, Market Place, Manchester, 1896; SLH. Page 106, Blackburn town centre; BDL. Blackburn market and market hall, 1910; BDL. Page 107, St James's Street, Burnley, 1896; BuDL. Page 108, Rushcart at Oldham Road, Uppermill, 1888; OPA. Laying the foundation stone, Victoria wing, Blackburn

Infirmary, 1897; BDL. Page 109, Trawden Band, 1910; JH. Page 110, Fish hawker, Wigan, 1891; WHS. Page 111, Tommyfield Market, Oldham; OPA. Page 112, Dan Hardie's concert party, Morecambe; JH. Page 113, Slum clearance, Market Place, Manchester; SLH. Page 114, Traditional New Year's Day concert, Whalley Church of England School; DPA.

KEY: BDL, Blackburn District Library; BML, Bury Metro Libraries; BuDL, Burnley District Library; PC, Peter Cole; DPA, Documentary Photography Archive, Manchester; JH, John Hudson; LFM, Lancashire Fusiliers Museum, Bury; OPA, Oldham Photographic Archive; SLH, Salford Local History Library; WHS, Wigan Heritage Services. Acknowledgements also to Lawrence Purcell of Prestwich, Manchester for photographic services.